Meyer Schapiro

His Painting, Drawing, and Sculpture

Meyer Schapiro

His Painting, Drawing, and Sculpture

Preface by John Russell

Introduction by Lillian Milgram Schapiro

Texts by Meyer Schapiro

Edited by Lillian Milgram Schapiro and Daniel Esterman

Photographs by John Bigelow Taylor

HARRY N. ABRAMS, INC., PUBLISHERS

Editor: Adele Westbrook
Designer: Dana Sloan

Library of Congress Cataloging-in-Publication Data

Schapiro, Meyer, 1904–1996
 Meyer Schapiro: his painting, drawing, and sculpture / preface
by John Russell: introduction by Lillian Milgram Schapiro : texts by
Meyer Schapiro : edited by Lillian Milgram Schapiro and Daniel
Esterman : photographs by John Bigelow Taylor.
 p. cm.
 Includes index.
 ISBN 0–8109–4392–1 (hardcover)
 1. Schapiro, Meyer. 1904–1996—Contributions in art. 2. Art,
Modern—20th century—United States. I. Schapiro, Lillian
Milgram. II. Esterman, Daniel. III. Title.
N6537.S338A4 2000
709'.2—dc21

Printed and bound in Japan

Harry N. Abrams
100 Fifth Avenue
New York, N.Y. 10011
www.abramsbooks.com

Contents

Preface by John Russell

ne of the best things about New York used to be that Meyer Schapiro was somewhere around. You didn't have to know him, or to have heard him lecture, or even to have seen him in the street. You just had to know that he was there, as he had been since he arrived on Ellis Island at the age of three in 1907. To be in the same city as Meyer Schapiro was a privilege, and we knew it.

To open this book is to become aware of that all over again. Meyer Schapiro the painter and draftsman is glimpsed here in many roles—as a wordless autobiographer, and as a devoted husband, father, and family member. He is also seen as a prized friend, a homebody, an untiring and inventive traveler, a lifelong student of architecture and sculpture in many parts of the world, a versatile portraitist and—this may come as a surprise—a master of light comedy in line.

In that last context, I would include the drawing in which Meyer Schapiro shows Bernard Berenson recommending an Old Master painting to an eager collector. (The likeness of Berenson is remarkably sharp, by the way.) "But are you sure that's by Masaccio?" the collector asks. "Sure of it?" the great savant replies. "Why, I know more about Masaccio's work than Masaccio did."

More kindly, but not less to the point, is the drawing in which a party of archaeologists stumbles upon a monumental sculpture in the desert, only to find that it is already fenced in and bears, "as big as all outdoors," the name of the man who discovered it.

This book reproduces over 200 paintings, drawings, and sculptures by Meyer Schapiro. The great majority of them will be both unknown and unexpected. This is, in fact, a private view of a largely unknown collection. From his boyhood days onward, Meyer Schapiro had loved to draw. When

he was in elementary school (P. S. 84 in Brooklyn), he had the good luck to be taught by John Sloan, the painter and etcher. Sloan's way of drawing had a plain, honest, sturdy quality about it, and there are many echoes of his work in this book.

In her irreplaceable introduction, Dr. Lillian Milgram Schapiro describes how Meyer Schapiro, her husband of sixty-eight years, "had thought deeply about becoming an artist. For him, an artist was someone who made something great. He couldn't believe he could. He gave up that hope." Thereafter, he called himself, at best, "a summer painter."

That may be, but there are summer painters who bring to their work a freshness, a heightened awareness, and a readiness to try anything. Meyer Schapiro, the young husband and young father, was wonderfully lively and unstilted in his scenes of family life on vacation. He could lay out a certain landscape and give every color and every well-judged form something of his own. There is nothing amateurish about his oils of the early 1930s. He could also move into family jokes without being facetious. Even after many years of domesticity, he brought a wild exuberance to a message to himself that reads, "Clear The Table Please!".

Drawing after drawing in this book reveals an exceptional delicacy and exactitude in the portrayal of architecture. Historic buildings in France (Auxerre, Conques, Clermont-Ferrand, Moissac) are set side-by-side with the Mosque of Hassan in Cairo and the Dome of the Rock in Jerusalem. There are also drawings after manuscripts in the Bibliothèque Nationale in Paris.

He had once thought that he might become an architect. But after he had talked to several architects and visited their offices, he decided that "architecture seemed too bound up with business, too commercial." This might have been a career decision, but Meyer Schapiro was in no sense of the word a careerist.

His every decision sprang from a lifelong determination to collect, classify, and define every kind of experience that came his way. Not only did he remember everything that had ever come to his notice, but he also knew its exact place in the general scheme of things. What he wanted from life was the quiet hum of undiluted cerebration, and he got it.

I became aware of this at first hand in the late 1960s. The Schapiros were heading for London and had nowhere to stay. Our mutual friend Thomas B. Hess, the foremost art critic of the day, asked if we had any

ideas. I said that, as it happened, the apartment which Suzi Gablik and I
then had in London would be empty. It would be an honor to lend it to
the Schapiros.

Their arrival overlapped with our departure by about half an hour.
We thought we would show them around in the traditional style, but Meyer
Schapiro wasn't going to be bothered with that. Something hanging on
the walls caught his fancy on the way in, so he put down their luggage and
wouldn't move until the driver of our taxi to Heathrow Airport was ham-
mering at the door.

One thing, one century, one language, one culture led to another,
seamlessly, complete with page references to the mention of whatever book
was passing through the room like a meteorite. Here was Meyer Schapiro,
who had never seen us before, giving of his thoughts and knowledge with-
out stint. We hated to leave.

I well understood our friend, the painter R. B. Kitaj, when he said
many years later that Meyer Schapiro had been to call on him in London.
"Like having Plato in the living room!" he said.

After I came to live in New York in 1974, I seemed to detect certain
successive phases in the respect and admiration with which Schapiro was
regarded. Initially, the artworld professionals claimed him as their own,
thanks in large degree to his lectures at New York University between
1932 and 1936, and at the New School for Social Research between 1936
and 1952. Of his years at the New School, Hilton Kramer, now editor of
The New Criterion, was to say that "those lectures, always crowded with
artists and writers, were dazzling performances that left one in no doubt
that the great work of the modern painters stood at the very center of life."

He was one of nature's illuminants. During World War II, when
European artists were arriving in New York as émigrés, it was Meyer
Schapiro who could astonish the sculptor Jacques Lipchitz by drawing
from memory a whole room of tribal sculptures in the Musée de l'Homme
in Paris. And it was Schapiro who took Fernand Léger to the basement of
the Pierpont Morgan Library and showed him an eleventh-century illumi-
nation from the *Beatus Apocalypse* that would be very useful to Léger.

When the first New York School of painters was coalescing, Schapiro
was right there. Unlike at least one celebrated critic of the day, he did not
go to a studio and tell the artist what to do. But given the prodigious

range, depth, and clarity of his understanding, every word was worth hearing. It was on an inspired, one-on-one basis that he dealt with the living artist.

An indication of the high regard in which Meyer Schapiro held the work of artists is reflected in his address to the Annual Meeting of the American Federation of Arts in 1957, when he said that, "Paintings and sculptures are the last hand-made, personal objects within our culture. Almost everything else is produced industrially, in mass, and through a high division of labor. Few people are fortunate enough to make something that represents themselves, that issues entirely from their hands and mind, and to which they can affix their names."

That he kept at least one artist in his heart is shown in this book by a very small drawing in color pencils, which he made in February 1970. It is clearly a private memorial to Mark Rothko, who had just died, and it is inscribed: "from sunshine to the sunless land, Remembering Mark Rothko." In later years, his widow tells us, Schapiro often quoted those first six words, which are by William Wordsworth.

The next phase—or perhaps a parallel one—was marked by his friendship with intellectuals: academics, critics, scholars of no matter what subject. All were as if magnetized by his company. Some of them were New Yorkers, others had come to New York during or after World War II.

The drawings in this book include what is, in effect, a portrait gallery of some of them. Among the New Yorkers are Whittaker Chambers, Irving Howe, Lionel Abel and Gandy Brody. Among visitors from Europe, Isaiah Berlin was drawn in Vermont in 1942. Another example of Meyer Schapiro's exceptional sensibility as a portraitist is his rendering of Jean Wahl in 1964. At that time, Jean Wahl was a frail and elderly Parisian philosopher who was tiny in stature and very slightly built. Schapiro did a beautiful job with Wahl's hesitant but eager gaze.

The drawing of Schapiro's favorite French translator, Jean-Claude Lebensztejn, also turned out very well.

All of this notwithstanding, Meyer Schapiro's best portrait sitters were himself and his wife. During a span of more than sixty years (from 1916 until 1979), there are self-portraits that very nearly bring him back to life, so intense is the scrutiny that they bring to bear and so steady the hand that makes the marks on the paper. And Lillian Milgram Schapiro is constantly there, without ever looking "posed."

For that matter, nothing in their family life was ever forgotten or discarded. When Meyer Schapiro's father was buried in Queens Cemetery in 1940, his son drew (twice) the view of New York as it presented itself on the way back home. And in 1942, long after the event, he drew an episode in which, as a small boy, he saw his father off to work on the elevated train, ran after it, got lost, and was brought home by the police.

To see Meyer Schapiro take stock of a great work of art was both a haunting and a humbling experience. In January 1993, during the last weeks of the Museum of Modern Art's great Matisse exhibition, it was suddenly whispered one day among the huge attendance that Meyer Schapiro was there. He may well have been the only visitor to that exhibition whose presence suddenly seemed to be as memorable as anything in the show. And what did he bring with him? As always, the quiet hum of undiluted cerebration.

Introduction by Lillian Milgram Schapiro

The works illustrated in this book were assembled by me from our New York, Vermont, and Florida homes, with no intention other than that of organizing and preserving them. Later, publication of the choicest pieces appeared an obvious step. I enlisted the help of my nephew, Daniel Esterman, who eventually took over much of the labor. We could sometimes get the artist himself to look at his works, to place or date them—and he would occasionally make an approving judgment, giving us the greatest pleasure.

eyer Schapiro (September 23, 1904–March 3, 1996) has recounted his memories of drawing at school and at home, where and how he was taught, as well as his early study and analyses of works of art as an undergraduate (1920–24) and graduate student at Columbia University.

He recalled that, one day, his father—who would sometimes have to physically remove Meyer and his drawings from the dining table so that the family could eat—brought home a large album of engravings after Renaissance masters in the Dresden Gallery. Meyer had begun to draw in his elementary school, P.S. 84 in Brooklyn, but this album, which his father had found in one of the secondhand bookshops on Manhattan's Fourth Avenue that he frequented, was different. "I was fascinated by the pictures," Meyer said simply. "I must have been nine or ten years old and had already been drawing for a while, and I began to copy some of them. I remember feeling particularly at home with the pictures that had a biblical subject. But I was already discovering old art apart from my drawings of objects." (Helen Epstein, "Meyer Schapiro: A Passion to Know and Make Known," *Artnews*, May 1983, pp. 60–85; Summer 1983, p. 84–95.)

" had the good fortune to live near the Brooklyn Museum and to visit there regularly on week-ends upon a recommendation from the Boys High School art teacher to a drawing from life art class where one of the staff, a Swiss painter, F. Mura, who adored the French Barbizon painters, took a shine to me and led me by the hand to look closely with him at paintings of that school and observe the texture of paintings, the brushwork, the relationships of tones, and the harmony of colors.

"Parallel to art readings and museum visits, was my attendance (in 1916–17?) at a Hebrew Educational Society evening drawing class consisting of workers, a schoolteacher and myself at 13, where—after some discussion—I was allowed to draw from the nude model.

"What I read and learned during those years before 1920 about both art and social life have been important for my ideas throughout my studies, research, teaching, and writing ever since, although not synthesized into an adequate, satisfying theory of art."

Not long after entering Columbia College in September 1920, he sought admission to the life class at the National Academy of Design. He was given permission to enroll after a test drawing from a plaster cast.

"At 15 or 16 I was much concerned with analyses of form in old and new art. I was influenced by reading Willard Huntington Wright's book on 20th-century art and by Roger Fry. I made many drawings analyzing the structure of lines, silhouettes, spotting of bright and dark areas (the balance, coherence, contrasts, and correspondences of elements—in abstraction from the represented objects). I still have the sketchbooks in which I pursued these studies, after photographs and illustrations in art books, soon after entering and while at college (Columbia) 1920–24." (The paragraphs in quotation marks are from a 1990 letter in answer to a question on his changes of approach, addressed to Leslie J. Connor, St. Lawrence University, Canton, N.Y.)

We have a longer account of part of his early education—his drawn analyses of paintings he admired:

"*W*hen I first began to look at paintings closely (when I was an undergraduate and even before) I often observed in paintings I admired most—old masters, modern painters like Cézanne—that there were clear structures, patterns, relationships of shapes and colors which were highly ordered, that therefore seemed to me to be purposive, not purposive necessarily in a deliberate sense but purposive in that they functioned, that without them the painting wouldn't be what it is. That is not quite the same as saying a painting is perfect, if a painting can be perfect. There are many purposive (?) elements. I would often make little drawings from the original painting or sculpture, isolating the shapes which went together, which

formed their rhythm or large configuration, and I discovered later in reading statements by artists of the Renaissance period and 18th and 19th century, that they did exactly the same thing—they noticed in old works the values, the features which were highly ordered, connected with one another, supported one another, and often of the most unexpected kind. Today, for example, looking at this Chinese painting here, I was struck by the fact that between the two legs of the horse there is a little triangular shape. It's an empty space. Looking around the work, I found a great many diagonals and triangles which were variants of that and which showed similar angles or similar enclosures. Sometimes in light it gets dark, and elsewhere dark gets light— like a theme, or a word which in a poem or a piece of music comes back again and again but always with some variation. Now, that type of observation struck me very, very early (I may say, when I was fifteen or sixteen years old) and I had already begun making drawings of that kind. Whenever I was in museums or in a building and saw a work of art that interested me, I would make a few tracings on paper, notes of such features, as one retains a melody or motif of a piece of music or remembers a very characteristic phrase or rhythm of a poem. This was, to me, extremely important in looking at works of art. So I began with a strong conviction about the formal structure of painting and sculpture, and this was before I had any real knowledge of the beginnings of abstract painting and sculpture which lay in that very period in Europe." *(From an unpublished recorded talk to Ralph Hyams on Form, Coherence, and Expression, February 1974, in Sarasota, Florida.)*

"particularly great debt I must acknowledge is one to a man who was not a historian or critic, who wrote nothing, and is little known in the academic world, though he taught for many years. As an undergraduate at Columbia I attended a class in drawing at Teachers College conducted by Charles Martin. He was a painter who had studied in Paris in the school taught by Maurice Denis and had been inspired in his own work by the example of Seurat. Charles Martin asked the students to present at each weekly meeting a carefully finished charcoal on a theme that interested us. By 'finished' he did not mean detailed or realistic, but fully considered in its shapes and composition. He encouraged us to lay out the whole in flat tones with clear silhouettes, and

to meditate the effect of every shape and tonal value on the whole. We set out our drawings on the edge of the blackboard for him to scrutinize, and after long looking he selected the best and grouped them in an order of quality. He commented on every work with great seriousness and invited our own judgments. In each he pointed to particular features that gave the work its special quality, and he spoke with a warm appreciation of what was distinctively good in the conception, the forms and tones, and the execution. He sometimes changed his judgment in the course of comment, finding beauties in drawings he had at first placed in a lower category. I learned from him to see works as individual things and to attend to the fine differences as well as the large, to the qualities emerging in scrutiny as well as to the immediate impact. I remember his voice as reverent and objective; he would not draw on a student's work, but his hand moved across it, drawing our eyes to the strong or the weak in lines, contrast, and spacings.

"What I learned from his criticism of students' work was at once applicable to the paintings and sculptures in the museums and in current exhibitions. (At that time in the early 1920s there were few galleries in New York that showed new modern art; but Martin, who taught composition in Clarence White's School of Photography, knew the moderns and spoke of Matisse, Derain, and Picasso, as well as of Cézanne and Seurat.) Unlike other teachers in the studio classes who accepted the traditional task of helping the student to draw the model competently or to apply paint according to one or another naturalistic recipe, Martin was concerned with artistic qualities which depended on awareness of the visual, the potentialities of the medium as an appearance and not only as a physical means. He wished to free us from illustrative craft and slickness; he knew how deeply the current academic and commercial art influenced taste and vision, and also how treacherous was habit. Today the old demands for 'truth to nature' hardly exist, but other constraining norms which present themselves as basic to art are no less conventional and hinder discrimination of artistic quality.

"If I had to teach a studio class in drawing and painting I would take off from Martin's approach. I would have a model and continue drawing and painting from the model and still life object; for nothing enriches the perception of form so much as the steady practice of drawing from the marvelously complex, variable, absorbing, and emotionally engaging object that is the naked human body. But I would also encourage a modern criticism that

invites the student to consider the intimate qualities of his lines, spacing, and color, and large conceptions as individual ideas and expressions." *(The quoted passages are from the transcript of a talk on the study of art history at the Fogg Museum, Cambridge, Mass., March 9, 1967.)*

He had thought deeply about becoming an artist. For him an artist was one who made something great. He couldn't believe he could; he gave up that hope.

Should he plan to be an architect? He had taken some courses at the Columbia School of Architecture while doing his graduate work. He decided against that profession, too, after visiting offices and speaking with architects. For him architecture seemed too bound up with business, too commercial.

Fortunately, he preserved works which he dated as c. 1920s: a pencil on paper, *Self Portrait*, early 1920s; an oil on canvas, *Betsy Head Park* 1920–21; a Conté crayon drawing from Charles Martin's class, 1923, and the sketch book of his own analyses, 1923–24.

He does not mention his continual life-long written analyses of works of art. His study notebooks (1926–1927) are full of analytical drawings. He gave great importance to drawing from the figure, of which there are many examples, including drawings from the nude. To understand the technique, while working on Seurat—a volume as yet unpublished—he copied Seurat drawings on the same kind of paper that Seurat drew on. His notes on artists he was thinking about contain many sketches.

He never called himself an artist—he would acknowledge that he was a "summer painter." Among his old unpublished papers is this undated one, entitled "What Is an Artist?" which clarifies his distinction between an artist and a painter.

"There is a special and general theory of artist: a poet, a musician, a barber, a dancer, a surgeon, is an artist; but an artist is a painter or sculptor, because only these two artists make something. The musician leaves nothing behind him but sounds, the poet only words, the dancer, movements, but painter and sculptor fashion a tangible and permanent object. The artist is the artisan artist.

"But of those who fashion an object, only certain are artists; others are

commercial artists, or applied artists, or craftsmen. It is only the artist who makes an object that has no practical use, who works for himself and not for others, whose objects are not means to doing something else, who is a real artist. But even among the real artists, only some are called artists; the others are painters and sculptors. The painter whose work shows an original feeling or inventiveness is said by his fellows to be an "artist"; the others are painters. Yet the term "painter" is often reserved for those artists whose painting is specially skillful or the main interest of their work. Thus Manet is a "painter," in a sense in which Daumier is not. The old masters were not painters, but craftsmen or artists.

"Among artists, a distinction is made between draughtsmen and colorists, poets and painters, craftsmen and composers, dilettantes and geniuses, and so on."

What did this critic (whose judgment of canvases they were working on was sometimes sought by artists) think of his own work? He let them be seen. He hung many of his canvases and drawings in his home. When asked in 1987 to exhibit at the Wallach Gallery, he would not have consented had he thought them unworthy of exhibition. He made the initial choice of those he preferred from the limited number in New York at that time. Furthermore, in choosing for the present volume in 1995 he was obviously pleased with what had been brought from Vermont and Florida. He delighted us (Daniel Esterman and me) by his "Did I do this?" and "It's quite good." Regrettably, we had his help for only a short time.

(L.M.S.)

Texts by Meyer Schapiro

Following are three texts which have been selected because of their relationship to his own drawing and painting.

(L.M.S.)

On Representing and Knowing

by Meyer Schapiro (1960)

ittgenstein (Ludwig Joseph Johan, 1889–1951, Austrian-born British philosopher) has said that one can only draw what one knows. This seems true enough if one thinks of drawing as an example of representing, which includes language. Our words represent concepts, already known; learning to draw means learning to represent what we know, what we recognize.

Painters will hesitate to accept Wittgenstein's statement or will reject it emphatically. They have said often enough that drawing is a means of knowledge. One learns the precise form and color of an object through the disciplined attention and controlled tracing of its outlines and surface in drawing. Through drawing one develops one's power of seeing.

This is also the view of scientific observers who, for centuries, have drawn their objects as a way towards knowledge. Botany, anatomy, histology, and even astronomy employ drawing as a method of research into unknown or incompletely known objects. The scientific work of Leonardo da Vinci (1452–1519, painter, sculptor, architect, and engineer) owes much to his skill as a draftsman. When he wished to learn whether the irregularities on the surface of the moon are solid or atmospheric, he drew them night after night in order to note their constant and variable features. The same method was used by Peiresc (Nicolas-Claude Fabri de, 1580–1637, French archaeologist, naturalist, scholar, and promoter of learning) a hundred years later, and today photography performs the same function for the

astronomer. It was in representing the human body and trees that Leonardo discovered new facts of organic structure.

The development of painting as an art has often been described as a progressive exploration of nature. With the growth of mathematical physics, with the replacement of descriptions by algebraic formulas, the descriptive aspect of science has become less respected, as if description is a preliminary, not yet fully significant, stage of science. And the loss of interest in representation in painting, with the recent emergence of what is called abstract art, has been explained as a counterpart of the increasingly mathematical and abstract character of science, which concerns itself with a world of imagined structures presented through arbitrarily constituted mathematical language. The objects of science are no longer directly seen objects of the draftsman. Yet the most remarkable achievement of contemporary science has been the discovery of the shape and components of the molecules of the living cell, a discovery that provides a visual model of the unseen arrangement and thereby permits certain inferences about the process of replication in living matter. It is true that one can draw this model only because ingenious and patient scientists have made extensive observations and deductions; but the diffraction patterns formed on a screen had first to be drawn, before the determining molecular structure could be known. One knew what a diffraction pattern was, but the system that produced this particular pattern could only be discovered through the precise tracing and study of the newly disclosed pattern. The relation between the diffraction pattern and the object it represented will help us understand the relation between drawing and learning in the more directly experienced world of objects.

The relation between drawing and knowing is illuminated by another conception of artists, one that had arisen in the course of the 19th century. Courbet was quoted as saying that he wished to paint an object as if he did not know what it was. The same idea is attributed to Ruskin and the Impressionists, and earlier to Constable. This ideal of art—and it is an ideal rather than a consistent practice—has led to much shaking of wise heads in recent years over the naiveté of artists who believed, in complete innocence of the facts of life, that one could recapture the first state of experience of the world, when—it is supposed—the child apprehended colors and shapes as pure appearances, without knowledge of their connec-

tions, constancies, determinations. But this was hardly the belief of artists, who knew very well the radical difference between the sparse and schematic drawing of the child and their own sophisticated representation of sunlight and atmosphere. What they were affirming rather was a program for observing and expressing the fabric of color in appearances by abstracting from those conditions of perception that divert the eye from color and fix attention on the few cues that help identify the object as a familiar enduring element in the visual field. But the highly unstable features of apparent color one must learn to grasp through a retraining of perception, a break with the habitual mode of seeing.

What does it mean to learn to see in drawing? In order to draw an object one must possess graphic devices for representing various types of features: the contours, the surface, the volume, the position in space (if the object is to be localized), the color, the texture. Now these are features found in many objects, perhaps in all. Outline is a means with a universal significance; it can be applied to a great many things, to almost all—only light and atmosphere are not susceptible to this means. For representing surface and volume, light and shadow are effective devices; for positions in space, for space itself, perspective provides a fairly flexible system. Learning to draw is the process of acquisition of devices which enable one to represent all objects, known and unknown. In order to draw them it is not necessary to know what they are but rather how to reproduce the appearance of their form, their surface, their volume, their texture, their position in space and relation to other objects in the same space. Thus to indicate the size of a huge beast, one must know the cues for size in ordinary experience. Learning to draw is the learning of the cues in common perception and applying them on a plane surface.

To draw the much discussed duck-rabbit correctly in order to elicit the ambiguous effect one must know how to draw. The experimenter's drawing is correct in an absolute sense, and not at all ambiguous. This applies to all illusion-producing forms; one can spoil the experiments with geometrical figures if they are not drawn correctly. The equality of lines and intervals in these figures is a fact that contradicts the idea that all perception is illusion.

Experience in drawing is not only of individual objects, but of features common to all visible objects. Wittgenstein's mistake was to ignore the universals in representation, which are also the universals in perception.

Color as Expressive

by Meyer Schapiro

(This excerpt is from a lecture given in 1969:
Lecture XIII in the course on "Theory and Methods
of Art" at Columbia University.)

want to summarize further the topic of expression through colors and shapes. I have already gone into the question of the extent to which one can confidently speak of colors and shapes as having a specific rather than vague expressive content. For centuries artists, philosophers, and psychologists have tried to match specific colors and forms with particular feelings or what are called affects in general, and have developed theories with regard to them. I tried to show by analysis of a number of them that insofar as a single element of color (or form) is identified with a single emotion or feeling, there is an error of the dictionary type, the likening of the elements to elements of language in which, for each unit of the vocabulary, there is one meaning. That does not even hold adequately for language; if you look at any good dictionary, you will see that for many words there are three or four possible meanings and even where there is one meaning the context will change a nuance, a connotation.

But when we come to colors and lines, because of the multiplicity of interpretations that have been made, there arise two views: one, that all such relationships are purely conventional and associative, rather than inherent, rather than unconditioned; or the view that they are really inherent but because of older associations or conventions the inherent meanings are somewhat disturbed or lost, and have to be restored through an effort

of the artists to use colors and forms in an absolute way, either through simplicity or through magnifying or intensifying or by the minimizing of the elements of representation, even eliminating them altogether so that finally the colors and lines will seem to work in a natural, universal fixed state. This is a strong position held by some artists of the so-called abstract school, and you will find that view expressed in Kandinsky's and Mondrian's writings, and among certain theoreticians of art.

A similar attempt was made in literature in the creation of letterist poetry—poetry which ultimately springs from the conviction that what gives a poem its real value are not the words as meanings, but the words as sounds, and the words owe their power of sounds to the inherent qualities of vowels, consonants, rhythms, frequencies, repetitions, recurrences. This was already a program in the 1870s and 1880s, under the influence of scientists and of the painters. A French poet, René Ghil, wrote *Traité du Verbe*—a treatise on the word—in which he tried to match the structure of poems with the structure of sounds, and finally the analogy to the structure of colors and their affects. This view is subject to the caution of Mallarmé who noted that of the two words *nuit* and *jour*, night and day, *nuit* has a lighter character than *jour* which has a heavy, dark character. So the vowel sounds in words and the associations may contradict one another. One can multiply examples of such apparent contradictions or at least incompatibility of the sound structure and the meaning structure and call attention to the fact that the same sound in different languages is associated with quite different values.

Finally, one is led either to abandon that notion, or to investigate it more deeply, to find what element of real power there is in the expressive physiognomy of sounds and colors. I have described to you the attempts of certain psychologists to investigate these. The investigation is very difficult because the elements of color are taken out of any context, but they are not altogether free of context, since the person who looks at the colors, seeing them as spots on a wall or on colored papers, is in a laboratory context which has an effect on one's response. Or he brings to it his last experiences of colors, which already are a context, or he makes classifications of colors: what is called blue is a range with an immense number of possible qualities from a light to a dark blue, a dull to an intense blue, a saturated to a lightened, washed-out blue—all of these are classified as blue. The word

"blue," the class "blue," has for each person somewhat different qualities and meanings, and they cannot easily be extended to the whole range. But we know, on the other hand, something about the response to color, when the individual is somehow attuned to feeling colors, and in a very special situation—that is, instead of looking at a color and saying "blue," he apprehends it, as having a physiognomy with a special kind of sensory appeal. He feels the blue; he says it stirs him, he says of another blue that it gives him goose-flesh or makes him happy; or softens his whole environment at the moment. The sense of the color as being active, the sense of a line as having a physiognomic presence, so that we respond to it as we respond to human faces when we really look at faces instead of merely classifying them, registering that it's a man, a woman, a child, an old man, an American, a foreigner, a Black, a Chinese or White. If we try to somehow experience the qualities in a stronger, richer way, we will discover that a color, a shape, considered as a unitary element, as a single note, is a bundle of qualities and not just one quality, and that our response to it is in terms of one of these qualities, not all of them, but one of them, which is somehow connected with our present disposition, our habits. But in every case, no matter how arbitrary we are, some aspect of that color or line enters into our response. That is why it is possible for both white and black to be colors of the funeral, colors of purity, colors of death, colors of life, colors of danger. It is because they do possess several qualities in their complex of meanings in common.

If it were not for that variety, it would be impossible to grasp the diversity. The diversity is the outcome of a genuine multiplicity of qualities in elements which we regard as ultimate and irreducible. They are not ultimate in the sense of being one pervading quality, but only in the sense of being isolated; even gold, or sunlight, which (according to Plotinus) are unique, ultimate, irreducible qualities that have no form, because they have no parts—even that argument can be shown to be inadequate. Plotinus, in criticizing the classic notion of beauty as a relationship of parts—and this is a tradition that runs throughout the whole of Western aesthetics and philosophy, down to the twentieth century, according to which the idea of proportionality of components is what brings about harmony, unity, order, their interrelationships, their magnitude, their directions—to this Plotinus said: No. What is more beautiful than sunlight? What is more beautiful

than gold? But there are no parts in light, there are no parts in gold as a color; and we must answer that we have never experienced first of all an absolutely static presence of the gold. This is an extremely important idea; what we experience is somehow given in a continuing experience and even if it stands still, it is not quite the same in the second or third moment of your looking at the gold. As you look at the color, it expands, contracts, comes forward, recedes, holds together, falls apart, it undergoes many changes of appearance. It's an extremely important idea and, on a longer prolonged vision, in terms of a more complex process, the same may be said of facial expressions.

Years ago, a professor in this very building, in the psychology department, Carney Landis, undertook experiments to prove that the reading of facial expression is conventional; there is no inherent sense that the face with the mouth turned up and the eyes expansive, is a smiling, expansive moment. Some viewers shown such a face give different interpretations. By submitting photographs of different facial expressions to people and eliciting the most varied readings, he attempted to show that there is no such thing as a fixed or common universal, expressive element. His work was immediately criticized on the following grounds: that our experience of a smile is the change in a face from one state to another, our experience of anger is a growing, emerging, and then settling expression and it is in terms of our experience of the physiognomic as having some dynamic qualities that is the basis of our everyday sense of physiognomics as an active process and quality. His exposing single, excerpted, still photographs of a face is bound to lead to a great uncertainty in those who are shown them. The face, when shown as static or still, presents itself also as a picture of an individual to a greater extent than the face in motion. When you see a dog running, you are more aware of its running than of particular spots on the dog or of any other properties. Movement has an intense effect upon our perception. And in judgment of the still photographs there is also a judgment of the face, of the direction, of many peculiarities, and they interfere with the judgment of the expression, or they become part of the judgment of the expression. So the experiment of Carney Landis has disappeared from the literature on physiognomics because he did not understand precisely what he was doing.

That brings us, in turn, to the judgment of physiognomic character or

expressive character of a painting considered as a totality. A painting, even a simple one, has many qualities, just as light and gold are more complex than Plotinus thought, gold offering itself to us on the one hand as brownness, having an earthy, solid, somewhat low-keyed element, and luminosity, having a certain lustrousness which means light reflected from two different layers, and also being unsteady. Our perception of gold as a color is fascinating because it seems autoluminous; the highlights change if you shift your head a tiny bit from it, unlike a flat painting of a yellow spot. Therefore, gold appears as a mysterious, complex, multiple color. It is not a pigment color; it is a material surface of which the qualities as a surface and the possession of luminosity through its polish and through the relative proportions—if one can speak of proportion—of the heavy, earthen, metallic element in it, the weighty element and the luminous element, enters into our perception. There are many kinds of gold which we classify differently according to these ratios.

Light has many properties, just as colors have, with regard to intensity, with regard to a particular illumination, with regard to degree of expansiveness, with relation to the background and the surroundings and degree of contrast, the difference between the light of a Caravaggio and a Rembrandt, for example, and the light of a Monet picture. These are all different qualities of light which we grasp through the interplay of numerous components. All the more is this the case for a painting or a sculpture which—even when a simple one—has many components. What we regard as the expressive face of a work is an outcome of the interplay of many factors, but when we look at a work, even when we see it as a whole, we do not see it completely. Even what we call a whole is something which is isolated from many possible whole isolations that can be made. Hence, the expressive descriptions are bound to be very different from one another and yet they all depend to some extent on actual properties of colors and lines.

The fact that there is disagreement means that we must go back to the object and the situation of the viewer and scrutinize both of them and find out what the person is describing, what he is looking at. Very often he is looking at something quite different than what you are looking at. That is quite evident from the interpretations of famous works like Botticelli's *Primavera*, which has been described in terms of quite different affect by various observers. But they are looking at different objects; one is looking

at a single maiden, another at the costume, another at the dance movement, another at the setting in the foliage in the background, another at the faces and the particular quality of the expression of the faces. These all suggest rather different characteristics, and unless the physiognomic description is somehow connected with a more specific indication of features in the work that one is looking at, or is pointing to, and that are the ground of one's judgment, it is extremely difficult to understand the discrepancies between one description and another description. This is still another argument for a greater consciousness of the fullness and complexity of works of art and the responsibility correctly to cite the verse, the passage, the word, which is the ground of one's judgment, or the structural relations; if one says form, unity, composition, well, what are you pointing at? Now, you may say there is an intuition of a whole, but the intuition of a whole is not exhaustive; it may be the work is seen in its large aspect but it is not complete. We know that from the numerous discoveries of changes, of corrections in works which were not noticed until very late times. The most keen observer, the most expert, technical, descriptions of 1870 may miss things that a student in 1970 would recognize instantly in an old work of art. Hence we cannot commit ourselves to the view that the perception of wholes, whether in structure or in physiognomic, are self-certifying, that they are right because someone speaks with conviction about their having such and such a character. These things have all to be reexperienced, tested, seen from different points of view, remaining always open to renewed perception, criticism, exploration, and even with x-rays, even with devices that belong to the laboratory, because they make us aware of important features which we have not noticed before.

Art Schools: Drawing from the Figure

by Meyer Schapiro

(This text was given as a lecture on May 22, 1967, at the New York Studio School of Drawing, Painting and Sculpture. It preserves the lecture form.)

planned to talk about a particular painter or some type of art from another time, but arriving late in the city—I've been away all year in Cambridge—I've chosen to talk about an extremely problematic subject and one in which I cannot claim any special competence through study or experience.

But at the same time it is a subject that interests me deeply because questions concerning it are constantly addressed to me, and also because, since I am in contact with students all my life, I am involved in their own difficulties and doubts about the subject. It has to do also, essentially, with the existence of the school. I should like to raise a question as to the central place given to drawing from the model, and the nude model, in a school today.

It is easy to understand why that should have been the main basis of learning to be a painter between the fifteenth century and the nineteenth century. It makes sense, it seems rational, because in the painting of that period one constructed human figures. One represented the human body. It is therefore perfectly natural to learn how to paint by first studying the human figure, mastering its forms, acquiring all the necessary experience of representation.

We can state the relationship of the learning to the practice by saying that, in the old days, drawing from the human figure was connected directly with the ends of painting. It was not just a means, like learning how to glaze or how to prepare grounds, which belong to technique but which are not the ultimate ends of the artist. The mastery of the human figure, all that one learns in the persistent study of the human figure by drawing it, is itself part of the end of painting. That is, the great masters create figures

on canvas or in drawings which arise in part from all that experience in observing, studying, drawing, controlling the form of the human figure.

However, in the twentieth century, it is obvious that very few artists are going to make paintings like Rubens', or Leonardo's, or Poussin's, or even Watteau's. It is not indispensable to know how to draw the human figure in order to paint like Mondrian or Kandinsky or any number of artists who have established themselves as important, original, modern painters. But already in the seventeenth, eighteenth, and nineteenth centuries there were painters for whom the human figure was not of first importance—namely landscape painters and still-life painters, who did not have to grasp the human form. They could not think, as did many artists, that not only did one have to draw the human figure, but one had to study its anatomy, even the parts that do not belong to the visible surface, that part of a mechanism that is hidden. That was justified for painters who were going to create these vast Baroque machines or Renaissance compositions in which the figure had to be turned, twisted, and articulated. And the proper relationship which would make a figure look right, seem to live on the canvas, could somehow be reached, could be achieved better, if one understood the underlying anatomical structure. So that painters found the study of anatomy not only a means but more directly bound with the end, just as a physician or a surgeon studied anatomy in order to know more fully the body with which he was going to occupy himself all his professional life.

But then there came, as I said, landscape painters, still-life painters, even portrait painters who were rarely, if ever, required to represent the body with that kind of articulation that one gets to know in drawing from the human figure. Now, in response to this drastic revolutionary change in the whole concept of painting, the shift from representation—and particularly idealized representation of the human body—to free construction of forms, free painting with colors, those who took seriously the problem of teaching, of learning, had to ask themselves, what shall one learn? What shall be the important steps in becoming a painter if the old method no longer fits, no longer yields the sort of experience and knowledge that is going to be applied directly to painting?

So, artists who were serious about these problems, or painters who wanted to establish schools, or were called upon to do so, tried to think through the problem. Many did not. Many just went ahead in the old rou-

tine manner, saying, well, just as I learned to draw from the model and paint from the model, but eventually found my way to a quite different sort of painting, so every student will have to go through that experience in a somewhat blind manner, hoping for the best, or depending for the final push toward real work upon the stimulus of the things he admired in the painting around him, what he saw that really gave him zeal or enthusiasm for doing something on his own.

There was another side to it. In the old days, one could generalize the method of learning how to paint by the formula that one copied the master one loved, or the master to whom one was apprenticed. One tried to reproduce what he did from the beginning to the end. And as the method of painting changed, the method of learning had to change with it.

In the same way, people hoped in the twentieth century that you could simply study Mondrian or Kandinsky or Picasso, or any painter you admired, and learn gradually how to make the same sort of thing. But could one do it without some discipline, some method, some type of teaching, or some school arrangement in which one had to keep at it steadily and submit to a sort of criticism and overview of an attending artist who would keep one on the right track, and steer one when one went wrong? Was there any way of replacing the older, standardized, well-adapted method—but adapted to another kind of painting—was it possible to replace that by an equally effective method that would yield the new kind of painting, which was the creation of men who had broken with some tradition, who, in order to realize themselves, often had to surrender a lot of things that they had learned, that they had acquired? It would be comparable to a new type of engineering in which one no longer needed mathematics, no longer needed physics—just pure fantasy—trying to conceive that the six years of engineering school, the pre-engineering, in which you learned all these sciences and crafts and techniques, could be dispensed with, as there was no excuse for them then. Well, one tried to find such a method.

The most famous attempt was that of the Bauhaus in Germany, which was not, however, a school conceived as a place to train painters and sculptors primarily, but rather designers, industrial artists, commercial artists, who would work, who would learn their craft, in relation to the modern tasks, materials, and techniques, instead of the old ones, and would also be inspired by the new taste in color, and forms, and surfaces, and would have

a modern spirit, a certain freedom and feeling for simplicity and for the grandeur of modern constructions. And their art would somehow grow into that or draw from it a particular inspiration, just as with the Gothic cathedrals rising, the people who made furniture began to shape the furniture like Gothic arches, Gothic moldings and tracery. And there arose a coherent style which isn't necessary, isn't latent, but it comes about if a new style is so beautiful, overwhelming, and so much in demand that everybody is somehow carried away by it, and artists who have other traditions are led to assimilate it for their own special tasks.

Well, something of that kind took place in the Bauhaus, partly because of the great intelligence and will of Gropius, and a few other people, who felt that it was indispensable to train men who would know how to work with the new materials, and new techniques, and new requirements of adaptation to a dominant aesthetic of the time.

Now the Bauhaus also had as teachers Kandinsky and Klee, as painters, and at one time Albers, and several other artists—Schlemmer, for example, taught there. Their teaching is distinctive apart from the painting that they did in that they were theoretically minded. Now that is not an obvious word, theoretically minded. It doesn't mean that you have ideas. It means, rather, that you are concerned with a systematic set of large, governing ideas from which certain things will follow readily, logically. You will understand how something is to be done from the basic principles. When you have such broad, clear principles, even if they seem somewhat arbitrary, they will give you the possibility of deducing from them, or seeing intuitively through them what has to be done next, or what kinds of things are possible, what things are desirable. It gives one a certain intellectual power, so to speak. Theory is not the same as knowledge of the observable world. It is something which pertains to the less observed world. It relates in part to a program of work to guide you in making a lot of other decisions.

Both Kandinsky and Klee—though one would hardly believe it from looking at much of their painting—were highly constructive, theoretical minds when it came to teaching, to pedagogy. This is a most extraordinary fact. When Kandinsky was in charge of an art school in Moscow in 1918–1920, in those years he actually prepared documents, programs, for the reform, the rebuilding of all art education in the Soviet Union so that it would be in keeping with the new art and the new possibilities in art,

instead of repeating an already sterile academic tradition. And when he went back to Germany and worked in the Bauhaus, he wrote his book *Point, Line, and Plane*, which is an attempt to systematize, in as clear a fashion as possible, the elementary principles of form and color, and texture, and surface, in which he proceeds from a few leading ideas which he regards as obvious or intuitively right, and he tries to build upon them a method of pedagogy which would lead a student to a deeper awareness of how shapes work, how colors act upon each other, how things lie on a surface. If you have read the book, you will remember the subtlety with which he distinguishes between the line printed in an etching, the line printed in a woodcut, the line printed by a lithograph. They are as different as a line which lies in the surface, on the surface, above the surface. And he discusses what different modes of appearance they have, and how they can be utilized, developed, made into something new and fresh according to your temperament or fantasy or a particular problem.

In the same way, Klee tried to understand how lines work, the quasi-mechanical system of oppositions, of contrasts, of continuities, of discontinuities, of analogies, and of spacings, the difference between the small and the large when one is above and the other below. Or, conversely, the importance of particular parts of a field. These statements, which were developed experimentally and intuitively, were also connected with his own practice. But he wasn't telling people how to make one of his pictures. He was trying to arrive at some universal ideas which would hold true of all art, he thought.

Nevertheless, when you see the work that came out in that model systematizing of art, you find that the large character of the school itself, as primarily a school of architecture and practical design, tended to govern the painting that was done there. Most of the painters worked in a manner that was adapted to making posters, displays, works which could be incorporated into writing and into printing, and so on. And the sort of highly personal, individual fantasy and expression that you find in the work of Klee and Kandinsky did not emerge from the teaching of the school. Perhaps that isn't so important. Perhaps you cannot judge a school so narrowly, by the work that comes out of it in one generation. The school only lasted from about 1918–19 to 1934 when it was closed by the Nazis. That's a very short period in the life of a school. And yet, within these other fields of architecture, and of practical design—what's called applied design and

commercial art and so on—their work was the most important work in Central Europe, and had an effect in America, England, Italy, everywhere. It was genuinely effective. And the reason is that there was a close connection between what they learned and what they were to do with it.

Now, in the practical design they learned somewhat differently than Kandinsky and Klee taught them. What they learned was, first of all, the properties of the various materials they were to use: how to handle metal, how to handle paper, cardboard, how to handle leather, how to handle wood, or the alloys, how to use the machines provided in the machine shop—all the typical industrial techniques. So they learned the various arts of practical design somewhat in the fashion that a highly skilled workman or machinist learns his. He learns how to do certain elementary things with his materials. He learns how to make an edge, a perfect cube. It's very hard. If you learn to do that, you have advanced very far in handling materials.

This close connection, this intimacy between the learning and the practice was more evident, I should say, in that part of the school than in the painting and sculpture. But the fact is also that the painting and sculpture were only a small part of the curriculum. Very few people came for full-time painting and sculpture. There were a certain number of hours when one did that. And people looked at it in two ways. Some said it gave one a taste for modern forms. Or, it was a spiritual relaxation from the dryness and rigors of calculated design. If in all the other courses you had to be very scrupulous about surfaces, and everything had to be drawn out and planned, and there was no spontaneity and no free play with things, then to have Kandinsky and Klee there was to have a musical accompaniment while you were doing something very different from the main task.

So it was not fully a painting school or a sculpture school, but it stimulated in all the students a taste for them. And since Kandinsky and Klee were both very impressive and subtle personalities, they surely worked on students and gave them, I think, a push towards imagination which they might not have had otherwise.

Now let us consider the consequence elsewhere. Very few people were able to do what they did. They acquired a big institute, acquired support from the state, the Bauhaus had support from manufacturers all over Germany who gave contracts to the school for design and supported its publications. It required also the general modernism and liberality of a

quite large, cultivated stratum in Germany between 1918 and 1933, and that became impossible afterwards. And you see the close connection there between the political and economic state of Germany. The attempts to introduce it elsewhere were, therefore, on a much smaller scale, with less support, with less complete conviction.

Moreover, there had been a great change in the moral attitude towards that. When the Bauhaus was founded in 1918, it was the year of passionate expressionism, a sort of turbulent expressionism which you probably do not know because the work done then hasn't traveled very far. But in the years 1918 and 1919, one painted in an expressionistic manner as a way of being a revolutionary. It was parallel to the revolution that failed in Germany in 1918–1919, and the work tended to be very raucous, and demonic, and full of explosive force, curiously like certain paintings made in this country in the early 1950s, and also during the war in the 1940s but with no direct connection between them. If you are interested in looking at that, seeing some of that, look at the publications of a magazine or periodical called *Der Sturm*, (The Storm), which was edited by Herbert Walden, a very strange man whose portrait by Kokoshka you may have seen reproduced. He was a communist with a sort of anarchistic tendency, who published poetry as well as reproductions of paintings, and had a gallery in Berlin.

The first Bauhaus favored an architecture of a strangely expressionistic character that is now forgotten, and its main idea was the creation of a unity of style for a new age. In that year, 1918–1919, there were published dozens of books called *The New Age, The New Man, The New Woman, The New Child, The New Pedagogy, The New Art, The New Spiritualism*, the new everything, *The New Sport*. People felt that after this horrible period of four years, and this disintegration of the empire, that one had to start life all over again, which meant an individual life, but the whole of civilization and culture had to be changed overnight. And there was an immense production of books and pamphlets and magazines devoted to self-renovation, which was not a rebirth of something old but an attempt to build something new with a mixture of socialist, anarchist, spiritualistic, and metaphysical ideas.

Then when the economy in Germany, as well as the politics, stabilized after 1920, the greatest faith was placed in technology and in the technician as a model of the good human being: the cool, sober, calculating mind which did its job well and which strictly confined itself to the task of the

specialist, which ultimately possessed a general value because it was integrated in some common aim or style. This was the prevailing mood.

The great sociologist Max Weber in 1919 said: we've had enough of expressionism. What we need is *eine neue Sachlichkeit*, a new matter-of-factness, a new objectivity. And it is this spirit which provided for the Bauhaus a kind of moral, philosophical conviction that to learn the arts through a systematic method in which you start from a few basic elements, in which you define line, form, color, surface, textures, and you investigate the inherent relationships among them, and you do that in a highly organized way, that permits you to create order, harmony, function, unity, all the other goals of a society which does not want to change, but wants to stabilize itself in raising the standard of living and providing as much as is possible through the technology. One of the leading philosophies that came out of that time, logical empiricism, in one of its earliest works, K. Carnap's book on the logical construction of the world, began by defining atomic sentences. You start with single, acceptable statements, and then by applying rules of logical combination you build up to more and more, until you have the whole world comprised within it. The notion was that there are such things given to you immediately and intuitively as the pure basic elements of experience.

So, you will understand then the approach of the Bauhaus school and the break with the older tradition, which was not an entire break, since people could not help but love old paintings and buildings and admire them. But they felt one cannot advance by placing them in the center of learning or pedagogy. One has to do what they did. Just as they studied the figure because they were going to paint figures, so we must study the lines and spots and surfaces.

Now, in this country when an attempt was made to introduce such ideas, they were preceded by the existence of schools of design and schools of practical art, which taught form and composition and so on. But compared to the Bauhaus books and methods, they were extremely primitive and too much connected with ornament, and with traditional types of composition: symmetry, centrality, radial forms. Very interesting books of that kind were written in the 1890s in England on the principles of ornament and design. But when you look at them today you see that, although they helped to prepare an awareness of formal structures and combination which point to abstract art, they are still tied somehow to the older traditions of ornament and handicraft practice. The handicraft element is primary.

After the last war, more and more schools in this country, partly under the influence of the Bauhaus, partly because of the reform of design schools—and I think ultimately the Bauhaus was the most powerful single factor in that change—more schools introduced students to painting and sculpture by a method of elements, non-representational, so-called syntax of design, laws of design, working flat, experimenting with the properties of color, and using methods of collage to replace the brush and paint with colored papers as in Albers' school. The Moholy-Nagy school in Chicago was also built upon that idea. He came here in 1937 or 1938 and tried to found a school, which lasted for a few years. And there too, the main focus was on the practical design, on the applied design.

Once the idea became generalized, a new difficulty arose. If it's true that you are going to work toward that kind of design, or with that kind of design as a way of learning, because of the notion that it is not a preparation for a particular kind of design, but introduces the student to principles that have a universal validity, then no matter what kind of art you will practice, you will be working with surfaces, forms, colors, planes, volumes, cubes, masses, space, and so on. Once you commit yourself to that, you have to compare the results with actual practice. And it turns out that the method has built into it, unconsciously in many cases, a certain practice, and the instruction is very much determined by it.

One reason the Bauhaus method began to seem more and more inadequate is that after 1929 or 1930 already in Germany, people had lost faith in the possibility that by being a good technician and submitting all social, economic, practical, and human problems to the supposed rational methods—I say "supposed" because we are not sure that they are perfectly rational, nor do we think that they are applicable in quite that way to those problems—people began to doubt that they would be effective. Moreover, there was felt a great dissatisfaction with the outcome of such methods, not only in art but in life as a whole, because one could feel the consequences of such modes of rationality, which claimed to be universal within the political-economic fields. All the calculations of economists did not prevent a disastrous crisis. If the crisis was overcome, it seemed to come about not through the calculations of economists but because preparation for war and war itself brought about employment again. And then most of it led to sheer destruction. But in order to be effectively destructive, one had to be very clever,

very rational. One had to use all the science one had in order to do that.

And likewise with psychology, if psychologists were understanding human nature, their understanding could be used to manipulate people. Hence the notion of psychology as a rational science became a little fearsome. It had opposite possibilities. It could help, but it could also help malicious or powerful people, or designing people, to apply this knowledge for their own ends and not in a way which would satisfy those who were to be its victims.

In any case, I don't have to belabor the point that by 1930, and throughout the thirties, people began to distrust very profoundly the implications, or the assumptions even, of a style of life and of culture and of art in which rationality was identified with calculation, objectivity, impersonality, universality of lines, the appearance of strict control of things. Behind that were many hidden demons and destructive powers, and at any rate there was a deep repression, and that became more and more evident. And in that decade of the thirties, although a man like Mondrian did some of his best painting then, there was also a great vogue of surrealism, and also of an art that was socially critical, which did not produce works of great importance but represented at least the will of people to respond to what they felt to be the real situation.

It is as an outcome of this large experience that the demands for a systematic pedagogy, or schooling, based on the principles of the Bauhaus, were also felt to be tied to a certain mode of life and to assumptions about the right way to look, to enjoy, to make, and the physiognomic of the style was seen in a more negative or critical spirit. And that led also to doubts as to a system of teaching which would be based upon it. I remember being shown many years ago a memorandum by the head of one of the art departments of a college in a big city, proposing to the city that in all the elementary schools and high schools, the drawing of objects, the drawing of plants and animals, and the free play of children's drawings, should be replaced by strict learning according to the Bauhaus method. And the justification was that if one learned to draw and paint in that way—and one should begin in kindergarten—then one would not tolerate the ugliness of the environment. One would want clean, smooth, hygienic houses. One would want the streets to be regular. One would have a civic consciousness. So on this idea was built a complete transformation of social consciousness and the environment. Fortunately, this proposal was not adopted.

I say fortunately because if it had been adopted, it would take 20 or 30 years to replace it. Once such a thing gets started and all the textbooks are printed and teachers trained to work with it, it becomes an institution. It is very hard, when the institution is a huge city with a million or more people, to bring about any change in it. But this gives you an idea of the larger context.

Now we come to the most recent chapter of this problem of learning to paint and draw. I am not giving you a really accurate and complete account. I am sketching broadly for the sake of developing a point, and of course I would like you to raise any questions or objections that come to your mind as you follow this.

In the last fifty years, the notion of a way of learning to draw and paint which would do for the student in the twentieth century what the established methods did between the fifteenth and nineteenth centuries, and would be adapted to practice, in other words to the ultimate goals of an artist, became even more difficult because of the fact that within fifty years there were at least fifteen different kinds of art developed in succession. And in each of these kinds, there were many important variations, so that the average life of a new set of ideas in art was about three years. Some lasted five years as a vogue which attracted all the young artists. That is what we mean by the life of a new style. The men who originated it might continue working in that way. But as a force in attracting the new artists, the youngest generation, study shows that these styles ranged from three to five years in time. And some of them had revivals. That is, many of the styles practiced in the last ten years are revivals of styles of 1920–30, 1914, 1910, 1900, and so on. If I had time I would go into the question of what I call the Third Modernism. We are living now through the Third Modernism. The First Modernism was 1900 to about 1915 or so. The Second was between 1915 to the outbreak of the Second World War, 1939. And then in the forties to sixties we have had the Third Modernism. And the Third Modernism revives and gives new interest and force to styles and types that arose in the first two Modernisms. And there have been corresponding sequences in the seventeenth century, and in the nineteenth century. I mention that simply apropos of the idea of originality.

Now, what is more relevant is the fact that if the rapidity of change of style increases, as we have seen in the last fifteen years—so that recently styles last only two or three seasons—then there is a serious problem for

both the student and the mature artist. The mature artist who wishes to develop his own work, to mature further, and wishes at the same time to reach a public, finds himself stranded. If he is successful for a time, then his work is replaced by another kind of work which has the advantage of novelty or of coinciding with some rather vague, indefinable mood of the moment, or it helps to create the mood of the times. But at any rate there are these factors which we don't understand or can't put our finger on in a precise way, which lead to this constant displacement of one style by another.

So there are painters who, in order to maintain themselves before the public, have to change every three, four, or five years, and therefore never develop a style that is fully their own, or never carry through some impulse or idea long enough to see what it might lead to, or its consequences. And that is why a figure like Bonnard has for us a peculiarly heroic character, although he is anything but a heroic painter, because he worked along his own line for fifty to sixty years, and got better and better as he went on, but didn't move far away from his starting point. This is a most extraordinary situation in the twentieth century, and there are a few people like that. But most people have had to change, sometimes from within, sometimes because of suggestions from without or even compulsions from without.

But for the student it is an even more difficult situation, because if he realizes that whatever he likes momentarily will be not so important or interesting a year or two from now, how can he commit himself to a way of working? Or what shall he learn in order to be able to work on his own or to be free? I do not say that in criticism of the actual styles since, in many cases—if not all cases—they are manifestations of strong original artists who attract many other artists of lesser power or integrity.

But at any rate there are very good artists who have done these things, and some of them enter into a sort of aesthetic or spiritual crisis when they find themselves stranded, or lose full self-confidence after a repudiation of their work which has been held up and made very impor- tant, and copied by hundreds of artists all over the country. Some respond by holding very fast to what they have done, and others by trying to break with it drastically. But neither is a rational solution from the point of view of full growth of an individual. So then one is bound to ask, is there some- thing one can learn which is good for an artist—I will not try to define the word "good" any further—for all eventualities, which will be a ground or

basis for no matter what he will do eventually? Are there real fundamentals? Now, I do not mean technical ones. One can even dispense with those. One can make environments instead of painting. One can assemble. One doesn't have to learn the extremely complex, subtle, difficult skills which belonged to painting and sculpture in the past in order to be an exhibitor, in order to shape forms, or to make an object which someone will value. It is not indispensable at all. But the question that arises is, are there then basic skills, knowledge, habits of work, and modes of conceiving the work, which can be a ground for a great variety, or for the development of the individual?

This is really a much more difficult problem than is generally recognized. Whatever one says about it today seems to me to be hypothetical and a risk. But then all art is a risk. And many other things in life are great risks and one should not be afraid to look into these things because they are hypothetical, because they are risks. They do not give any full security. We are not living at a time when the painter's craft was so closely tied to a definite kind of commission, a definite kind of work, so that he could judge everything he learned in relation to how it would contribute, and what it would contribute to that well-known and anticipatable task of making a portrait, or making a heroic picture, or a religious painting or mural decoration or landscape, and knowing that there is a community which is fairly stable and which loves these things and will commission them, and which includes quite a number of people, non-artists, who will be ready to recognize differences of quality or value. This is the problem that I came to talk about.

Within this situation which, as I said, is so problematic and difficult, and for which there are no ready answers, this school has undertaken to provide at least one proposed solution, that the study in an atelier manner of the nude model and of still life, and of set objects, but particularly of the nude figure—with a great concentration on drawing, and with the facilities for prolonged study—will serve as such a ground.

Although that seems obvious to many of you, or if not obvious, at least it seems better than other proposals, and worth trying for quite different reasons, I'm sure that if each one of you were asked to write out his reasons for wanting to do that, you would find you would read many quite different statements and opinions. Different aspects of this whole possibility would emerge from a comparison, a reading, of all the answers.

I would like to speak about this from my own point of view, which is

not that of a student, and it is not that of a practicing painter. But I am interested in it as part of a large and indispensable process of art which includes the learning of art as an inevitable element of the production of works of art. And I am interested in it also as a general human problem because of the fact that, as everyone recognizes, if 1,000 people studied painting and drawing, after a certain period of time, only 100 would be practicing it. And after a longer period of time, maybe only twenty would be practicing it. And of all the works produced, only a small part will achieve the sort of recognition that belongs to the museum.

But the activity must be valuable and valid as you practice it, as you learn. That is, it must be intrinsically interesting, it must be fulfilling in some way. It must give you a feeling of growth, of increase of your own powers. It must be something that you enjoy even though it is painful at many times, even though it is discouraging and full of struggles. It is better than other things because it brings you into a fuller action as an individual, it brings into play desires, impulses, perceptions, and qualities which are part of yourself and your dignity as an individual.

If we consider the human figure from that point of view, I would propose that this method of study, which is not a clearly defined method, it is being improvised now and has some definition because it builds upon older practice—there have been art schools before, models and all that—but it is being done now within a new environment, and with a new generation, and with people who have a different sense of themselves and of art and the surroundings.

I would speak of the following aspects of the study of the human model as a general introduction to painting, the practice of painting, as follows. I would say, first of all, that the study of the human figure, and particularly the nude figure, is the study of the most complex, the most articulated, the most subtle, the most interesting, and most difficult object in the world. Nothing else begins to approach it. Just stop to think. Ask yourself, what else is there in the world which has these qualities? More than that, the nude human figure presents itself to us as a natural form which is self-adjusting, so constituted that a shift of the head changes the neck, a raising of the arm does something to the shoulders and muscles; all changes in it present themselves at once as changes within a finely constituted, organic whole which is self-balancing, and self-adjusting, and in which everything counts; that nothing that appears to the eye is superfluous. At the same time, it is an

individual object and not only a reproduction of something else.

This aspect at once allies it to a fundamental consideration in painting and sculpture, whether you make an abstraction or whether you make a landscape or still life. No matter what you are going to paint, or even if you make an assembly, you want to make something which looks as if, in its rightness, everything belongs and each part has a certain individuality, and the whole has an indefinable individuality that cannot be located in one part. The human figure, therefore, offers us a model of an aesthetic of nature in which these fundamental relationships are given to us but can not be understood immediately. They can be grasped only gradually and through persistent activity of fine looking and testing of your looking by drawing. Looking reveals much less than you imagine. Only in the process of drawing do you begin to see the fullness of what you are drawing. A philosopher has said: you can only draw what you know; if you don't know something you cannot draw it. That is not quite true. Degas and others have said: you do not know a figure until you have drawn it. That is the opposite of what the philosopher said, you cannot know something until you know it. The truth is, in the process of drawing we start with a partial knowledge, and it becomes fuller and deeper.

But also as you draw the single object, you have to construct forms and acquire a knowledge of relationships which hold for all objects. That is, you must know what a boundary is—what a shadow is, what light is, what the difference is between something above, below, and in the middle, side, and center. You build up all the practical categories in your medium of charcoal, pencil, and so on, all the practical categories of representation which apply to a great variety of objects. And when you see an object that you have never seen before, as though looking through a microscope and observing some strange organism or tissue, you already know how to relate lines to each other. You know what an outline is, what a change of tone is, what a grada-tion from a dark to a light, or a light to a dark is, what a surround is, what a boundary means as a stressed or unstressed effect, and so on. So you are acquiring in the most complex and difficult and most articulated object of all in the world, a knowledge and discipline and habit of constant organiza-tion and reorganization tied to fineness of perception, which can never end.

And you test yourself in that by often drawing without a model. Your drawing without a model incorporates a great deal of the unconsciously assim-

ilated habit of perception and also the sense of the rhythms of the body which are, in some very subtle way, built into the rhythms of the hand. There is some accommodation of the motor element and the perceptual element, about which psychologists are very curious, but about which they have very little to tell artists, so far as I can see, having tried to read the books on the subject.

So the study of the human figure, then, is an experience in which, regardless of what sort of painting or sculpture you will ever practice, you are creating for yourself certain habits of vision, and of execution, and of control. But that can be done as a mere routine. Or it can be done as a flexible, growing, continuously expanding and refining process. No method guarantees itself. You can learn to work like Mondrian and make bad paintings, and you can learn to draw like Giacometti or Rubens or Cézanne and also make bad works. So that when a method is proposed, it is not proposed as a foolproof or secure way of producing something good or sound. It is simply the creation of a program within which you have the opportunity to acquire this skill of perception, this refinement of vision, this responsiveness, this habit of control, this facility, which is good for a lot of other things, and which need not require figure painting, although I am quite sure that for many of you it will be a permanent thing, or it will be part of a continuing practice.

But in that process you acquire also a sense of an important aspect of all painting, whether representational or non-representational, and that is the intimate quality of the given in handling what is already given in the themes or motifs of a work. That is not a very clear statement, so I shall have to paraphrase it in other ways. You are aware that in trying to test the so-called creativeness or potential creativeness of students, psychologists give tests in which they measure the power of imagination or fantasy by asking you: write out as many ways as you can think of for using a brick. Well, you can use it to throw, you can use it as a book rest, you can use it to build, you can use it to scrape and to get a powder, you can use it as a unit of measure if you know its length, and so on. And the students who are able to imagine the greatest number of possible uses of an object are said to be more creative. There are other tests, which I shall not go into. But at any rate, these tests are also connected with fantasy. A picture is shown you, with some odd objects or figures, and you are asked to tell a story about them. And the more connections you can see, the more extended the branchings from those three or four objects in the picture, the more

imagination you have, the more likely you are to be a good artist. This is roughly the idea of certain psychologists, but we cannot go very far into that.

Now, when you draw from the model, you are all working with an object given to you. You don't have to imagine the model, you don't have to imagine the lights or the lines. You are given what seems to be a highly objective task. You cannot measure the talents, the potentialities, of students there by what they imagine in the figure. You are bound to the object. It is a very different situation than the one discussed by the psychologists.

And yet, when you go into a class and look at the drawings around you—there are maybe 20 or 30 people drawing from the same model—you will see instantly that this is a person of extraordinary sensitiveness, this is a person with great energy, this is a curiously individual person, this is a person with delicacy, that one has sweetness, and so on. How do you see these things? In what? In a number of ways.

In the first place, we cannot look at anything that is so close to ourselves as a nude human figure, or even a clothed figure for that matter, without responding. It evokes in us, whether consciously or unconsciously, an intense response or manifestation of our own tendencies of feeling and of thought. And this is a very important situation for an artist. An artist is distinguished from most other people by the fact that an artist is especially responsive. An artist is a person who is not only responsive, but values the responsiveness of others. It is natural for him to show feeling or, even if he restrains feeling, to appreciate feeling, to sense that there is a being which is actively engaged with this world, for whom perception, feeling, and thought are of the greatest momentousness for existence, for life. And such a person has a different look and a different manner, and no two are quite alike.

In this sense, then, the same object brings out a kind of individuality which is already part of the process of art, and to a higher degree and with a greater complexity and range of possible responses, than would be drawing, let's say, working with a regular pattern, or taking a given motif—a square or a circle—and filling a space with it, which could also show very marked individual differences, no doubt. But the range, I think, and the possibility of eliciting responses from all the people in the room would not be as full as with the nude figure.

The second aspect of this lies in the quality of the execution itself. The difference between a dull line and a live line, the difference between a

felt passage from light to shadow and a mechanical, routine one, is of the utmost importance. It is a kind of imagination, one might say, but it does not belong to the type of fantasy which is being tested by the psychological experiments with the brick. It is because the artist is drawing from the model, is making 1,001 judgments and choices with every stroke, not six or seven about a brick. But he has to make judgments which will be consistent with one another and build up to a complete object which finally has a face, a physiognomy, that belongs to the work. That is not quite the same as making a complete composition when you fill a canvas. You can draw just an eye or a hand and do exactly the same thing.

The recognition, then, is that the drawing of the model is an occasion for this extraordinary perception of a complex, living, self-articulated, self-adjusting body, in light and shadow, with elusive lines and complex interrelations of parts. There is the sense also that the fineness of the result depends upon the qualities of the marks you make on the paper, and that every one counts, and that they build up and that they have continuity with each other, and that they can be bettered. Moreover, it has to be done again and again, and that each time the model will have a different posture, a different character for you, depending also upon what you bring to it from that day's experience or that day's mood or feeling, and at the same time, connected with a will, a commitment, to the discipline of doing it steadily and continuously.

It seems to me that these are high values and possibilities that, taken by themselves, would make the study of the model interesting to any artist, even if he paints abstractly. He may be too busy to do this, or he may find it to be a distraction, or it may even be dangerous for his self-satisfaction with what he is doing at the moment to encounter altogether new difficulties. But for a student who is not yet bound completely to any way of working, who wants to discover himself, and wants to penetrate the possibilities of forms and of art, I think this is a natural.

We can see that we have shifted our ground from the notion of learning through an object or through a practice which will then be used in the final work by its reproduction, to the idea that learning is a process that you measure not just by its repetition in a final painting, but by the qualities of feeling, of line, of thought, and of work which you will bring to any kind of task. That seems to me more in accord with our sense of life, and of growth, and of individuality today.

Meyer Schapiro's Painting, Drawing, and Sculpture

SELF-PORTRAIT
Pencil on paper, Hebrew Education Society, 11 × 8½″, 1916–17.

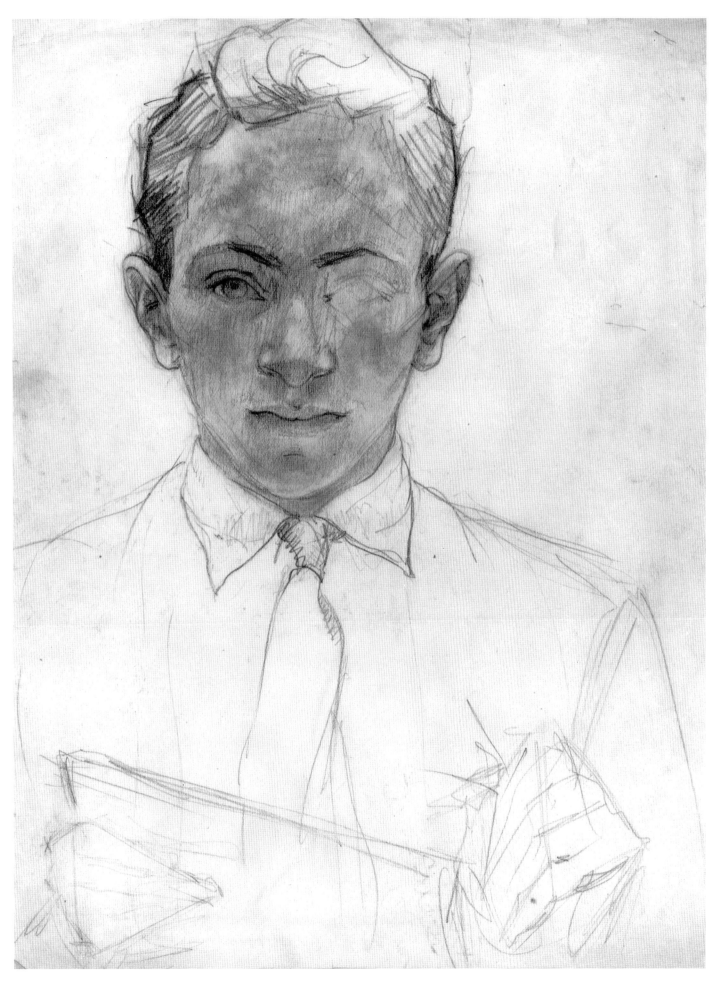

51

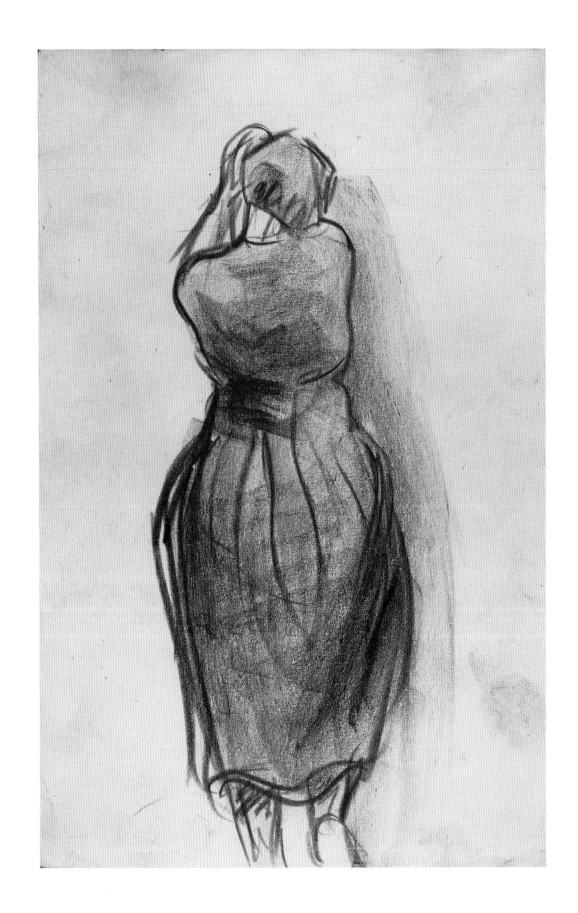

ANNA ZWILLING
Conté crayon on paper, 8½ × 5½″, Hebrew Education Society, 1916–17.

The subject was another student in drawing class.

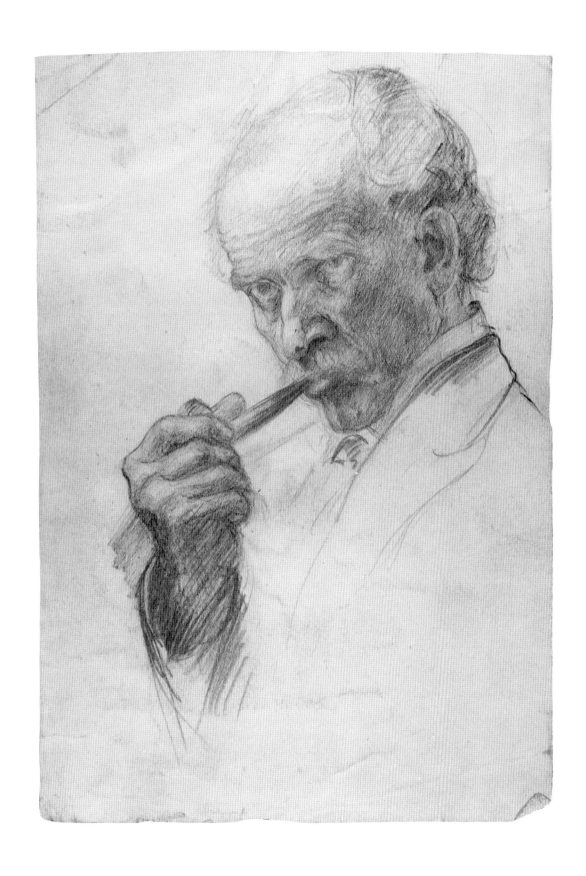

MAN WITH PIPE
Pencil on paper, 8 × 5½″, Hebrew Education Society, 1916–17.

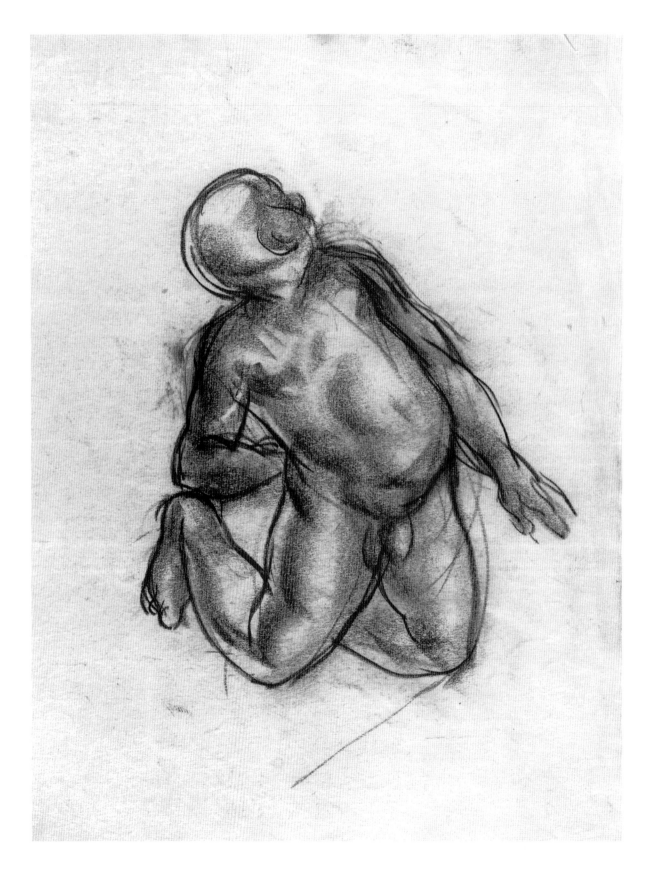

NUDE
Conté crayon on paper, image 5½ × 4¾″, National Academy, 1920–21.

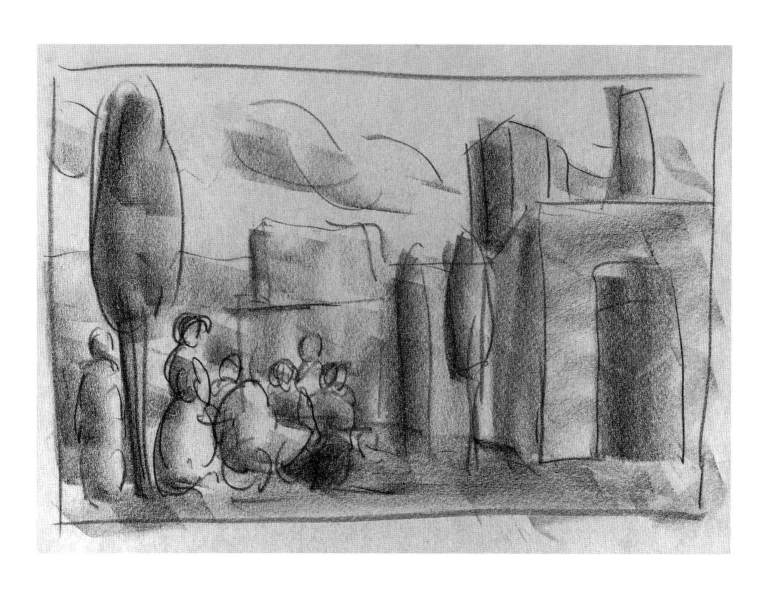

BETSY HEAD PARK, STUDY
Conté crayon on paper, image 6⅝ × 9¾″, 1920–21?

Playground on Hopkinson Avenue, Brownsville, Brooklyn, near where the artist's family lived.

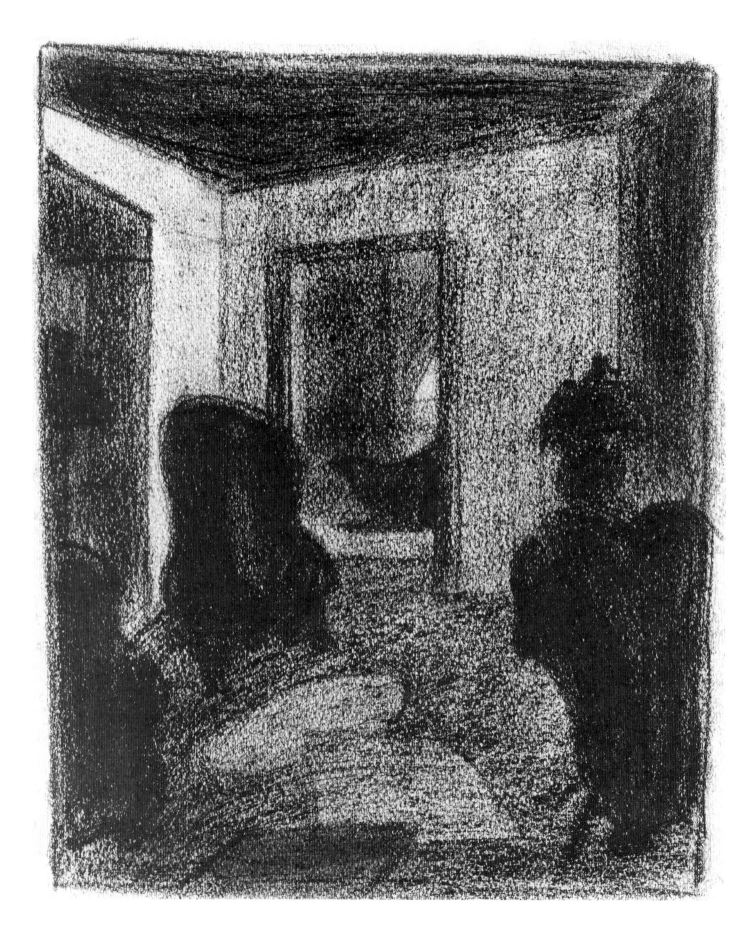

INTERIOR, COLUMBIA UNIVERSITY
Conté crayon on paper, image 9 × 7½″, c. 1923.

This illustration and the next one were studies done for Charles Martin's class at Teacher's College, Columbia University.

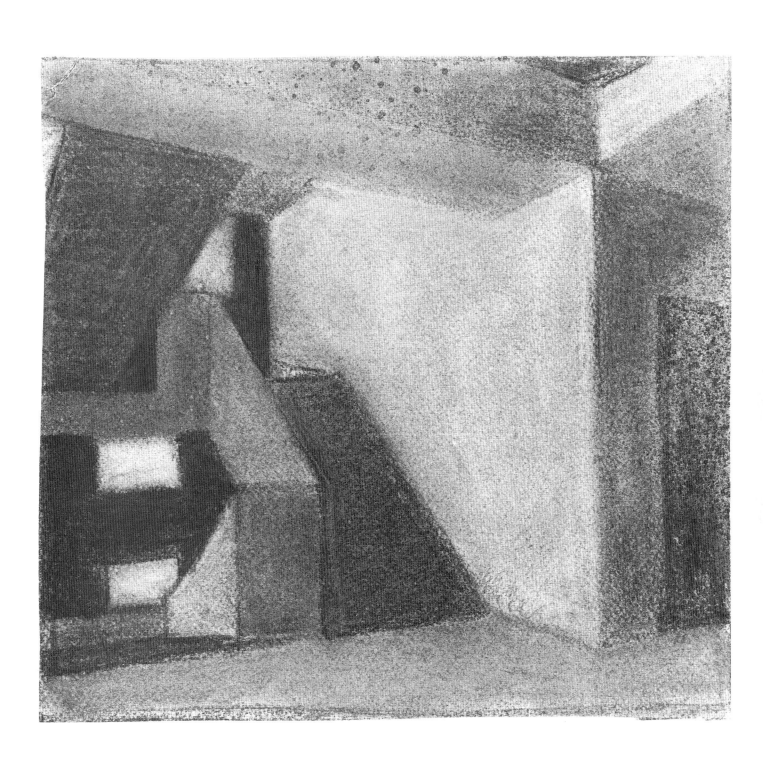

HARTLEY HALL, COLUMBIA UNIVERSITY
Conté crayon on paper, 7 × 7½″, c. 1923.

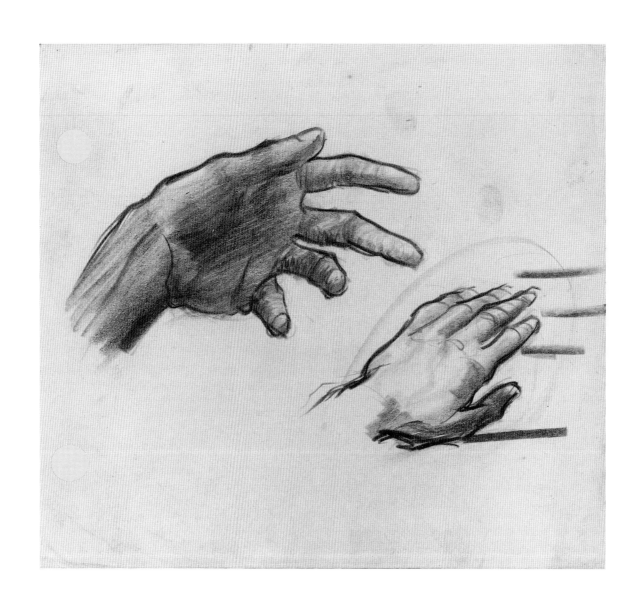

SELF-PORTRAIT, LEFT HAND STUDIES
Pencil on paper, 5½ × 6¼″, early 1920s.

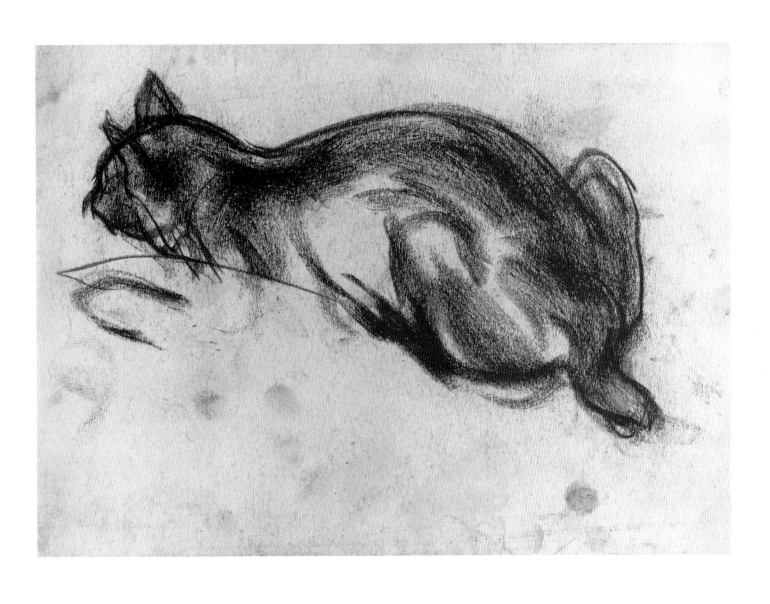

Feline at the Zoo
Conté crayon on paper, image 3⅞ × 6⅝″, early 1920s.

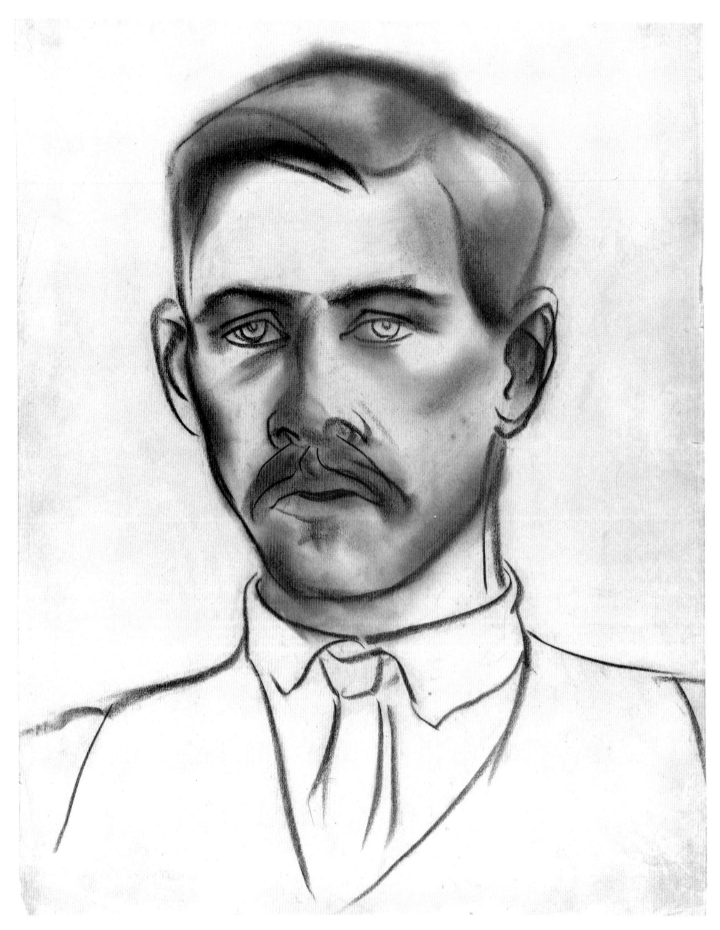

WHITTAKER CHAMBERS
Conté crayon on paper, 10⅛ × 8⅜″, Berlin, 1923.

Chambers was a friend from Columbia College.

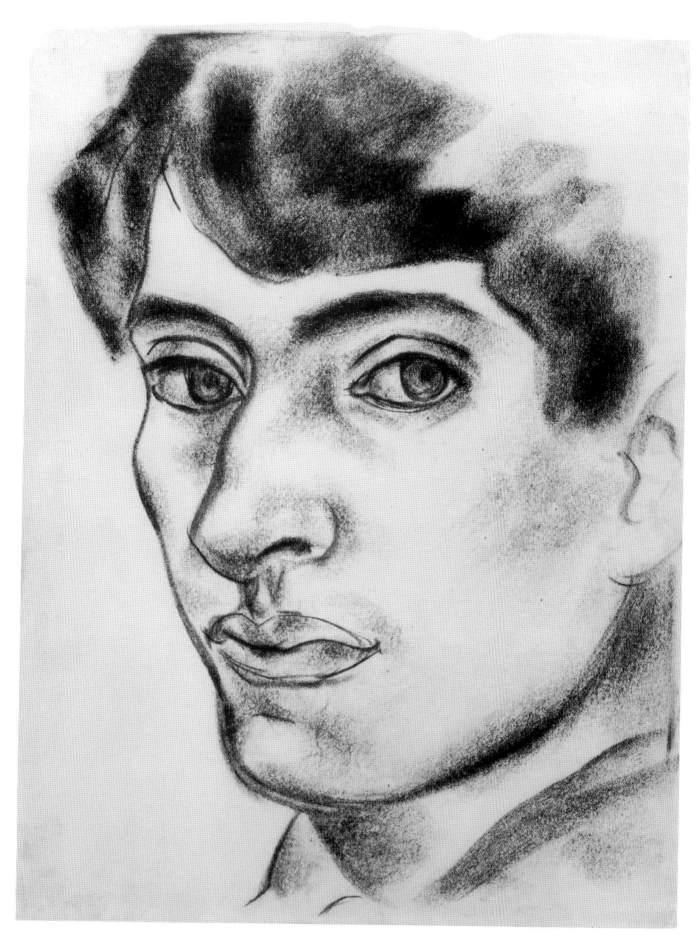

SELF-PORTRAIT, BRUSSELS
Conté crayon on paper, 10⅞ × 8¾″, 1923. Courtesy of the Jewish Museum, New York.

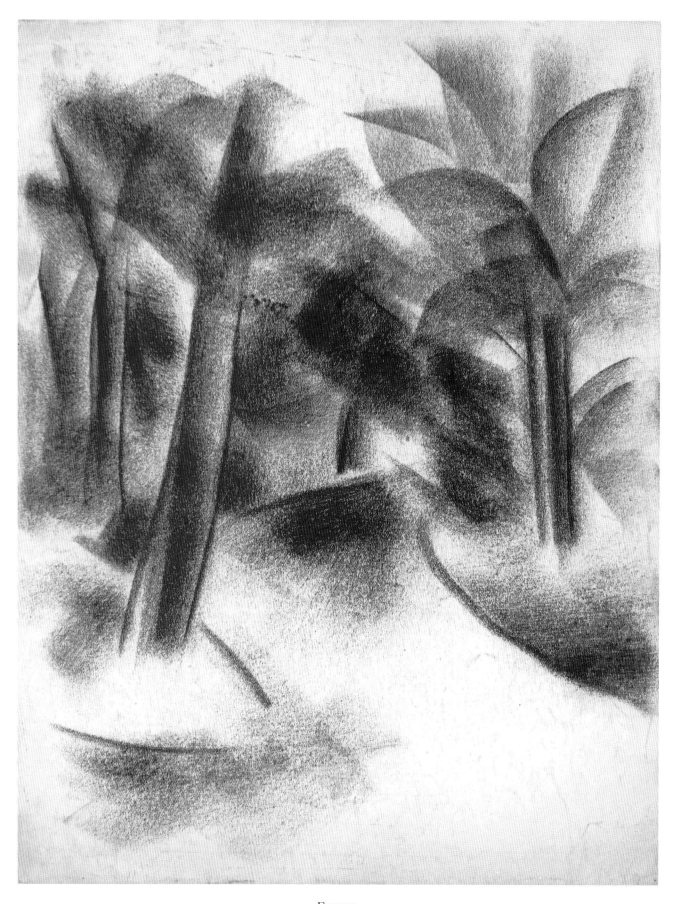

FOREST
Conté crayon on paper, 10⅞ × 8½", Berlin, June 1923.

*In the summer of 1923 the artist "felt [he] had to go to Europe." He worked his way
across on a Holland–America ship, traveled, and met friends in Berlin.*

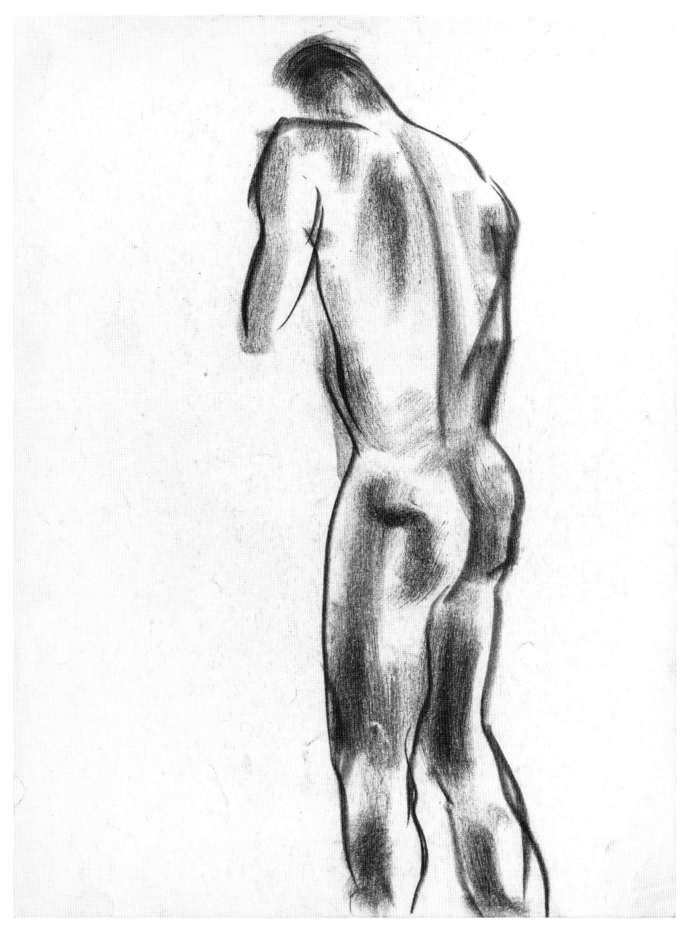

NUDE
Conté crayon on paper, 10⅝ × 7⅞″, Berlin, June 1923.

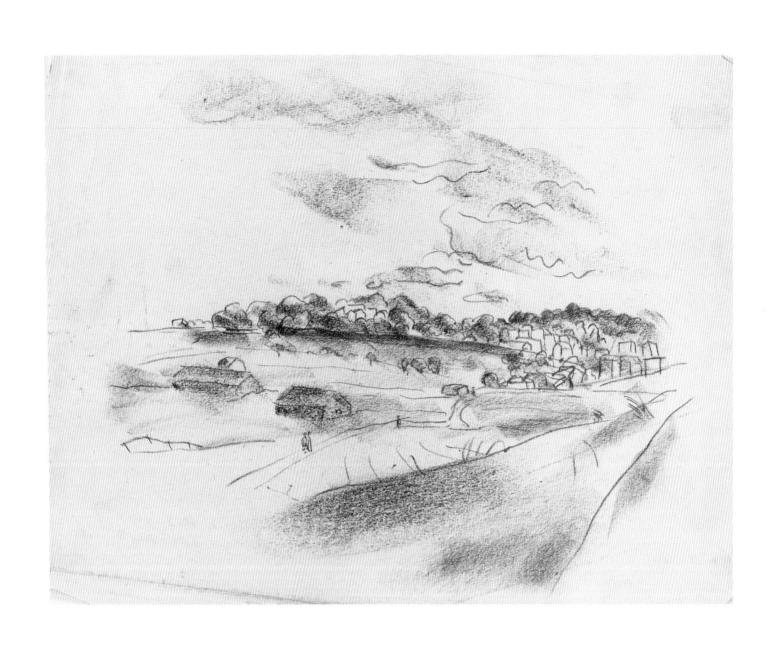

LANDSCAPE, OUTSKIRTS OF BRUSSELS
Conté crayon on paper, $8\frac{7}{16} \times 10\frac{7}{8}''$, 1923.

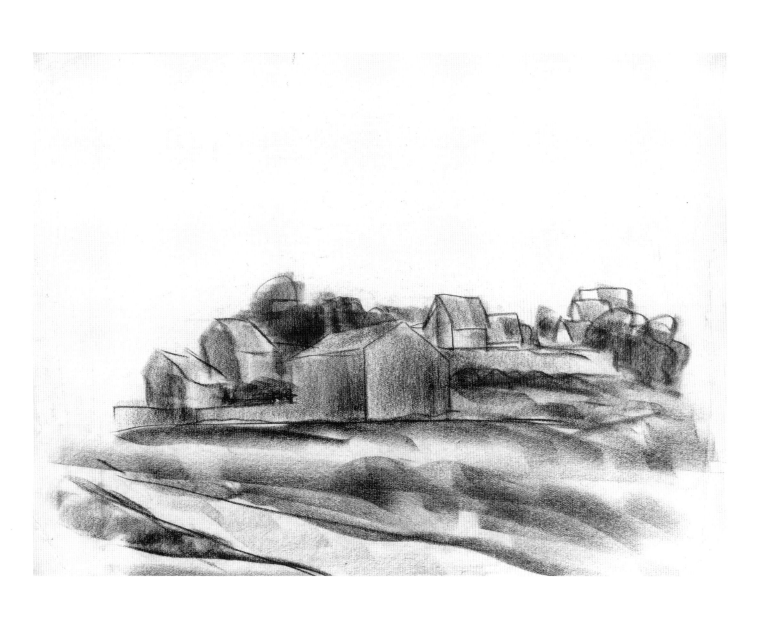

LANDSCAPE WITH BUILDINGS, BRUSSELS
Conté crayon on paper, 8⅜ × 10⅞″, 1923.

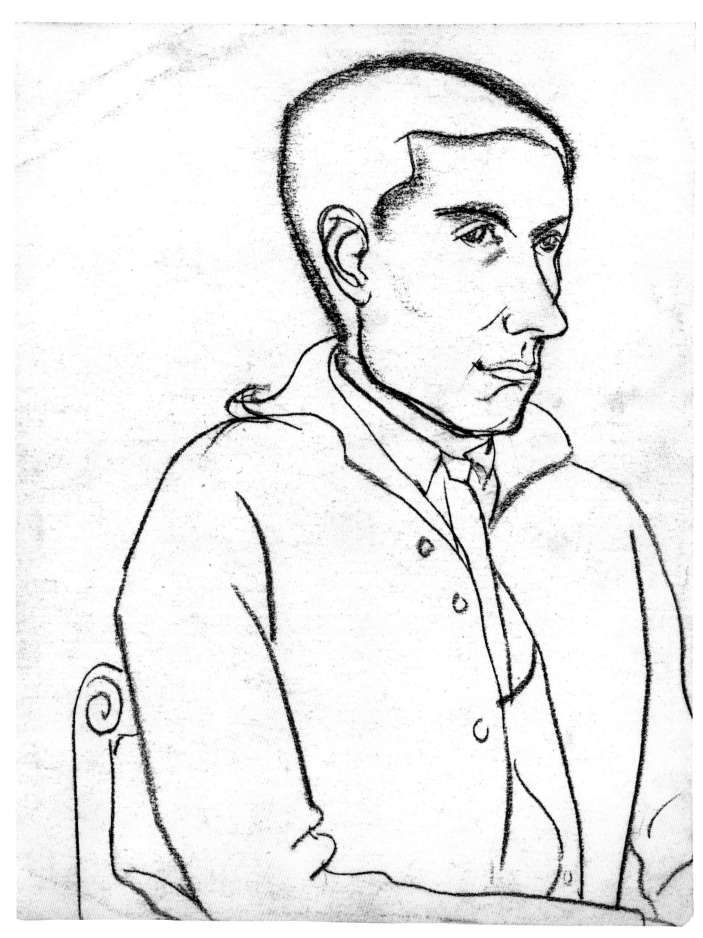

HENRY ZOLINSKY
Conté crayon on paper, 9⅛ × 7⅛″, Berlin, June 1923.

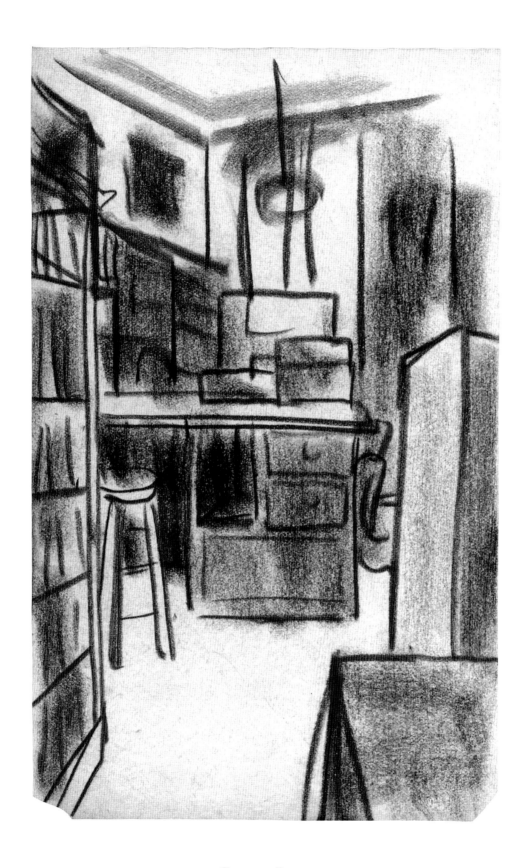

COLUMBIA LIBRARY
Conté crayon on paper, 8 × 5″, 1924.

The artist had an evening job at Butler Library, Columbia University, during his first year of graduate school.

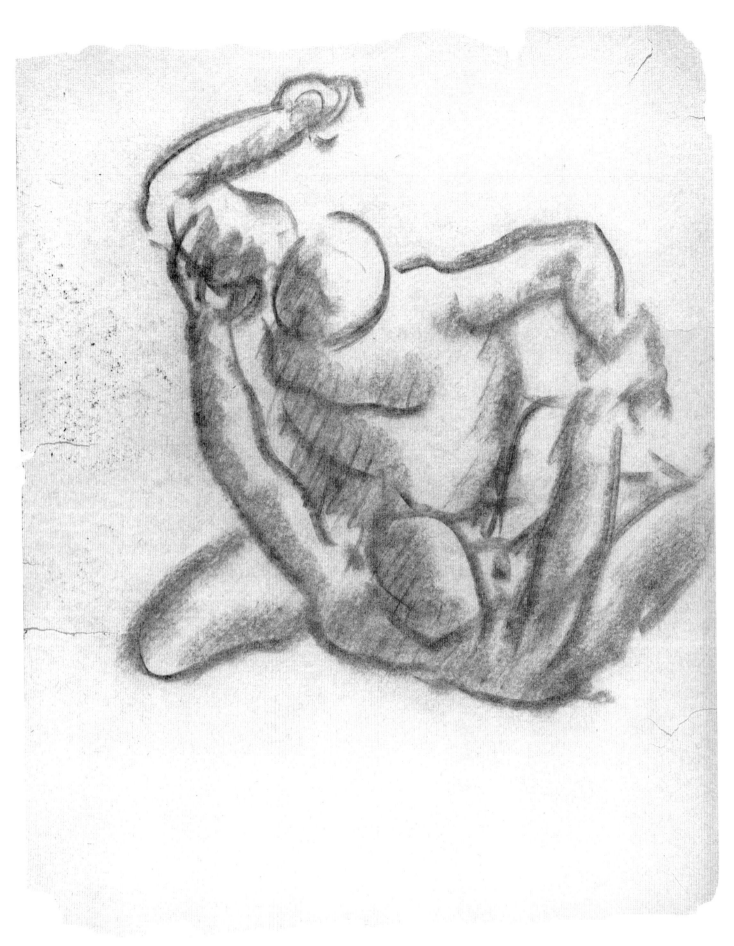

WRESTLERS
Charcoal on paper, 11½ × 9″, mid-1920s.

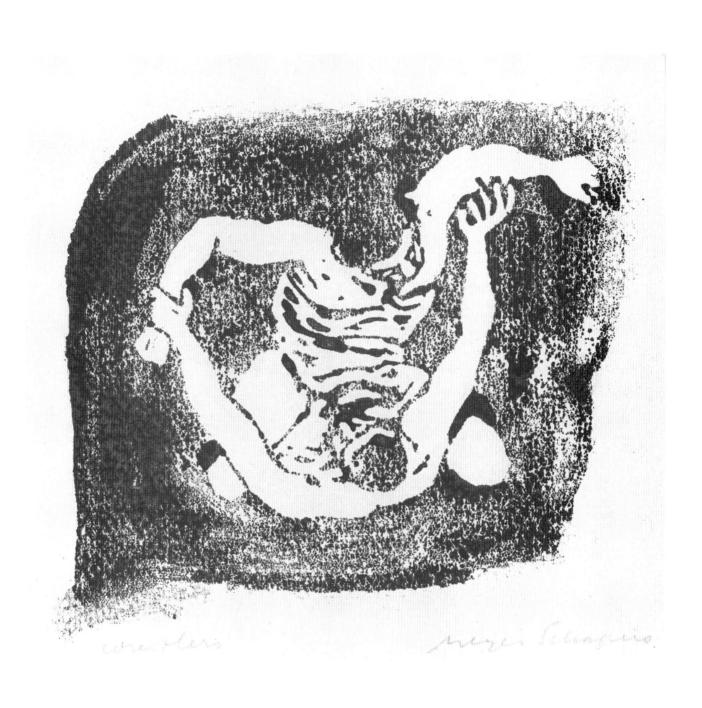

WRESTLERS
Linoleum print on paper, image 5½ × 6″, mid-1920s.

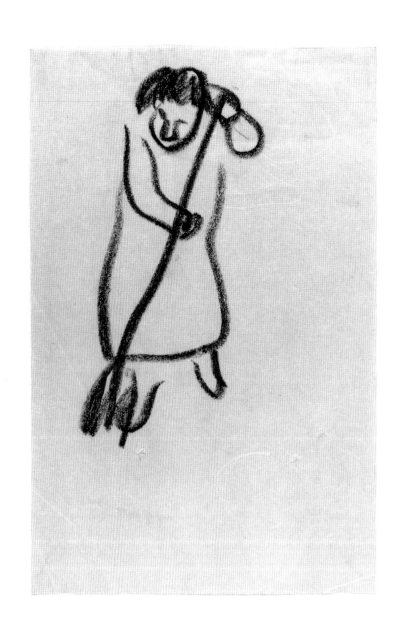

WOMAN SWEEPING
Conté crayon on paper, 6 × 4″, 1920s.

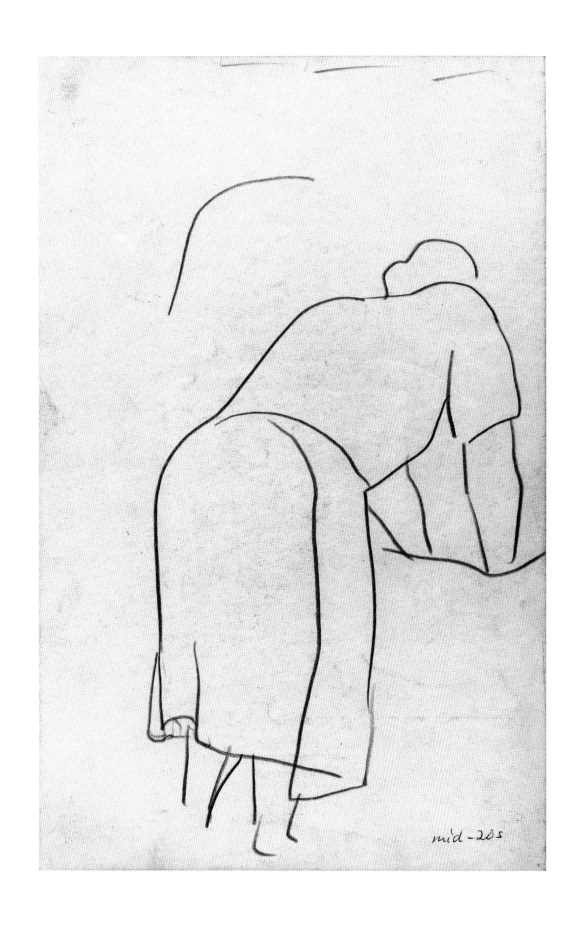

WOMAN WASHING, BARROW FARMS, NAPANOCH, NEW YORK
Pencil on paper, 8½ × 5½", 1924.

In the summer of 1924, the artist worked in the kitchen of a vacation colony.

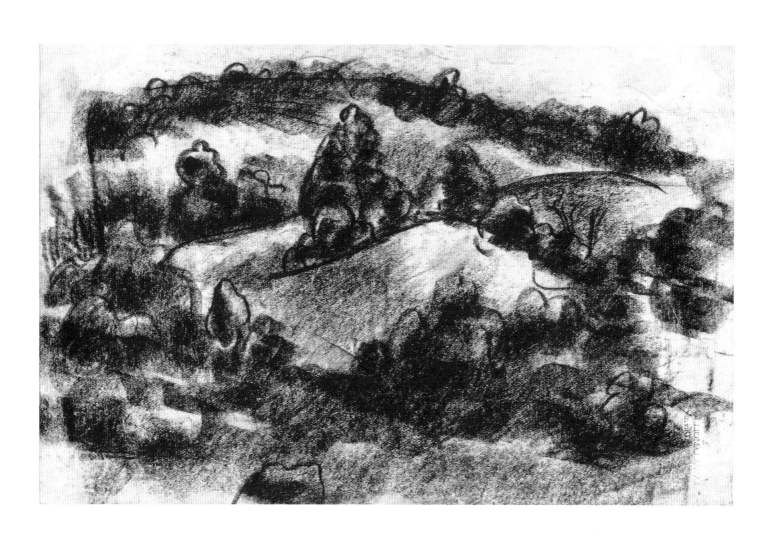

LANDSCAPE, BARROW FARMS
Conté crayon on paper, 5½ × 8½″, 1924.

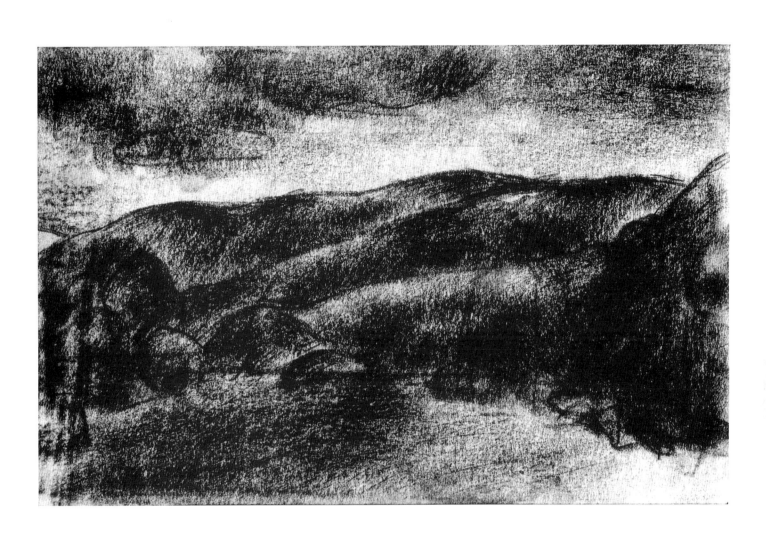

LANDSCAPE, BARROW FARMS
Conté crayon on paper, 5½ × 8½″, 1924.

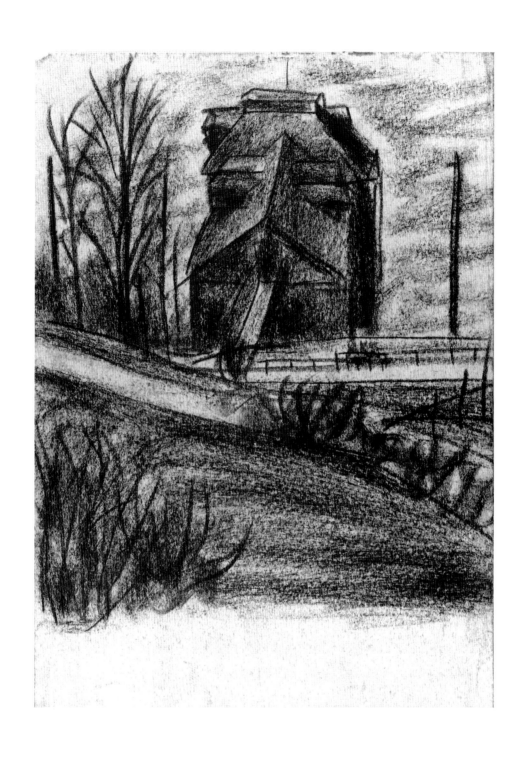

COAL STORAGE BUILDING
Conté crayon on paper, image 6 × 5″, c. 1924.

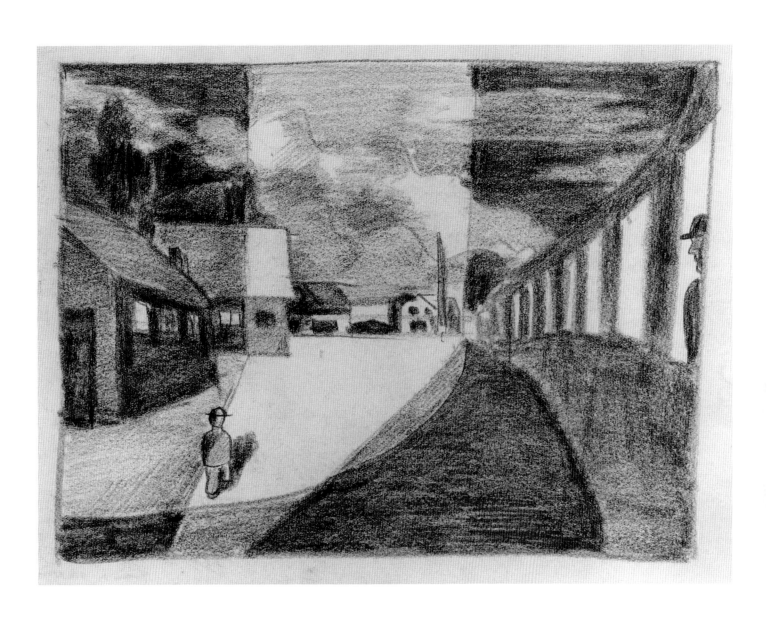

TRAIN STATION
Conté crayon on paper, image 6 × 8″, 1920s.

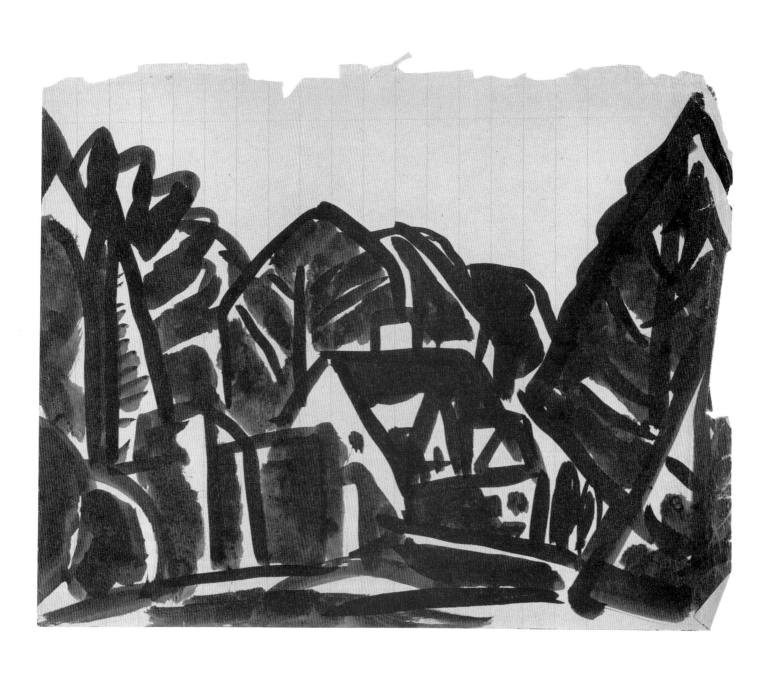

HOUSE ON LONG ISLAND
Brush and ink on paper, 6½ × 8¼″, 1924 or 1925.

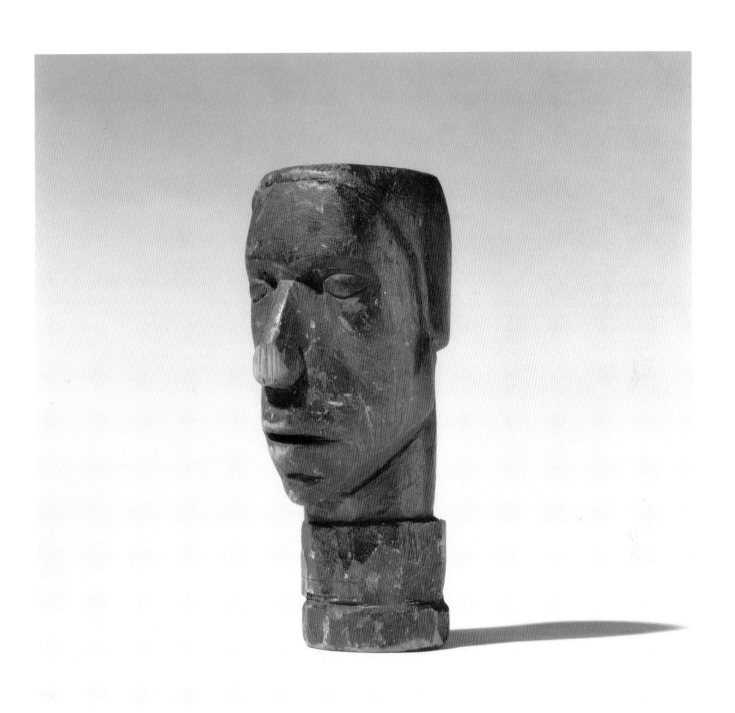

HEAD
Wood 5⅛ × 2 × 2½″, c. 1925.

STUDY NOTEBOOKS

In 1926–27, Meyer Schapiro had a fellowship for study in Europe. He traveled in Western Europe and the Near East, sketching and taking notes in preparation for his doctoral thesis on the sculpture of Moissac.

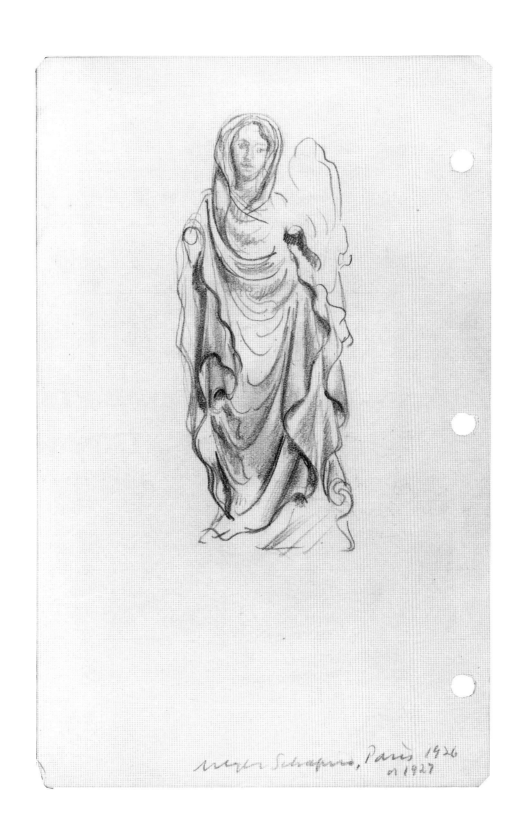

PARIS, FORMERLY IN CLUNY MUSEUM, NOW IN LOUVRE, VIRGIN AND CHILD
Wood sculpture, pencil on paper, 7⅝ × 4⅞″, 1926–27.

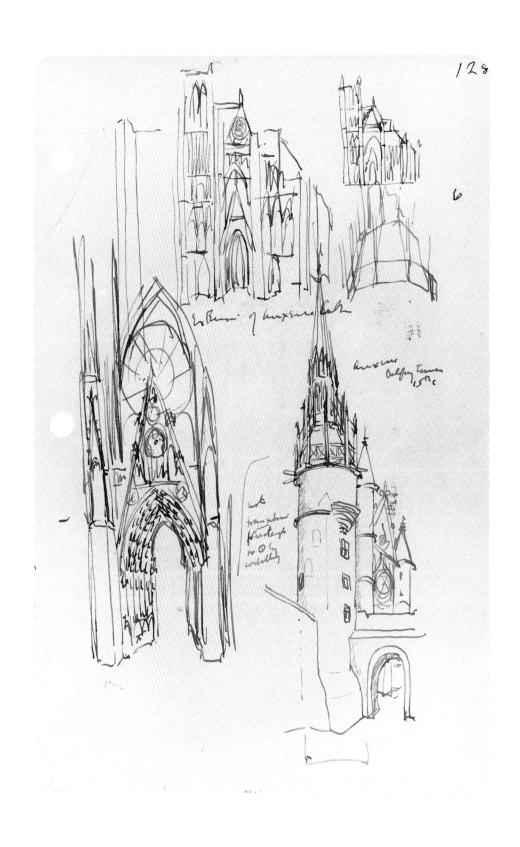

AUXERRE, CATHEDRAL, VIEWS
Pen and ink on paper, 7¹¹⁄₁₆ × 4¹⁵⁄₁₆″, 1926–27.

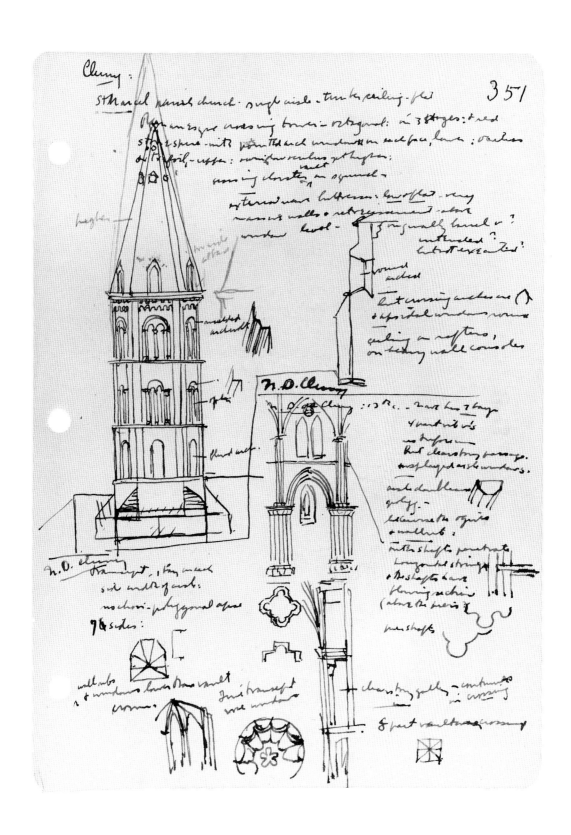

CLUNY, SAINT MARCEL, TOWER; NOTRE-DAME, DETAILS
Pen and ink and pencil on paper, 7⅝ × 5½", 1926–27.

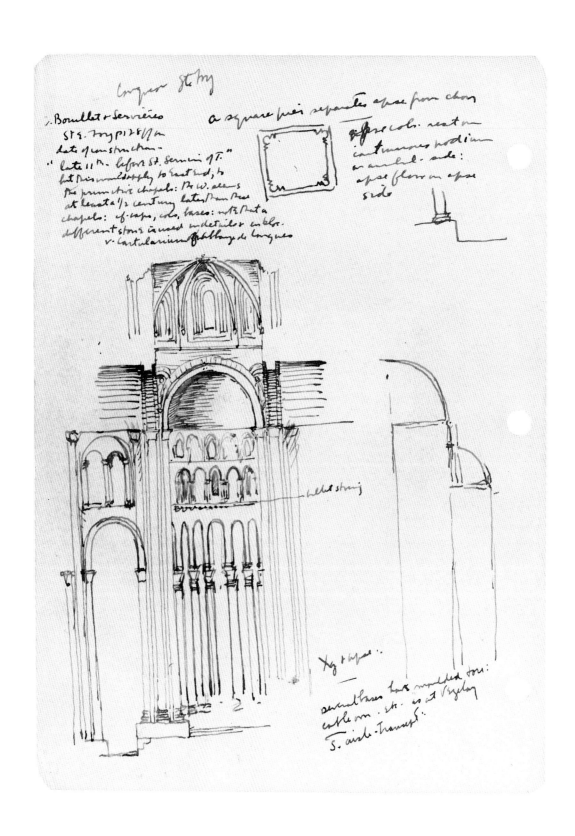

CONQUES, SAINTE FOY, SECTION OF CROSSING (faces opposite page in notebook)
Pen and ink on paper, 7⅞ × 5½″, 1926–27.

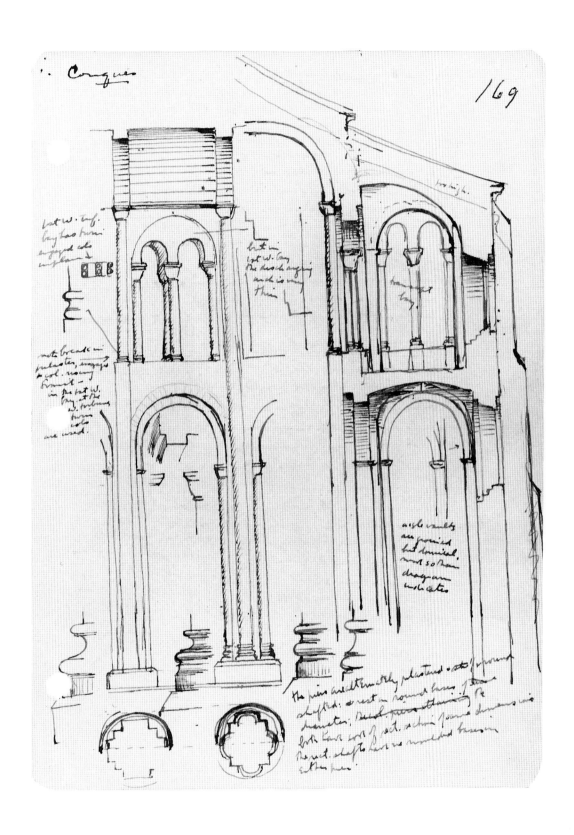

Conques

169

CONQUES, SAINTE FOY, SECTION OF SOUTH TRANSEPT AND AISLE ELEVATION
Pen and ink on paper, 7⅝ × 5½″, 1926–27.

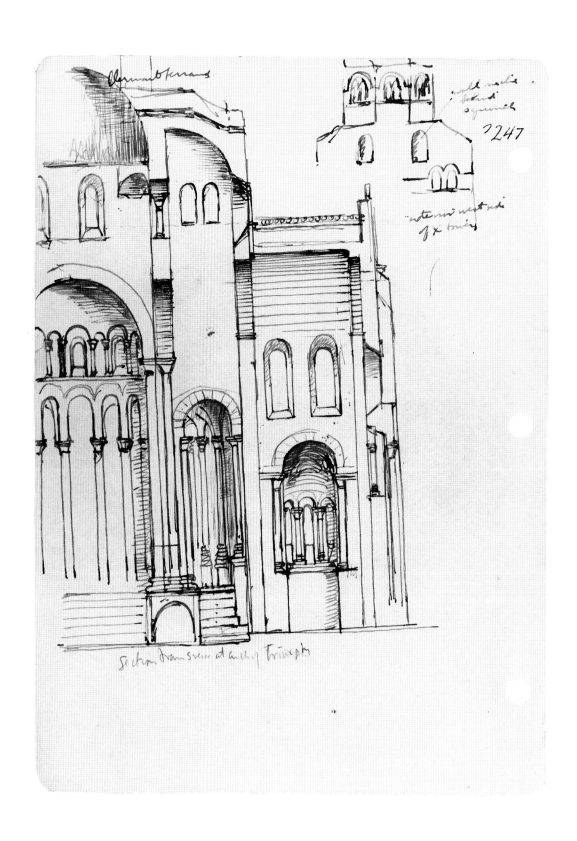

CLERMONT-FERRAND, NOTRE DAME DU PORT, SECTIONS OF CROSSING AND SOUTH TRANSEPT
(faces opposite page in notebook)
Pen and ink on paper, 7⅞ × 5½″, 1926–27.

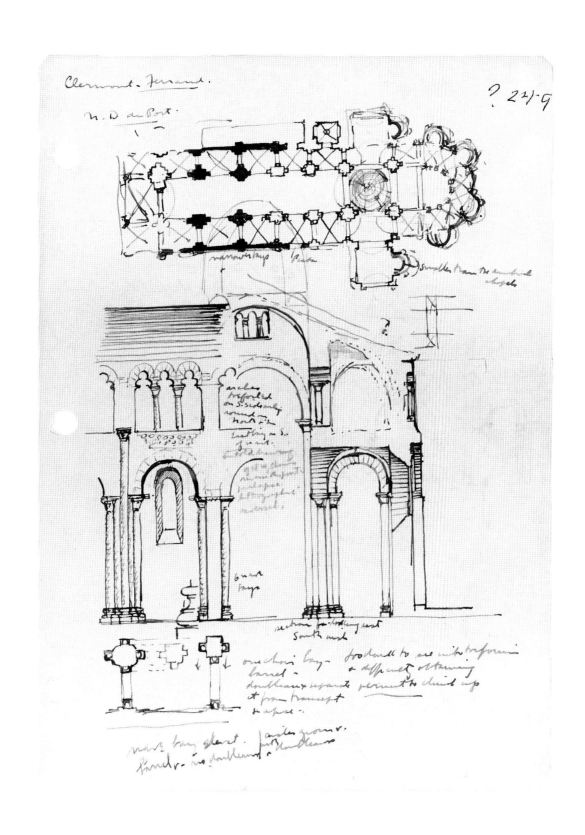

CLERMONT-FERRAND, NOTRE DAME DU PORT, SECTION OF AISLE, AISLE ELEVATION, AND GROUND PLAN
Pen and ink on paper, 7⅞ × 5½″, 1926–27.

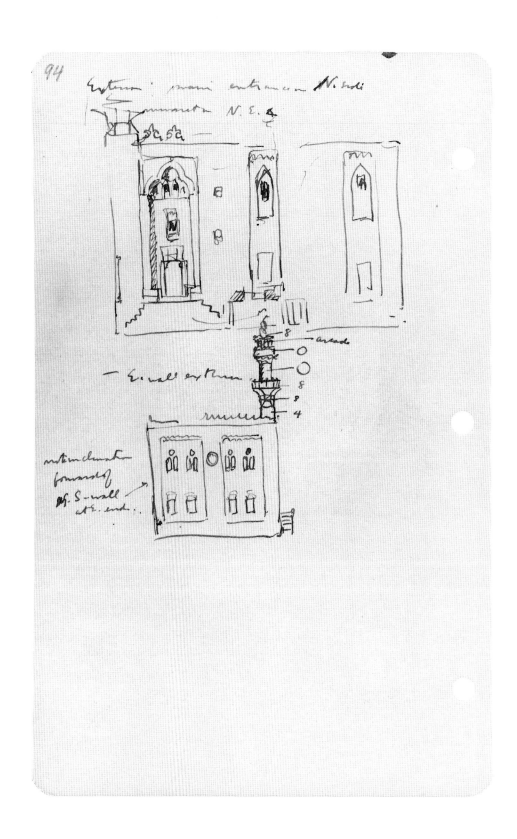

CAIRO, MOSQUE OF HASSAN (faces opposite page in notebook)
Pen and ink on paper, 7¹¹⁄₁₆ × 4¹⁵⁄₁₆″, February–March 1927.

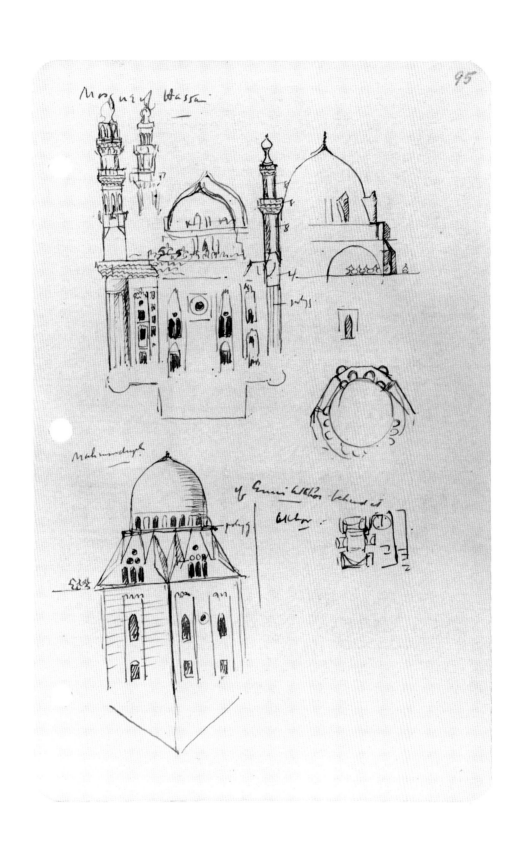

CAIRO, MOSQUE OF HASSAN
Pen and ink on paper, 7¹¹⁄₁₆ × 4¹⁵⁄₁₆″, February–March 1927.

JERUSALEM, QUBBET AL-SAKHRA (THE DOME OF THE ROCK) (faces opposite page in notebook)
Pen and ink on paper, 7¹¹⁄₁₆ × 4¹³⁄₁₆″, March 1927.

JERUSALEM, QUBBET AL-SAKHRA (THE DOME OF THE ROCK)
Pen and ink on paper, 7¹¹⁄₁₆ × 4¹⁵⁄₁₆″, March 1927.

MOISSAC, CLOISTER CAPITAL WITH OG AND MAGOG AND GOLIAS
Pen and ink and wash on paper, 8¼ × 6¹⁄₁₆″, 1926–27.

SERPS
ANTICVS
QVI:EST
DIABOLVS

MOISSAC, CLOISTER CAPITAL WITH ANGEL AND SERPENT
Pen and ink and wash on paper, 8¼ × 6⅟₁₆″, 1926–27.

MOISSAC, CLOISTER CAPITALS
Pen and ink and wash on paper, 8⁵⁄₁₆ × 5⁵⁄₁₆″, 1926–27.

Moissac, Cloister Capital with Banquet of Dives
Pen and ink on paper, 8⁵⁄₁₆ × 5⁵⁄₁₆″, 1926–27.

RIVERSIDE DRIVE
Oil on paper, 6¾ × 10″, 1928–29.

The Schapiros lived on 76th Street near Riverside Park, Manhattan, for a year or two after their marriage in June 1928.

MANHATTAN
Ink on red paper, 5⅞ × 8¹⁵⁄₁₆″, late 1920s–early 1930s.

NUDE
Oil on paper, 12 × 9″, 1928–32.

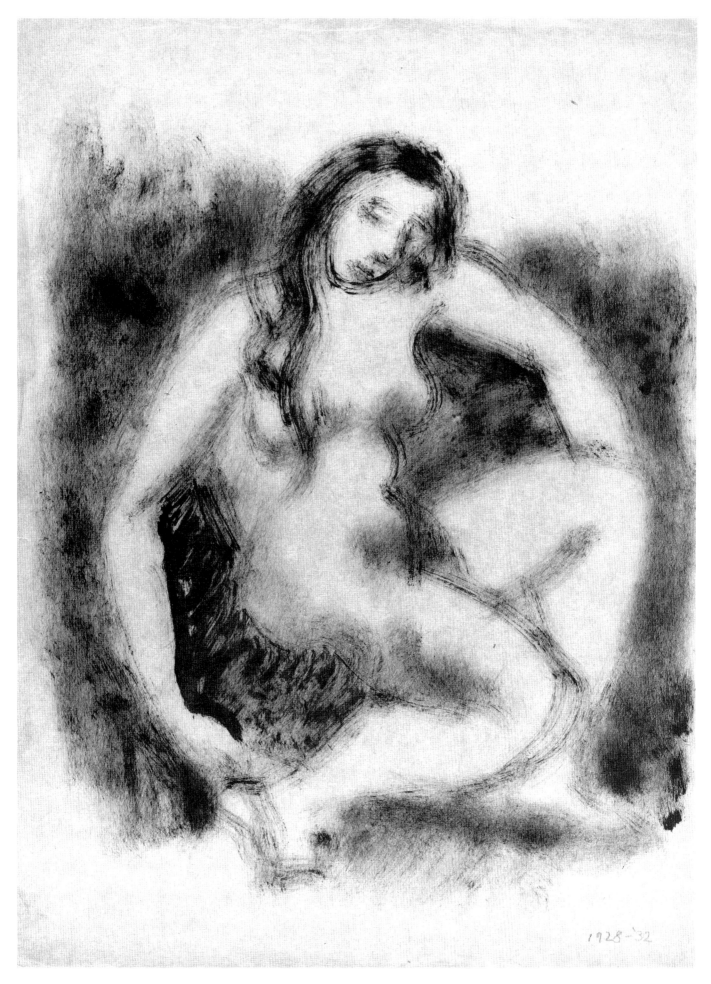

1928-'32

97

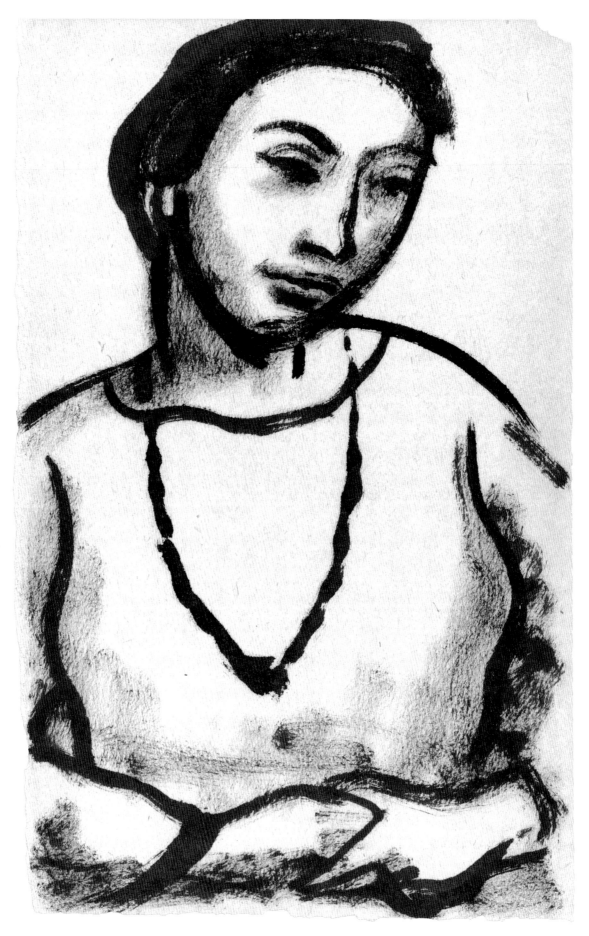

LILLIAN
Black brush on paper, 10 × 6⅜″, late 1920s–early 1930s.

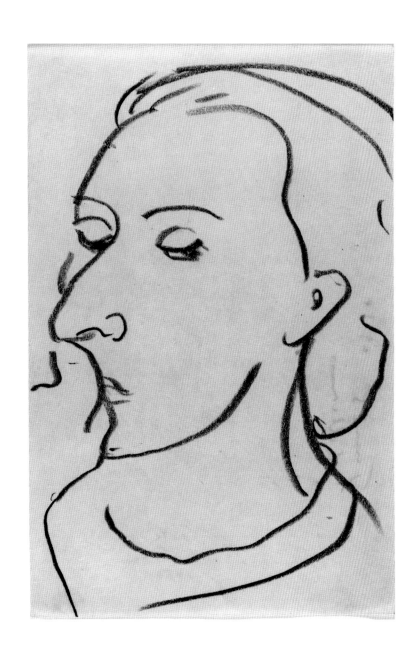

LILLIAN

Conté crayon on paper, 6 × 4″, June 25, 1930.

The Schapiros became acquainted in Brooklyn in 1921 and married in 1928.

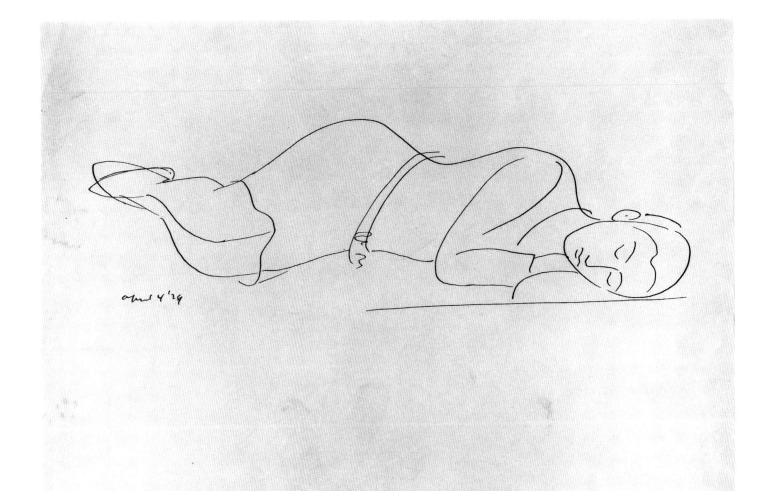

LILLIAN SLEEPING
Pen and ink on paper, 8½ × 11″, April 4, 1929.

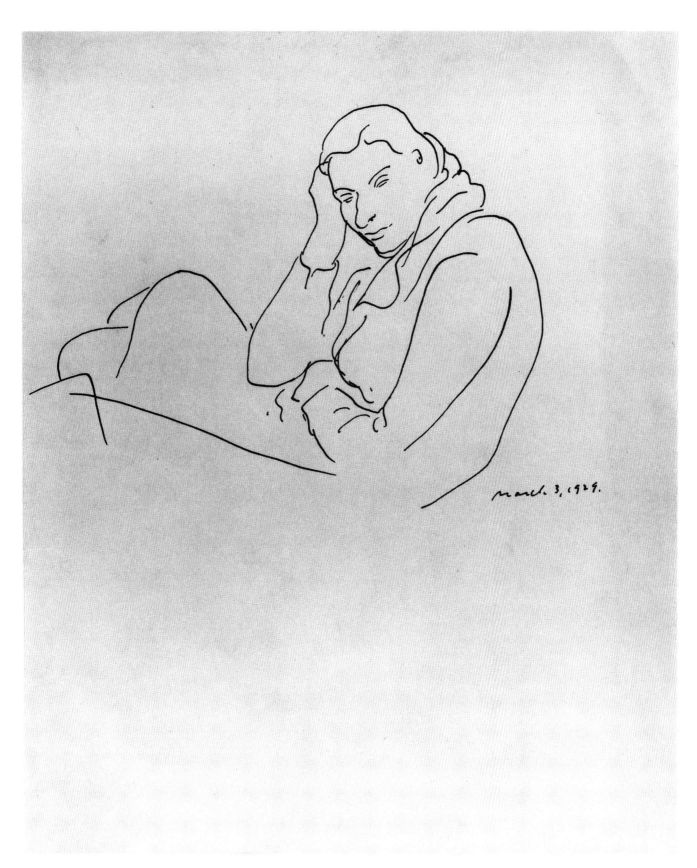

LILLIAN
Pen and ink on paper, 11 × 8½″, March 3, 1929.

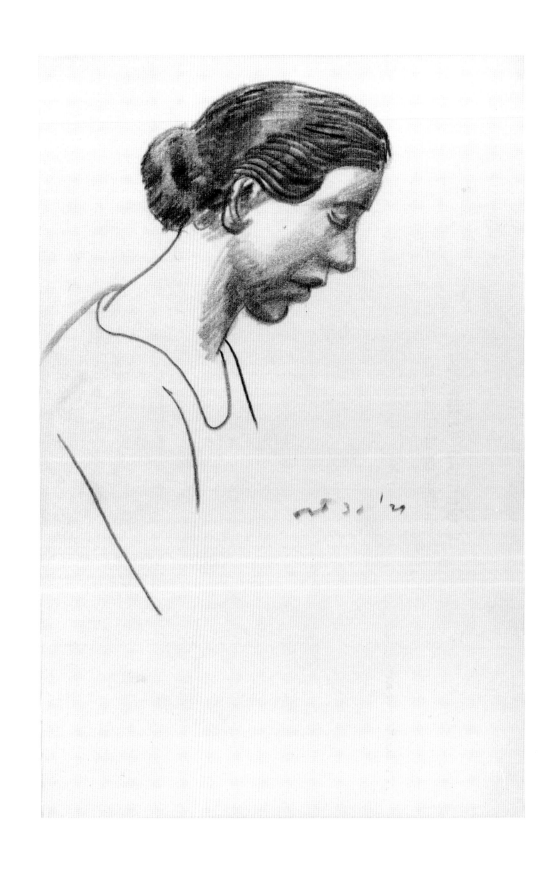

LILLIAN
Conté crayon on paper, 8 × 5¼″, October 30, 1929.

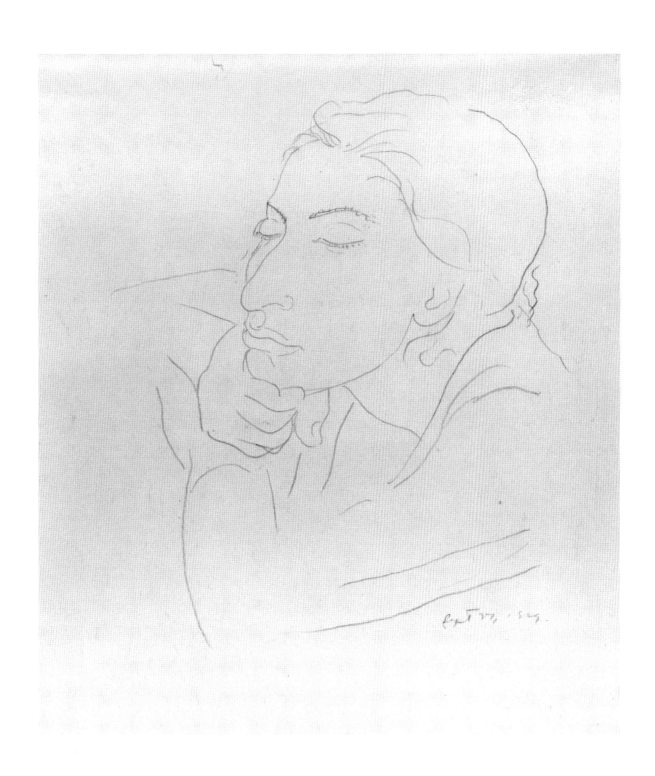

LILLIAN
Blue pencil on paper, image 5¾ × 5″, October 27, 1929.

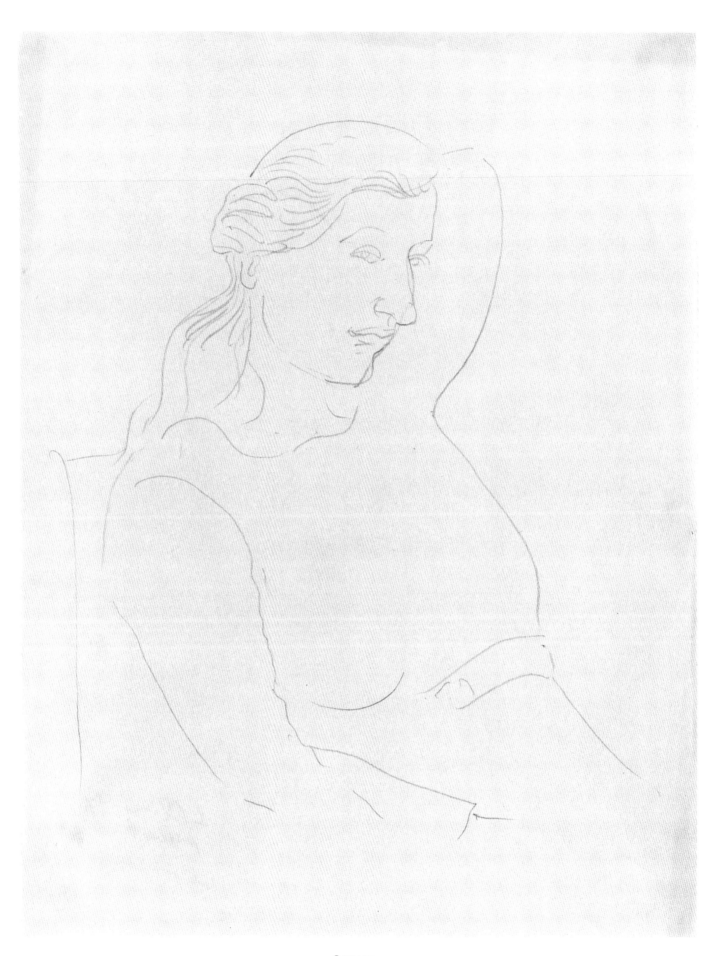

LILLIAN
Pencil on paper, 11 × 8½″, late 1920s-early 1930s.

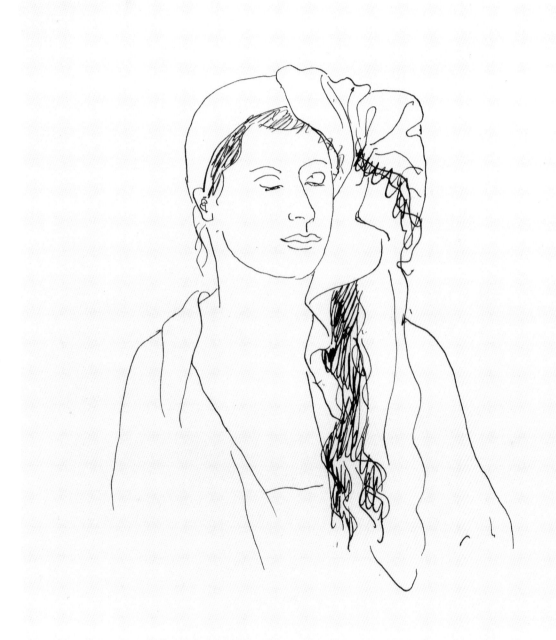

LILLIAN WITH TOWEL
Pen and ink on paper, image 5½ × 4⅜″, 1928–30.

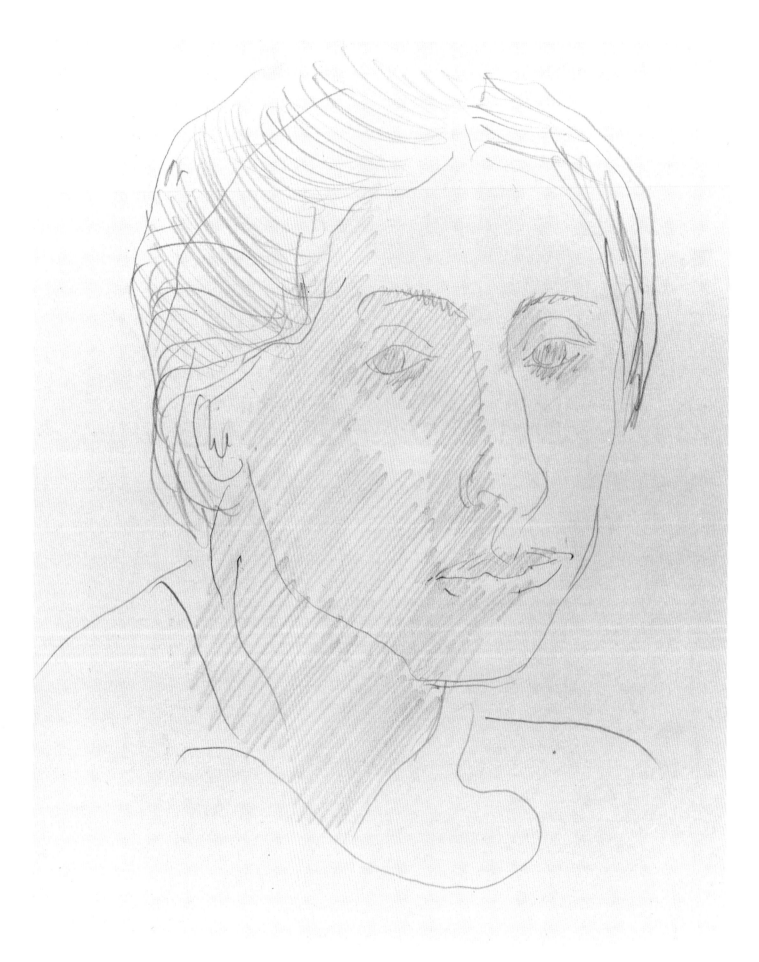

LILLIAN
Pencil on paper, image 8¾ × 6¾″, March 17, 1930.

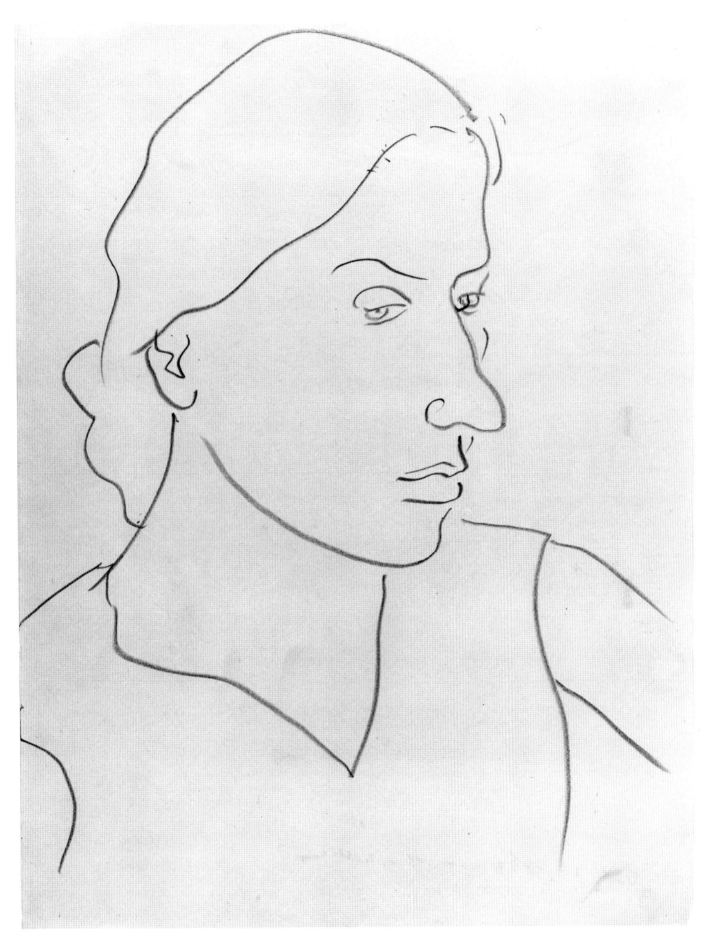

LILLIAN
Conté crayon on paper, 10¼ × 8″, 1930.

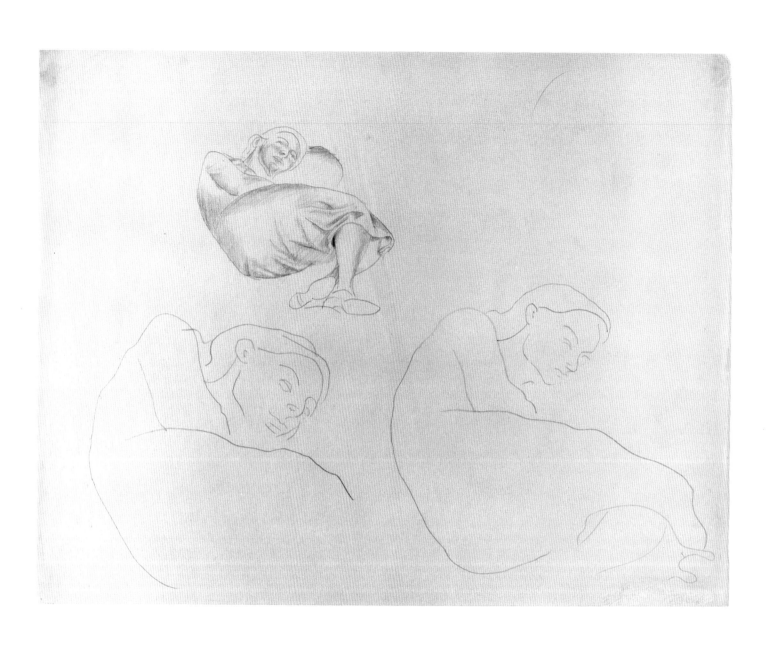

LILLIAN ASLEEP
Pencil on paper, 8½ × 11″, 1930–31.

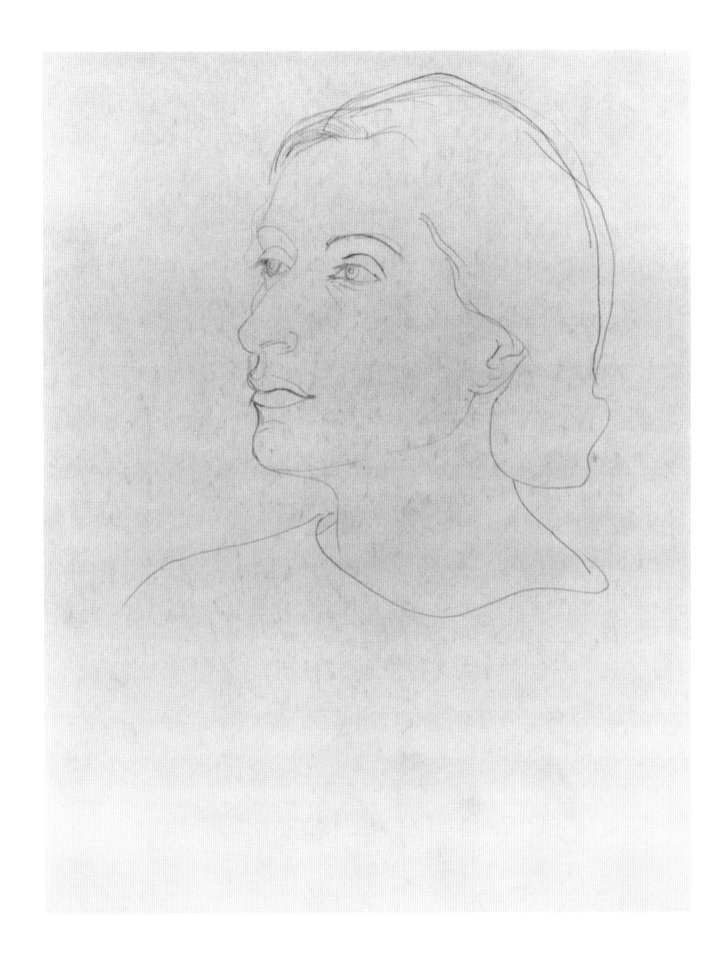

LILLIAN
Pencil on paper, image 5¾ × 5⅜″, 1928–31.

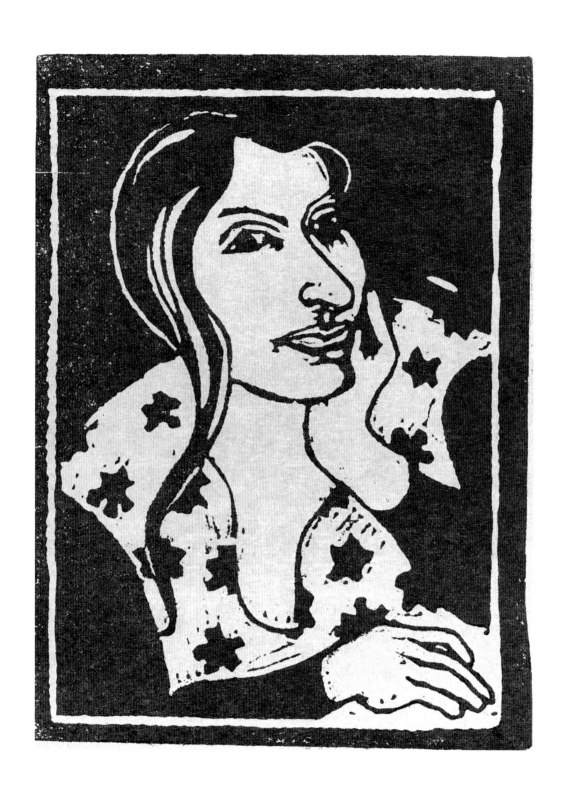

UNKNOWN WOMAN
Linoleum cut, image 7¼ × 5⅜″, 1929–30.

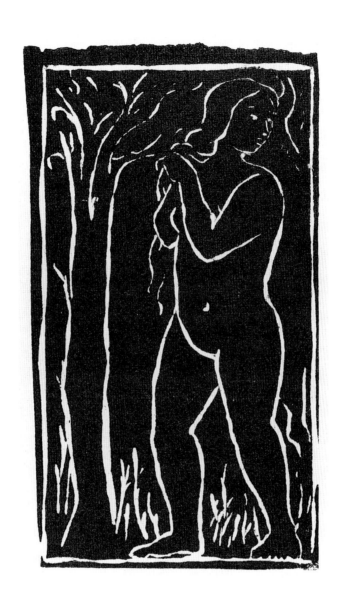

WOMAN AND TREE (EVE)
Linoleum cut on paper, image 5½ × 3⅛″, 1928–30.

HEAD
Stone, 5¾ × 3 × 3¼″, 1929. Collection of Daniel Esterman.

112

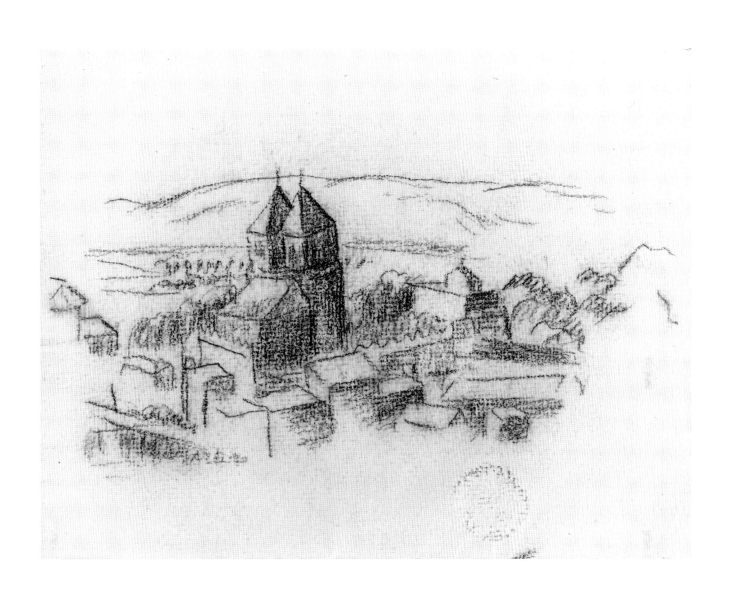

PARAY-LE-MONIAL, FRANCE
Conté crayon on paper, 5⅜ × 7″, 1930–31

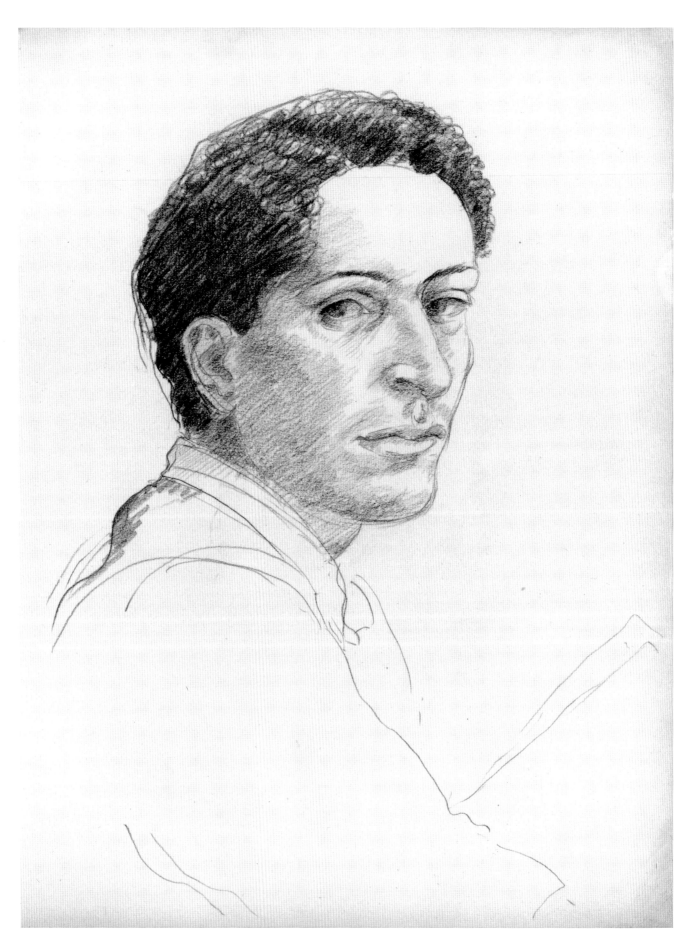

SELF-PORTRAIT, PARIS
Conté crayon on paper, 16⅜ × 13″, 1931.

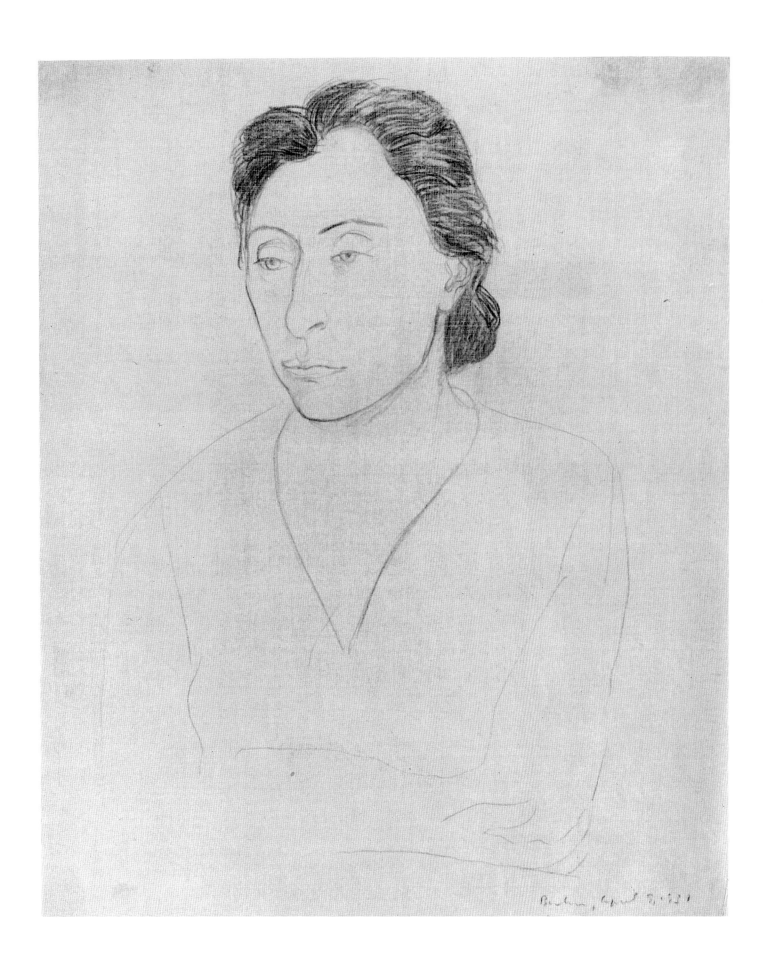

LILLIAN
Blue pencil on blue paper, image 9⁹⁄₁₆ × 6¼″, Berlin, April 9, 1931.

In 1931, the artist had a fellowship which he used to study manuscripts. He followed the same procedure as in 1926–27, sketching and taking notes.

TROPIARY FROM SAINT MARTIAL, LIMOGES
PARIS, BIBLIOTHÈQUE NATIONALE, LATIN 1119, INITIALS
Pen and ink on paper, 8⅜ × 5¼″, 1931.

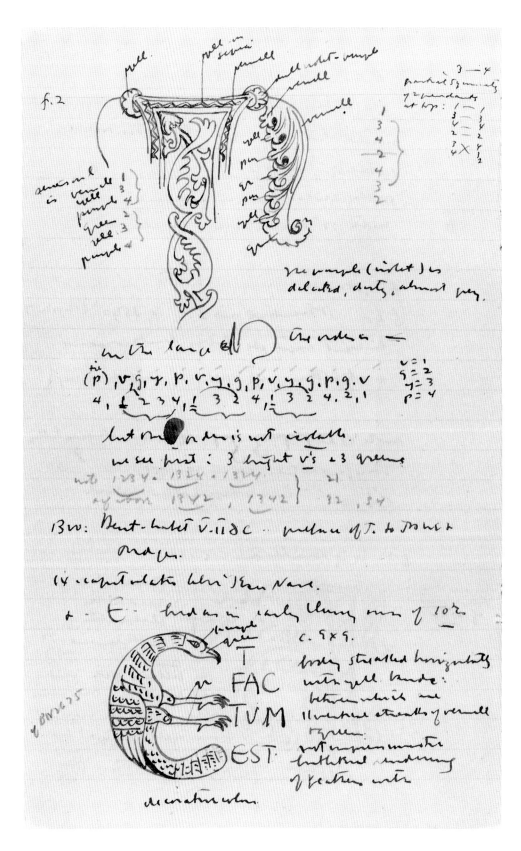

BIBLE FROM SAINT MARTIAL, LIMOGES
PARIS, BIBLIOTHÈQUE NATIONALE, LATIN 5, INITIALS (faces opposite page in notebook)
Pen and ink on paper, 8⅜ × 5¼″, 1931.

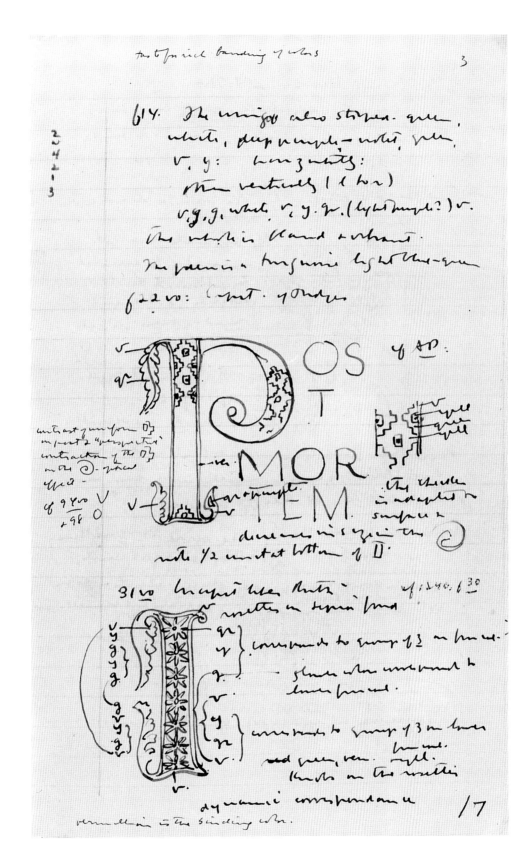

BIBLE FROM SAINT MARTIAL, LIMOGES
PARIS, BIBLIOTHÈQUE NATIONALE, LATIN 5, INITIALS
Pen and ink on paper, 8⅜ × 5¼″, 1931.

BIBLE FROM SAINT MARTIAL, LIMOGES
PARIS, BIBLIOTHÈQUE NATIONALE, LATIN 5, INITIALS (faces opposite page in notebook)
Pen and ink on paper, 8⅜ × 5¼″, 1931.

BIBLE FROM SAINT MARTIAL, LIMOGES
PARIS, BIBLIOTHÈQUE NATIONALE, LATIN 5, INITIALS
Pen and ink on paper, 8⅜ × 5¼″, 1931.

Tropiary from Saint Martial, Limoges
Paris, Bibliothèque Nationale, Latin 909, Initials
Pen and ink and pencil on paper, 8⅜ × 5¼", 1931.

122

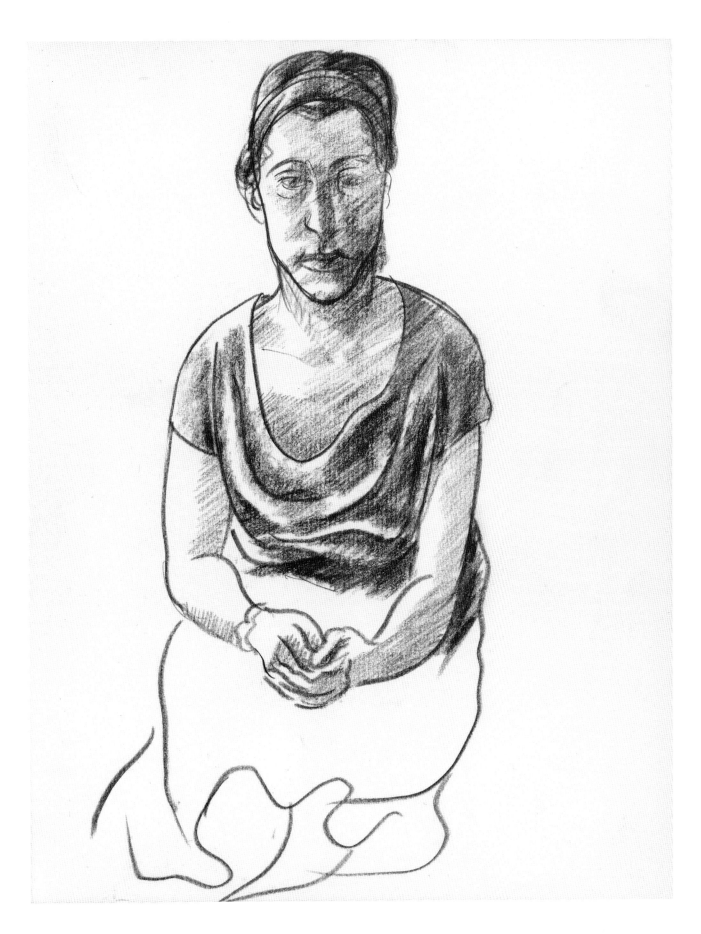

SOPHIE MILGRAM
Conté crayon on paper, 9 × 7″, early 1930s. Collection of Daniel Esterman.

Lillian's younger sister.

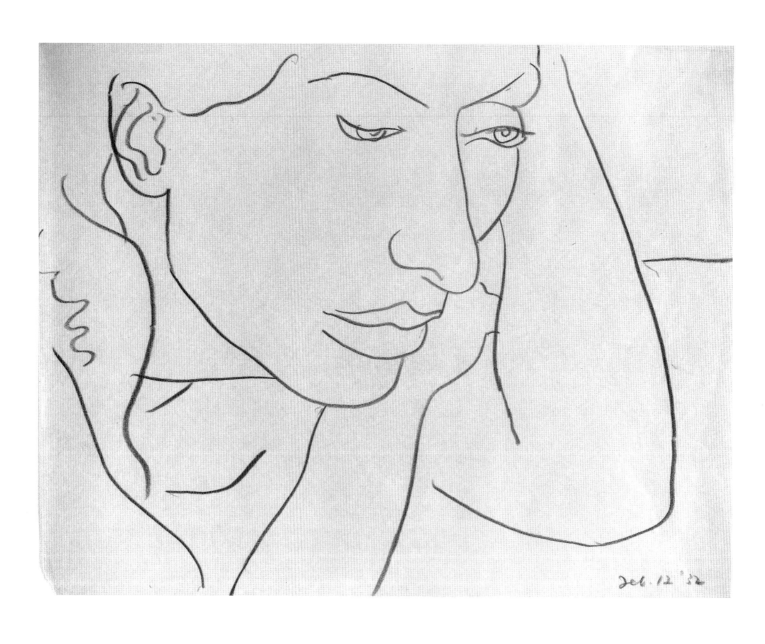

LILLIAN
Pencil on pink paper 8½ × 11″, February 12, 1932.

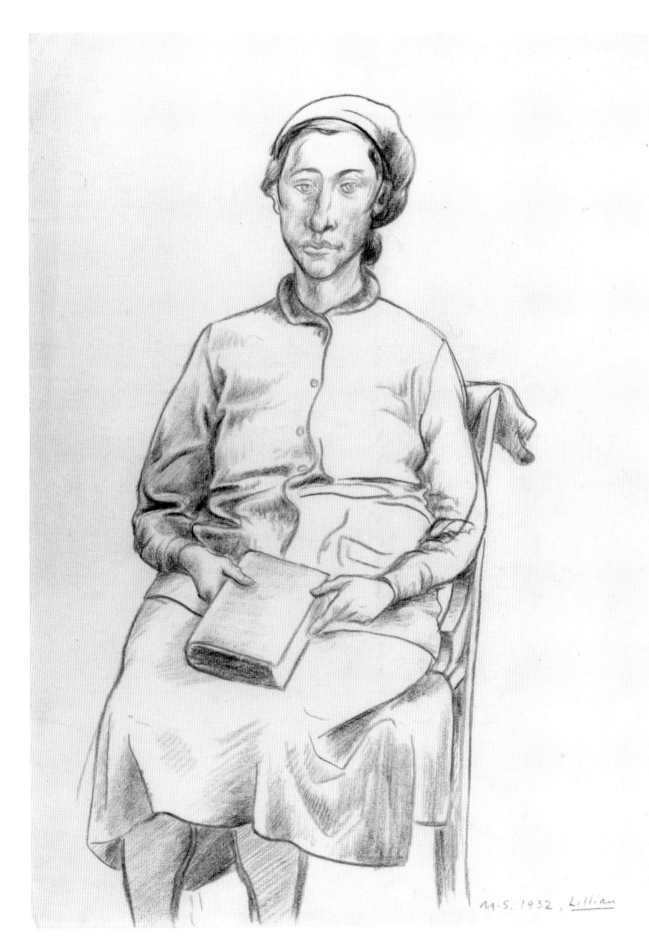

LILLIAN
Blue crayon on paper, 11 × 8⅜″, 1932.

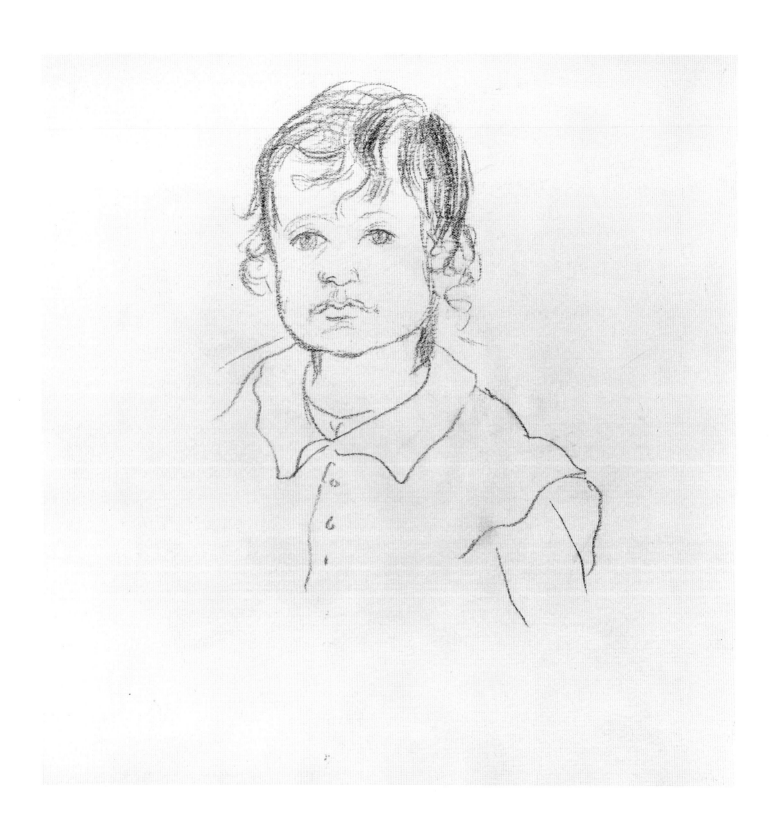

MIRIAM

Conté crayon on paper, image 5¾ × 4⅜″, September 28, 1935.

Miriam, the Schapiros' daughter, was born in December 1932.

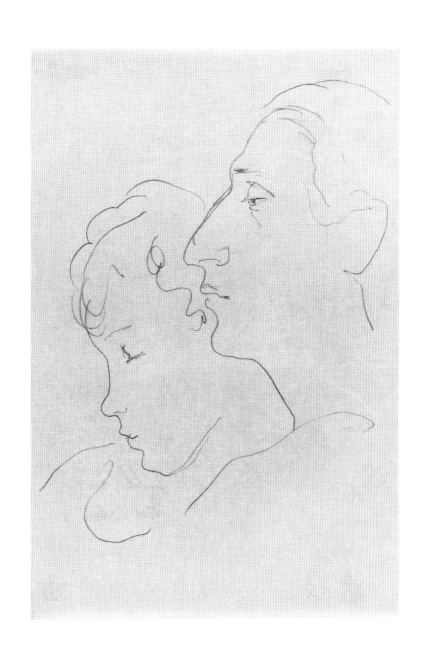

LILLIAN AND MIRIAM
Pencil on blue paper, 6 × 4″, 1934–35.

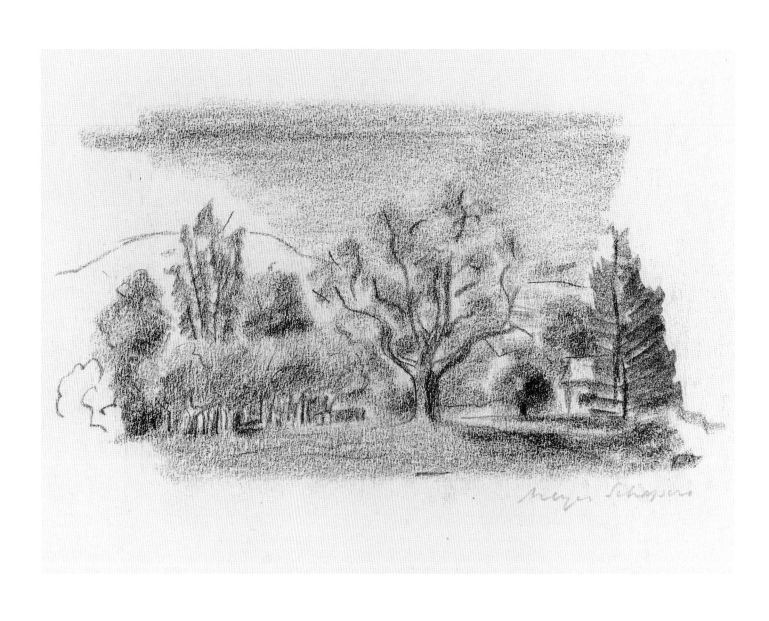

RAWSONVILLE CEMETERY AND LANDMAN HOUSE, VERMONT
Conté crayon on paper, image 3⅞ × 7¼″, c. 1933

The Schapiros bought a house and land in Rawsonville, Vermont, in 1933.

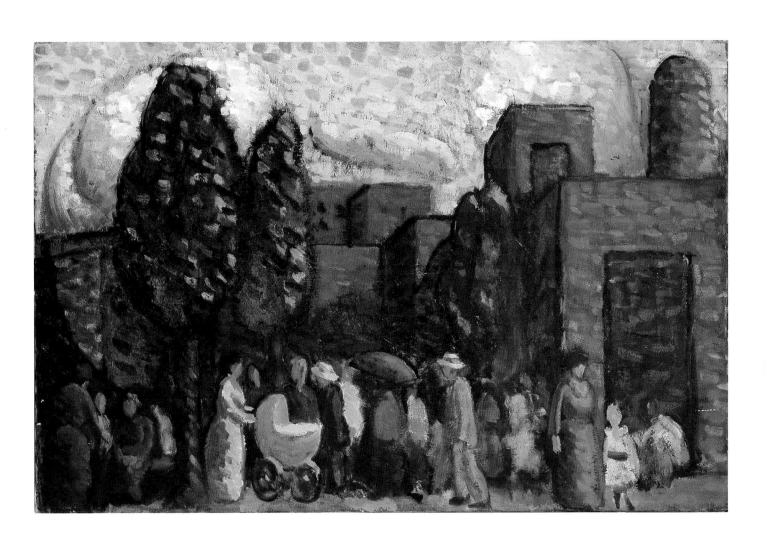

BETSY HEAD PARK
Oil on canvas, 19¾ × 30″, 1920–21?

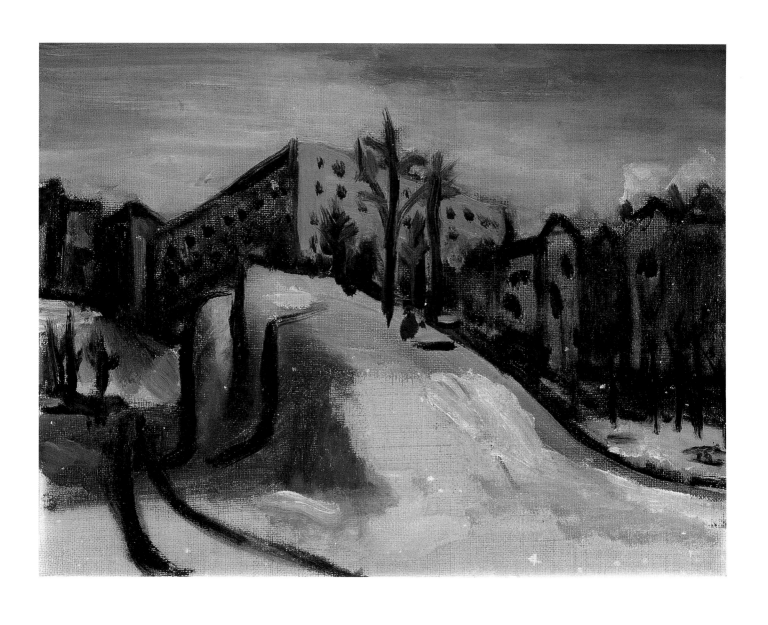

RIVERSIDE PARK
Oil on canvas board, image 11⅝ × 15½", 1929.

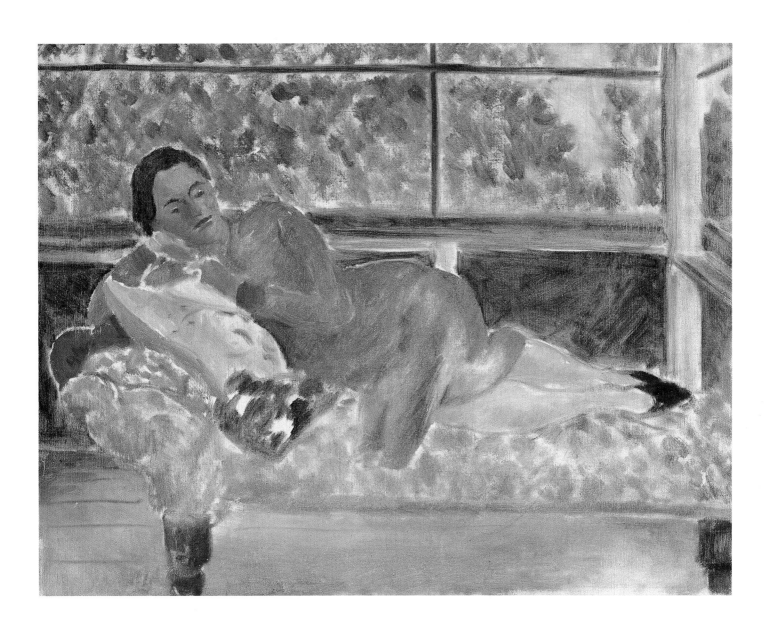

LILLIAN ON COUCH AT BELMONT, VERMONT
Oil on canvas, 20 × 26″, 1932.

A summer boardinghouse where the Schapiros spent a month in the summer of 1932.

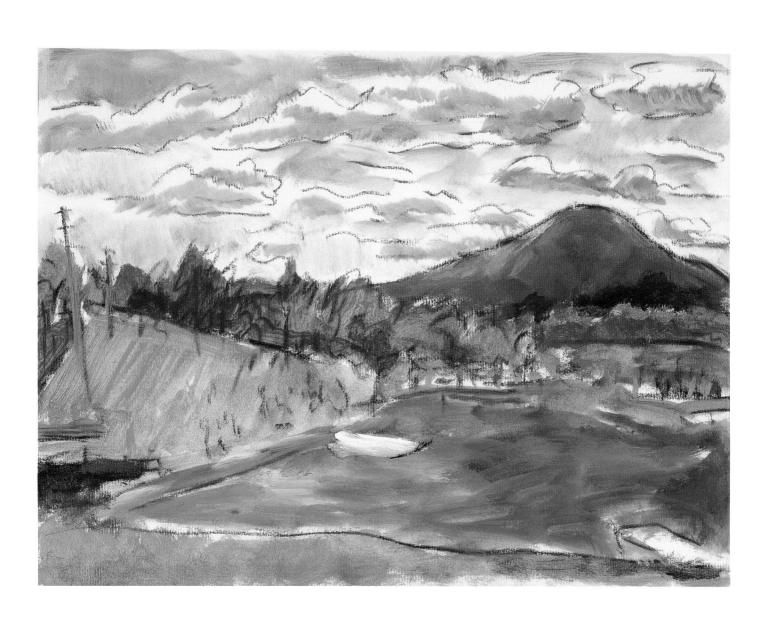

BELMONT
Oil on paper, image 9⅛ × 12¼″, 1932.

A view of Star Lake at Belmont.

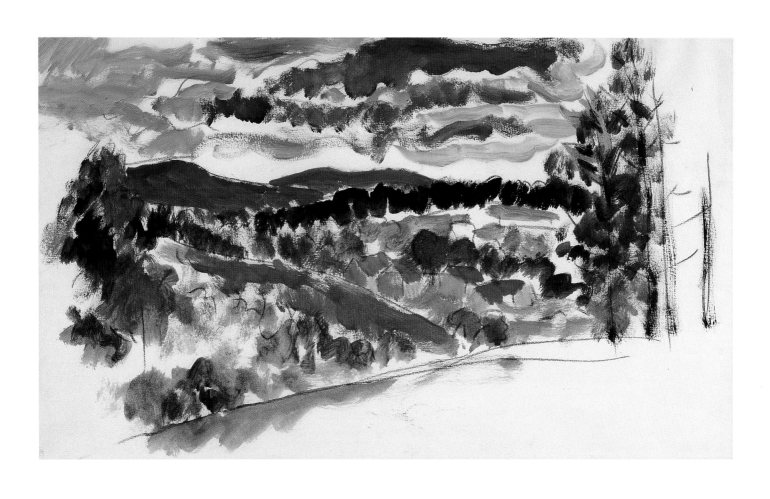

VERMONT

Oil on paper, image 10¾ × 18⅜″, 1933.

View across the Winhall Brook opposite the Rawsonville house.

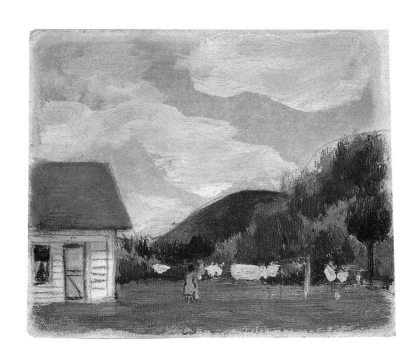

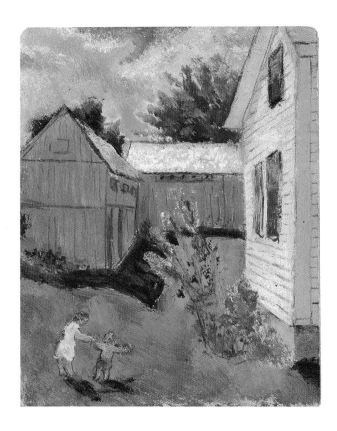

TWO VIEWS OF THE RAWSONVILLE HOUSE
Oil on cards, 3¼ × 4″ and 4 × 3¼″, 1937.

To the north the meadow and Glebe Mountain, to the south the hill house, the barn, and a corner of the house.

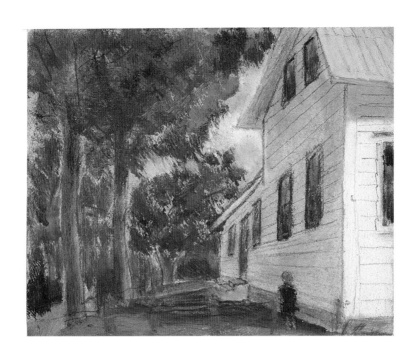

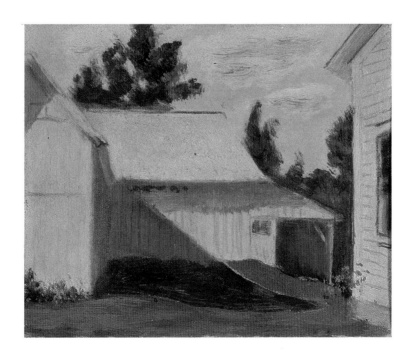

TWO VIEWS OF THE RAWSONVILLE HOUSE
Oil on cards, both 3¼ × 4″, 1937.

The river (west) side of the house and the view to the south.

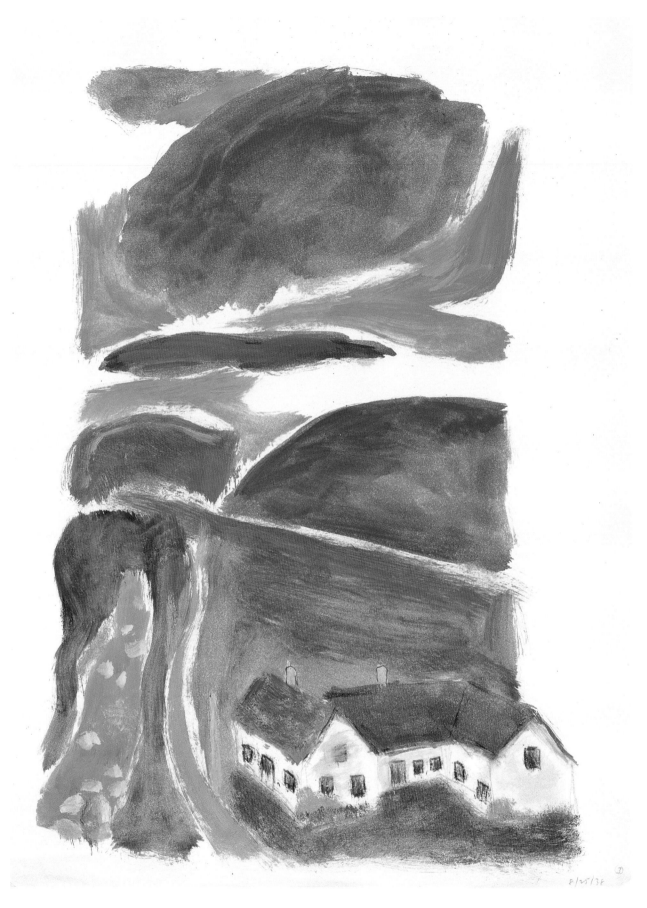

THE RAWSONVILLE HOUSE AND SURROUNDING LAND
Oil on paper, 12 × 8⅞″, August 25, 1938.

An imagined view.

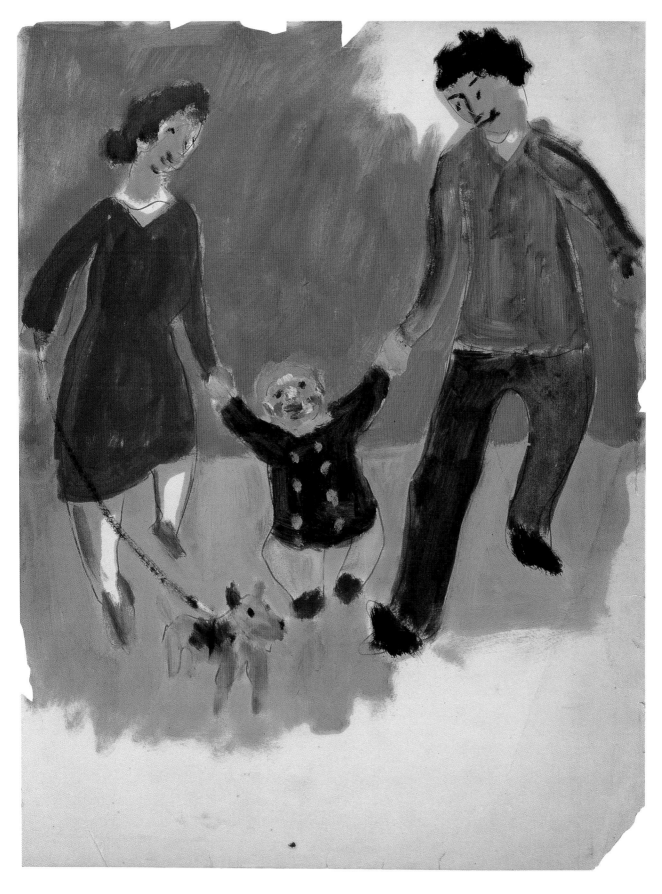

MEYER, LILLIAN, MIRIAM, AND DADA
Oil and pencil on paper, 19 × 14⅝″, 1934.

The Schapiros had lived on West 4th Street, New York, since 1932. In 1934 they moved to a rented house that they eventually bought and lived in for the rest of their lives. Miriam named the dog.

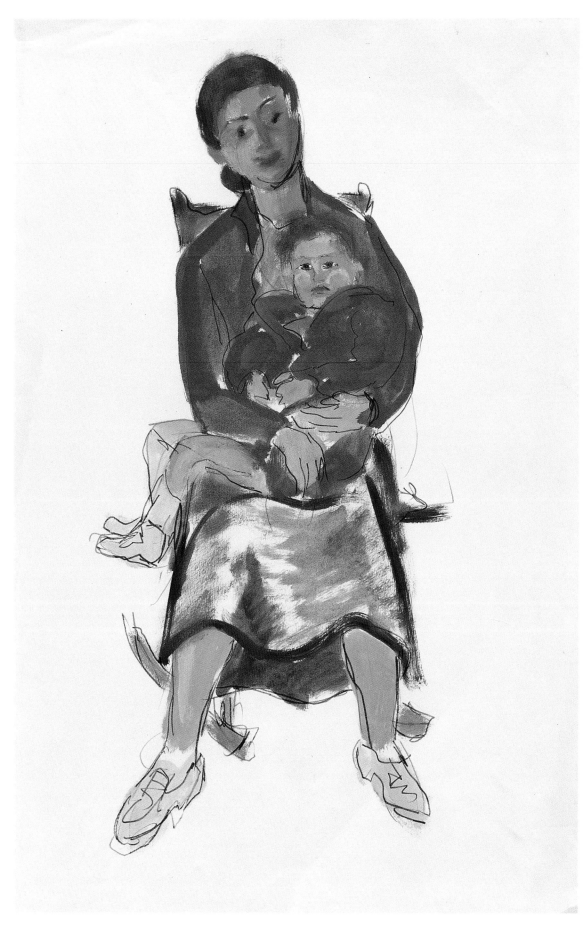

MIRIAM AND LILLIAN
Oil and pencil on paper, 19 × 12½″, 1935–36.

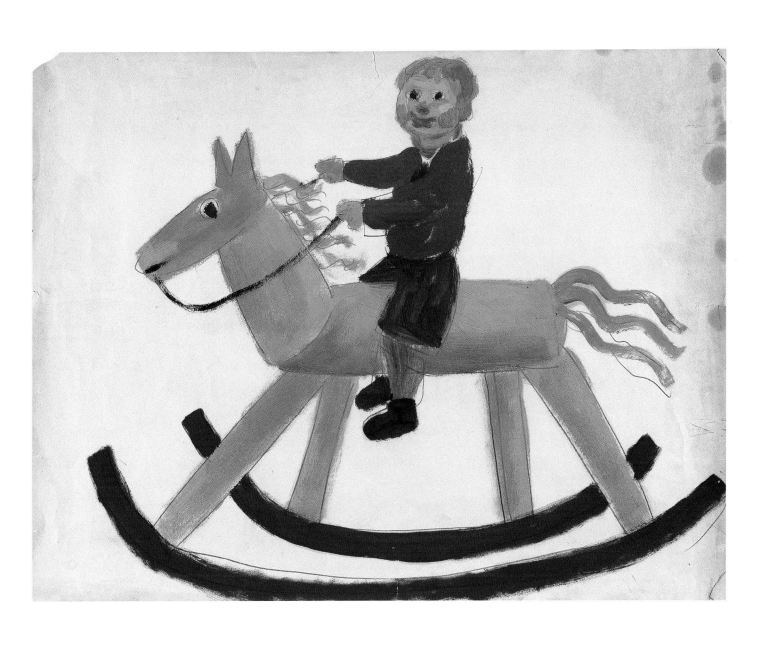

MIRIAM ON HER ROCKING HORSE
Oil and pencil on paper, 14⅝ × 19″, 1935–36.

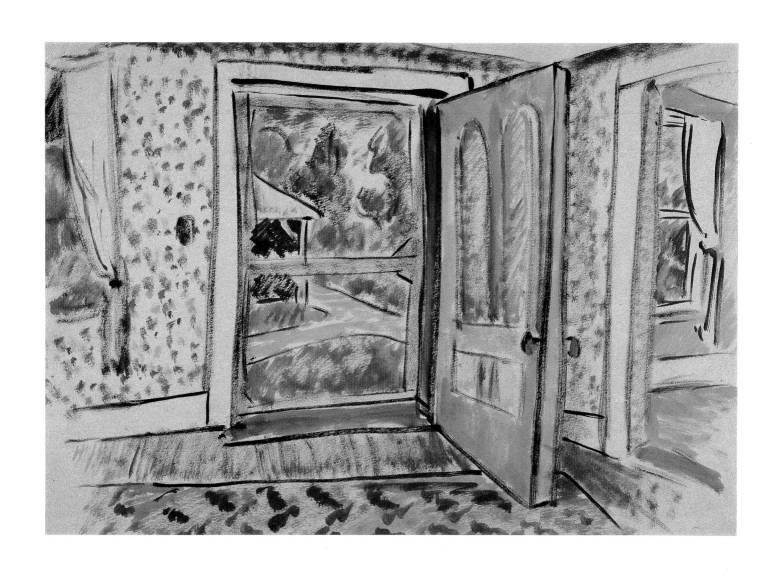

RAWSONVILLE HOUSE

Oil on paper, image 11 × 16⅛″, 1930s.

View of living room looking out the front door.

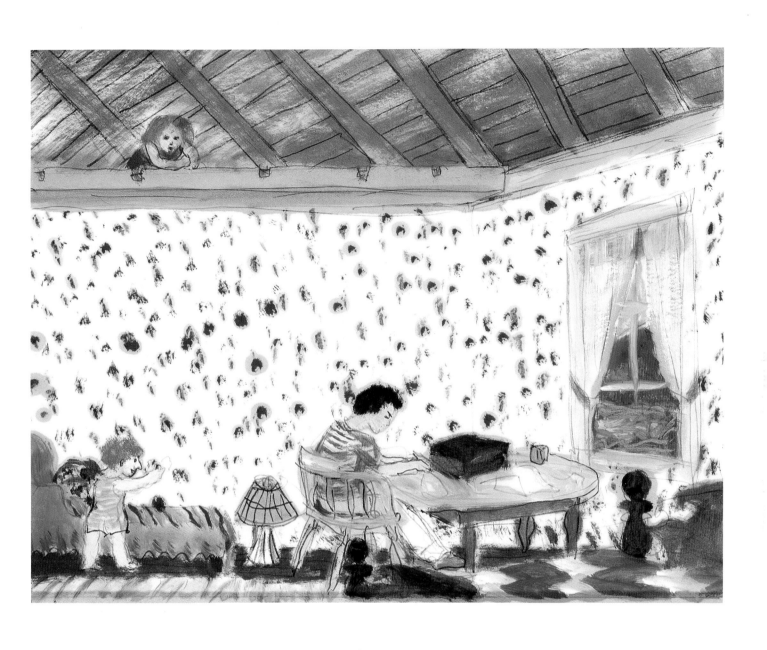

SCHOLAR AT WORK
Oil on paper, 11 × 14″, 1938.

A study room in the Rawsonville house.

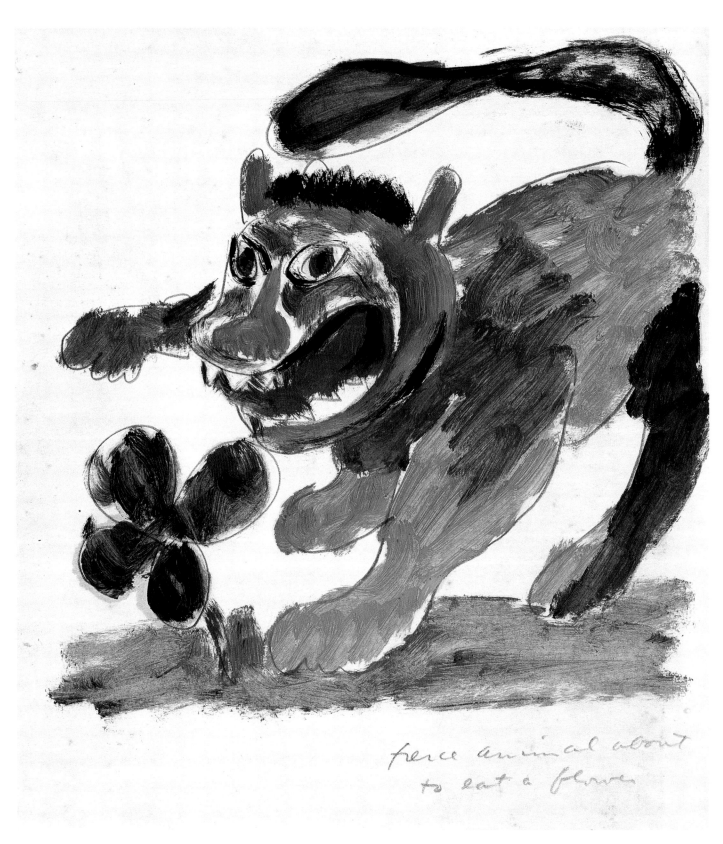

fierce animal about to eat a flower

"FIERCE ANIMAL ABOUT TO EAT A FLOWER"
Oil on paper, image 7⅞ × 8″, 1936–37.

Probably made to illustrate a story for the children.

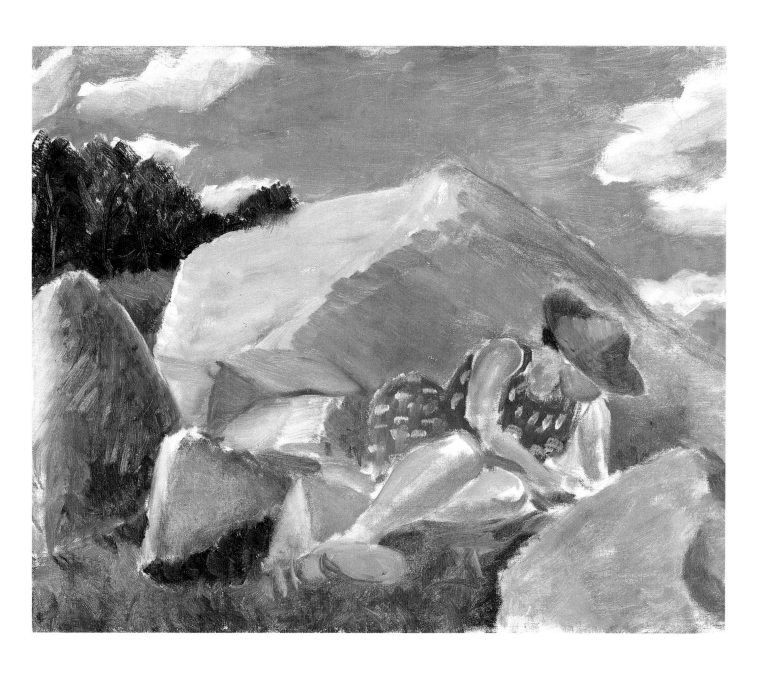

LILLIAN AND ROCKS

Oil on canvas, 18 × 22″, 1933. Collection of Laura Esterman.

The artist painted Lillian among boulders in a field near the Rawsonville house.

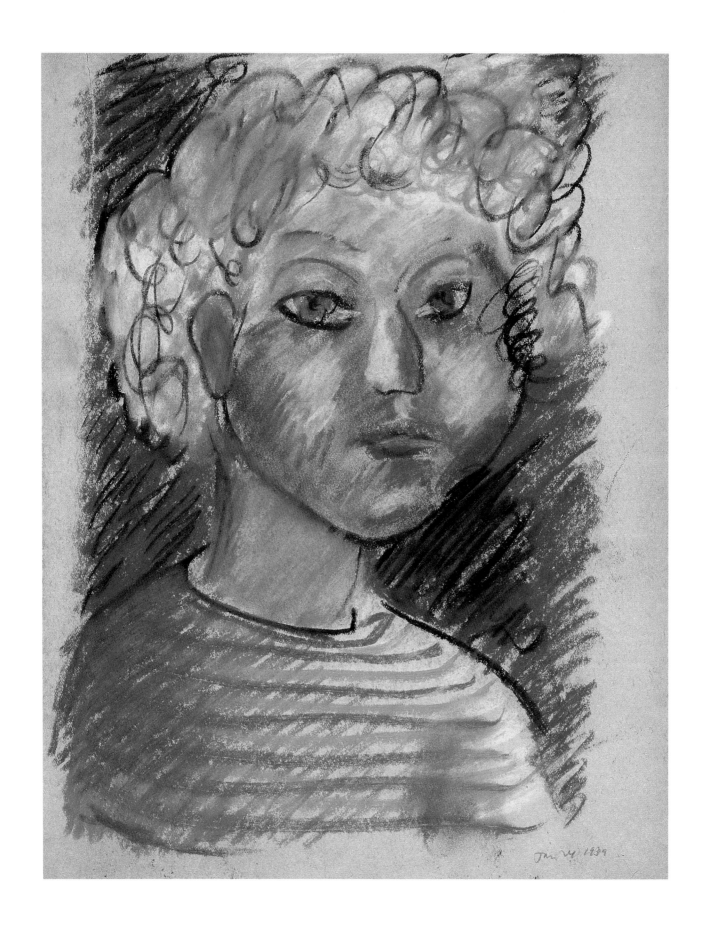

ERNEST
Pastel on paper, 11½ × 9″, January 24, 1939.

Ernest was born in May 1936. For Lillian, in 1998, this portrait "... really brings back his face. He had a great head of blond hair."

FRIGHT
Color crayons on paper, 11 × 8½″, 1930s?

"TUT, TUT, WHAT WILL DEAR OLD EUCLID SAY!"
Pencil on pink paper, image 8½ × 8½″, 1931–33.

*The Schapiros had just moved near this geographically improbable location,
the corner of West 4th and West 12th Streets.*

"MEAH ILLUSTRATION"
Pen and ink on paper, 7¼ × 5⅝″, 1930s.

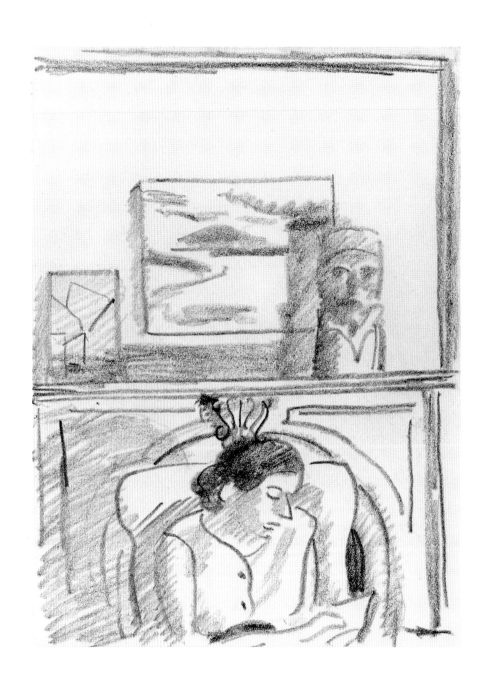

LILLIAN IN WEST 4TH STREET LIVING ROOM
Conté crayon on paper, 6⁵⁄₁₆ × 4²³⁄₃₂ ″, late 1930s.

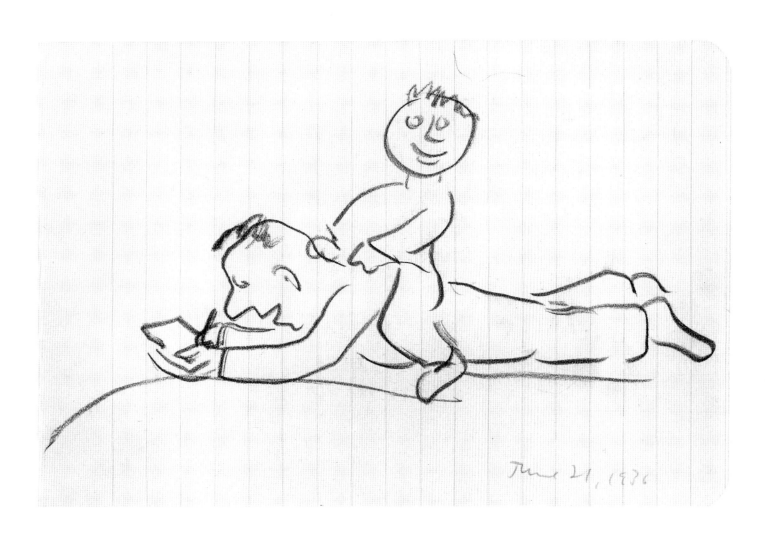

WORKING MAN AND CHILD
Pencil on paper, 5⅛ × 7¾", June 21, 1936.

The Schapiros' daughter, Miriam, was three-and-a-half.

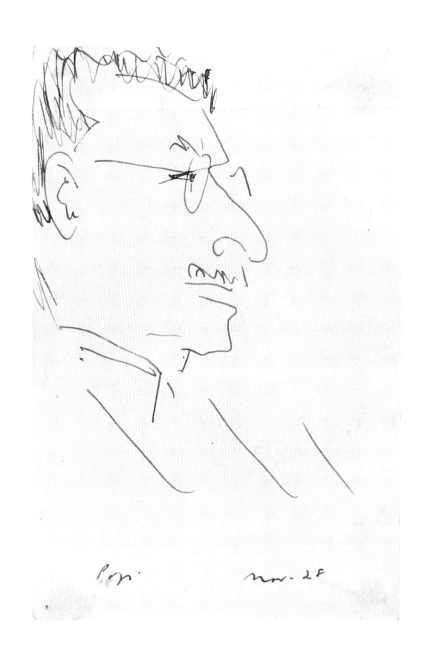

"Pop," Benjamin Milgram
Pen and ink on paper, 6 × 4″, late 1930s.

Lillian's father.

HEAD
Wood, 2¾ × 4¾ × 2¾″, 1930s.

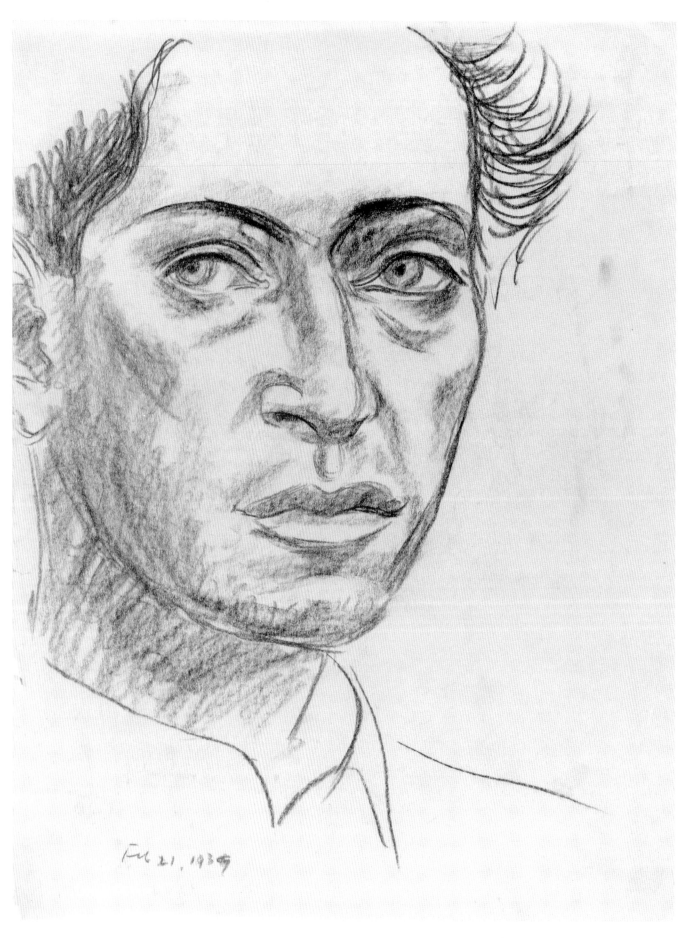

Feb 21, 1939

SELF-PORTRAIT
Conté crayon on paper, 11 × 8⅜″, February 21, 1939.

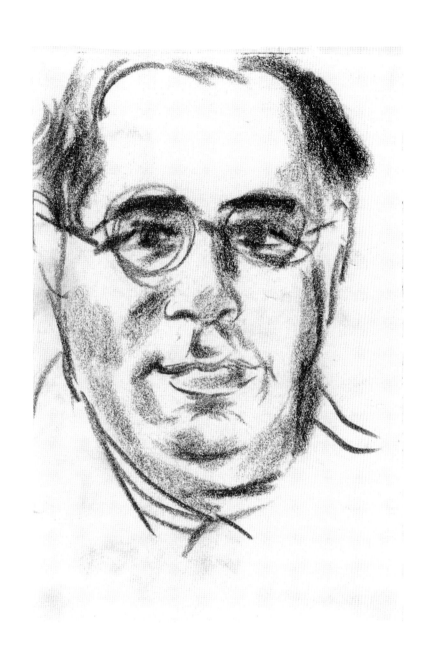

ISAIAH BERLIN
Conté crayon on paper, 6 × 4″, Vermont, 1942.

While working in the United States for the British Ministry of Information, this philosopher visited the Schapiros.

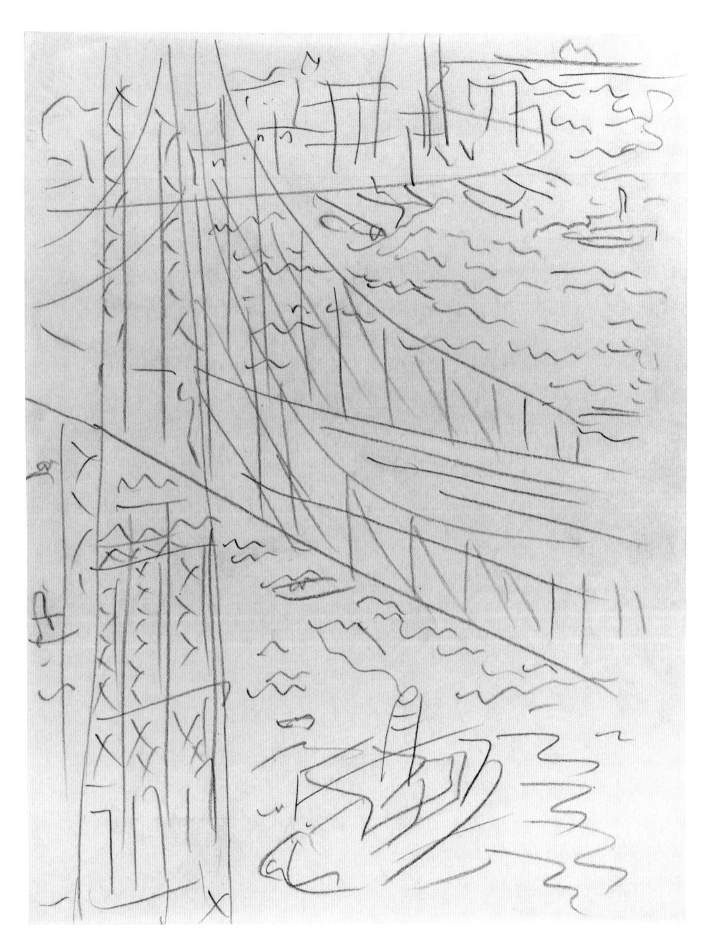

BRIDGE, EAST RIVER, NEW YORK CITY
Pencil on paper, 10½ × 8″, 1930s–40s.

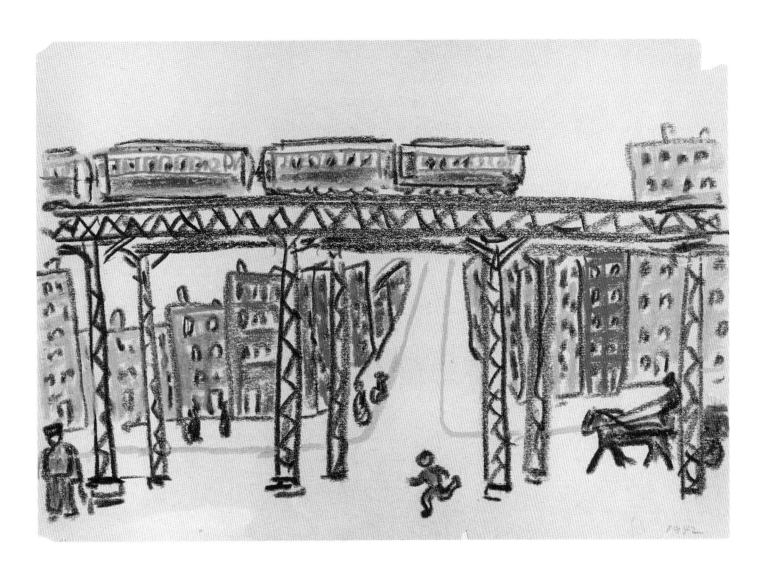

FOLLOWING FATHER'S TRAIN
Color oil pastels on paper, 8½ × 12″, 1942.

This was, evidently, a memorable occasion in the artist's childhood. One morning he ran after the elevated train his father took to work. He ran far enough to become lost and was returned home by the police.

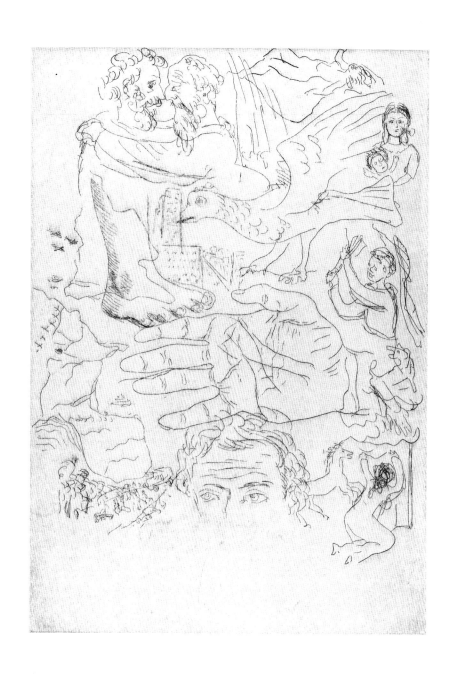

WAR AND PEACE
Etching on paper, image 6⅛ × 4⅜″, early 1940s.

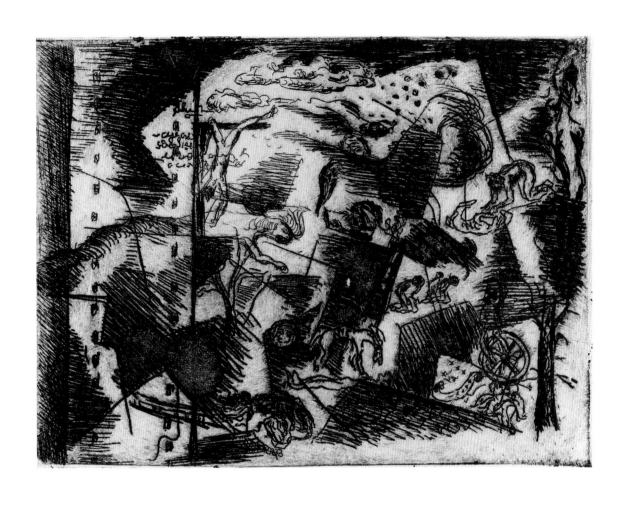

WAR ALLEGORY
Etching on paper, image 4⅜ × 5⅞″, early 1940s.

LANDSCAPE
Etching on paper, image 3¾ × 4⅞″, 1940s.

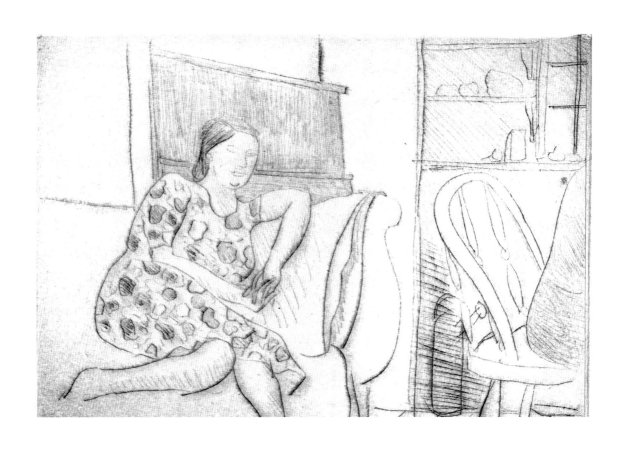

LILLIAN IN VERMONT
Etching on paper, image 4⁷⁄₁₆ × 5⁷⁄₈″, 1940s.

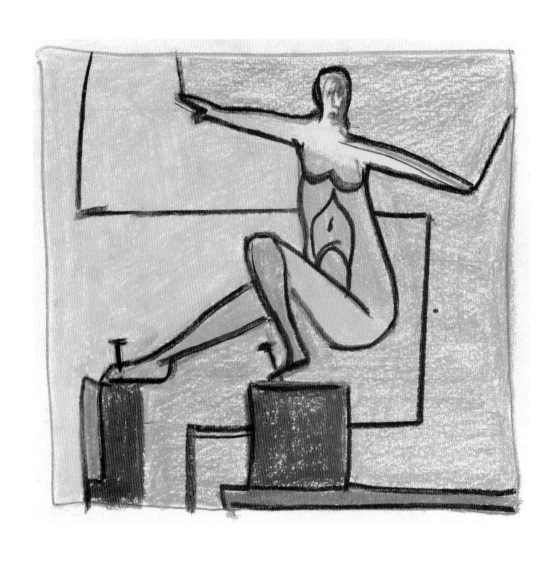

TORTURED FIGURE
Color oil pastels on paper, image 4⅞ × 5″, December 1, 1943.

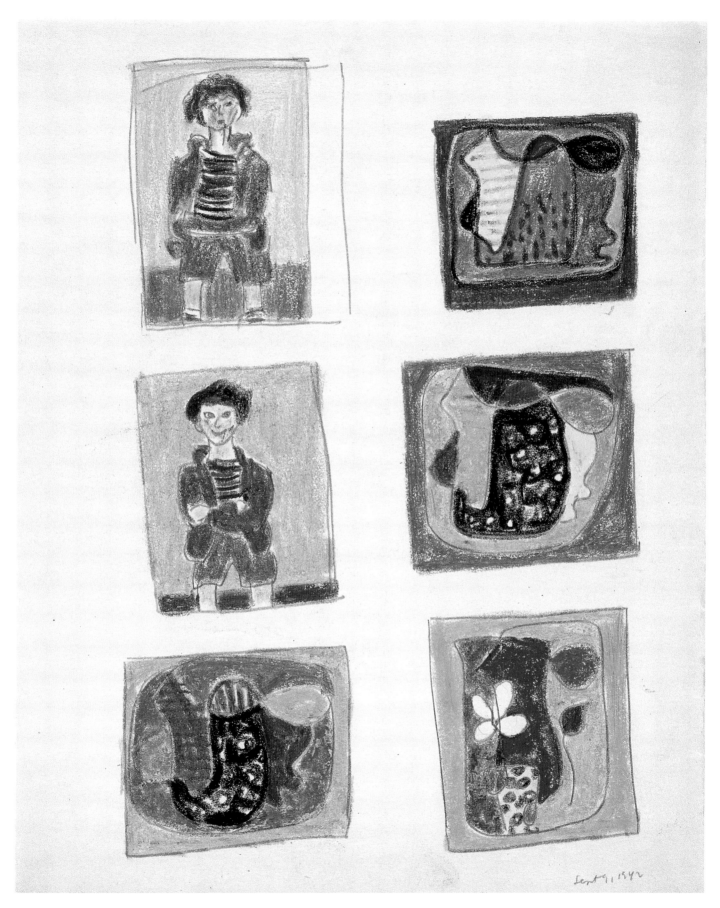

MINIATURES
Oil pastel on paper, 12 × 9″, September 9, 1942.

Includes two portraits of Ernest and four studies for an abstract painting that remained in progress for many years.

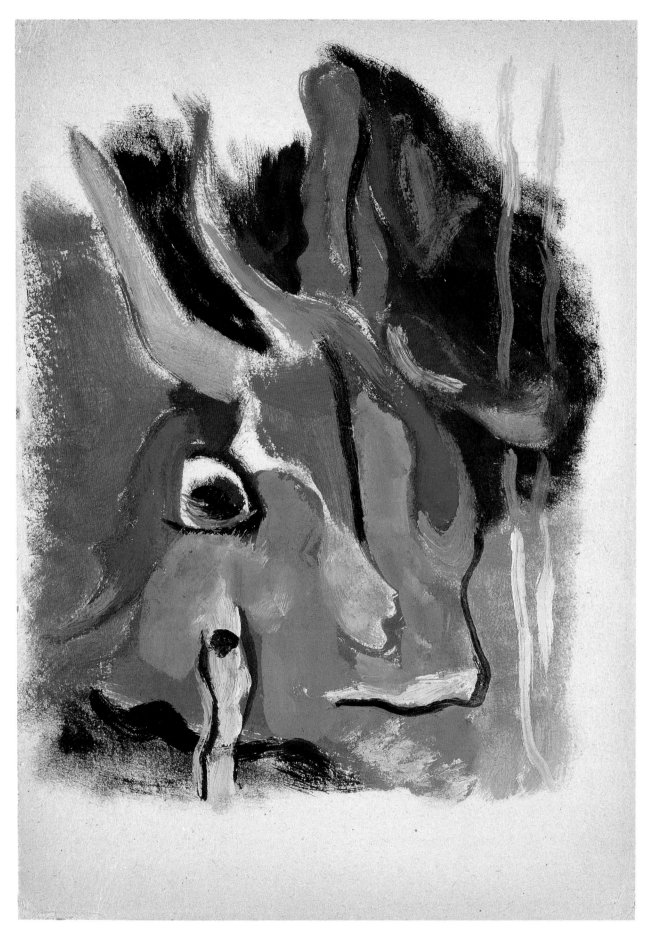

ABSTRACTION
Oil on cardboard, 9⅝ × 6⅞″, 1930s.

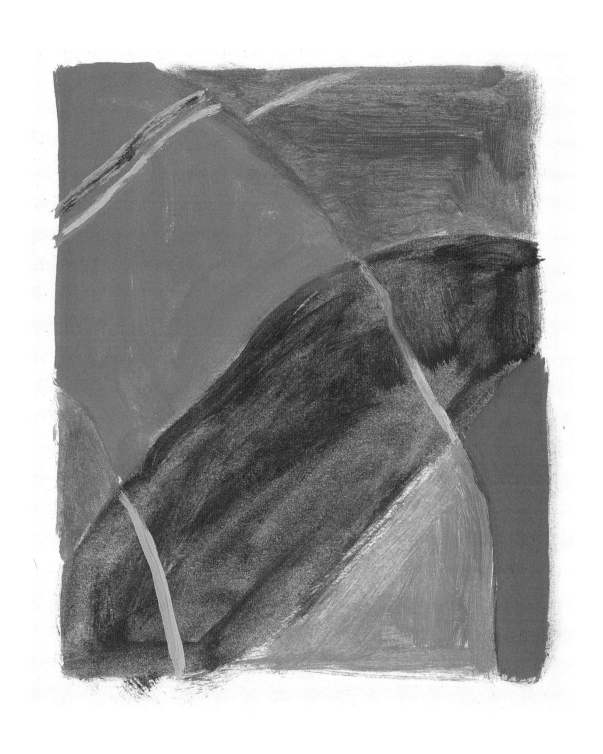

ABSTRACTION #5
Oil on paper, image 6¼ × 5⅜″, 1938.

ABSTRACTION, TRIANGLES
Oil on paper, image 7¾ × 6¾″, c. 1942.

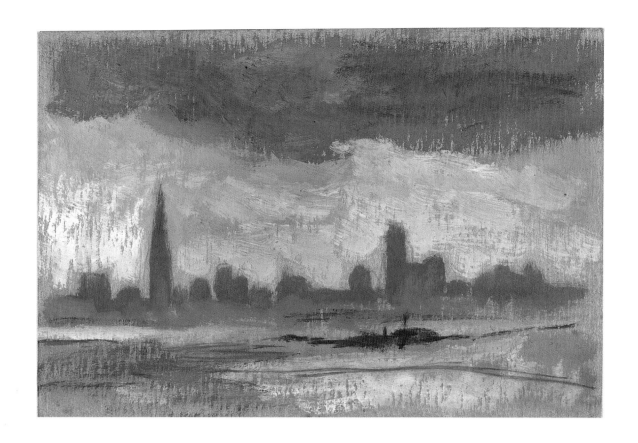

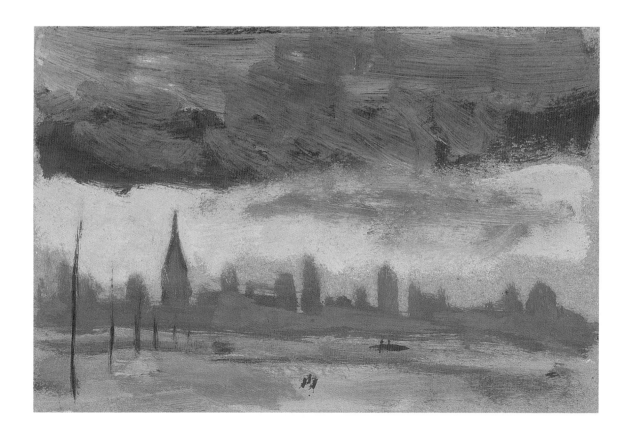

TWO VIEWS OF NEW YORK FROM QUEENS
Oil on cards, 4¹⁄₁₆ × 6⅛″, November 1940.

Inscribed later, on back, "after returning from my father's burial in Queens cemetery."

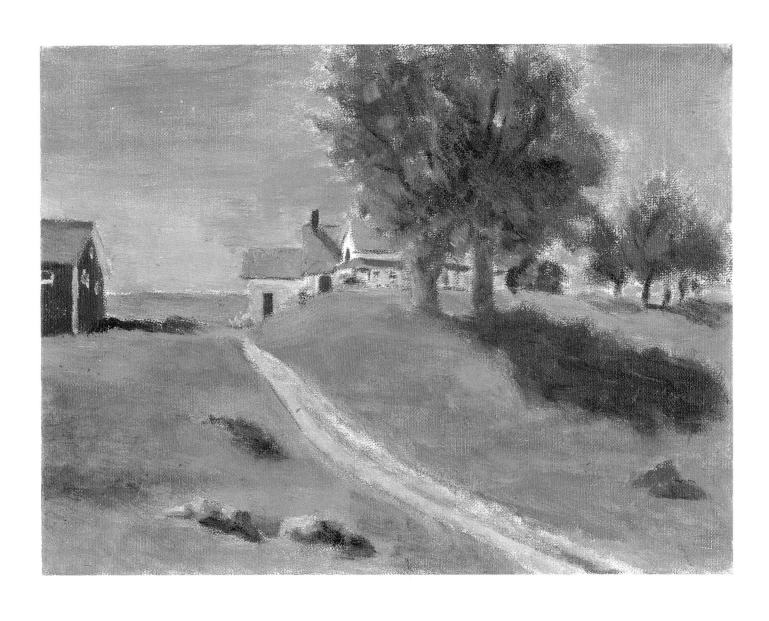

HOSLEY HOUSE, RAWSONVILLE, VERMONT
Oil on canvas board, 9 × 12 ″, 1940s.

This house is up the road from the Schapiros' house and is striking for its position on a hill.
The artist gave this picture to Mrs. Hosley and after her death asked to have it returned.

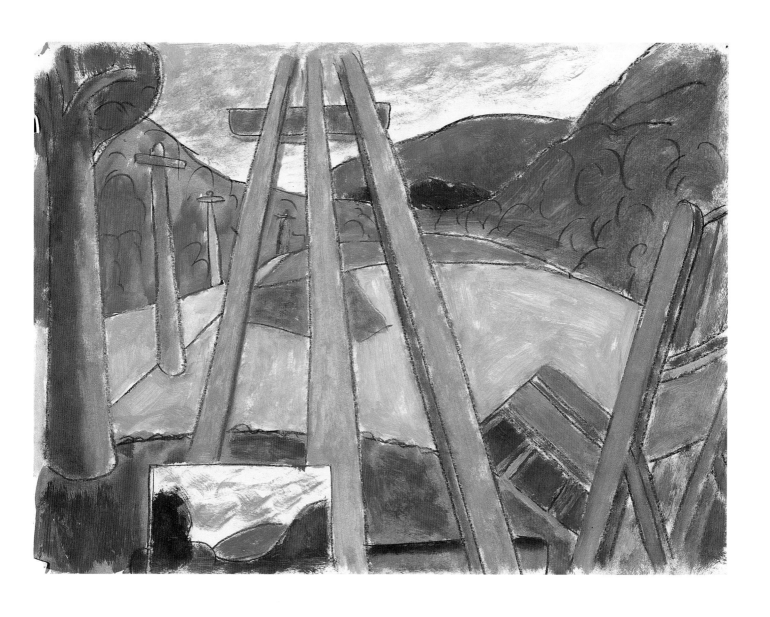

RAWSONVILLE, MEADOW AND GLEBE MOUNTAIN
Charcoal and oil on paper, 11 × 15″, 1940s.

This is a view the artist painted many times, but here, uniquely, with his easel and a folding beach chair.

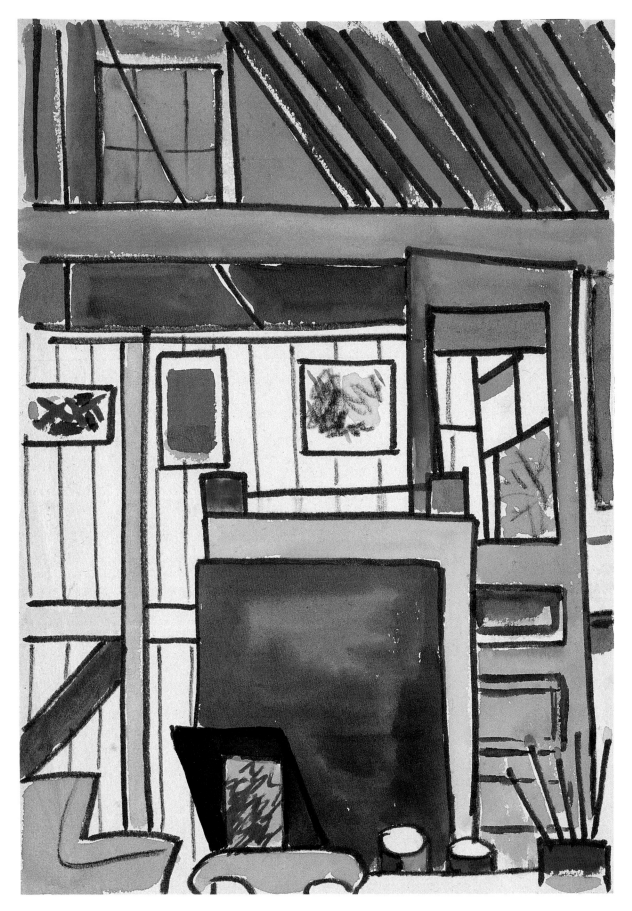

RAWSONVILLE, HILL HOUSE STUDIO, INTERIOR
Marker and watercolor on paper, 12 × 8½″, 1950s.

The hill house was the artist's studio and one of his workplaces.

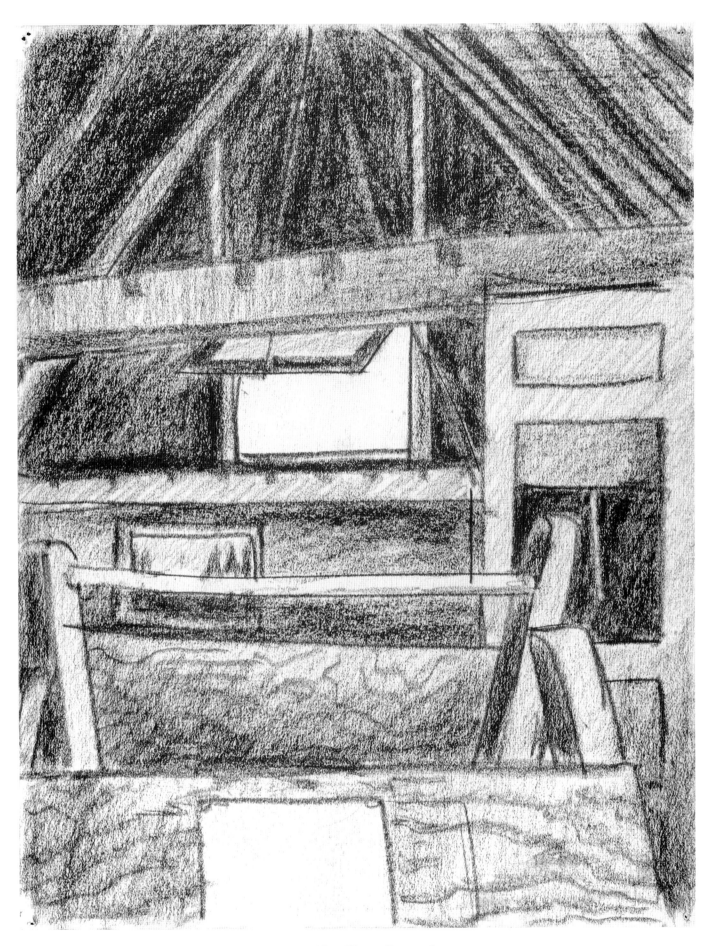

RAWSONVILLE, HILL HOUSE STUDIO, INTERIOR
Conté crayon on paper, 11 × 9½″, July 21, 1949.

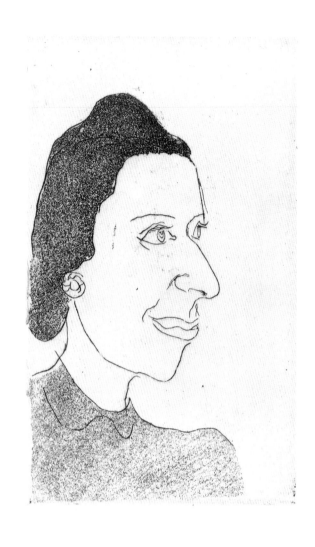

Arlette S[eligmann]
Etching and aquatint on paper, image $4^{15}/_{16} \times 2^{15}/_{16}''$, 1940s.

Wife of Kurt Seligmann, an artist and friend. Whenever Schapiro visited
the Seligmanns, he was usually given a plate to engrave.

170

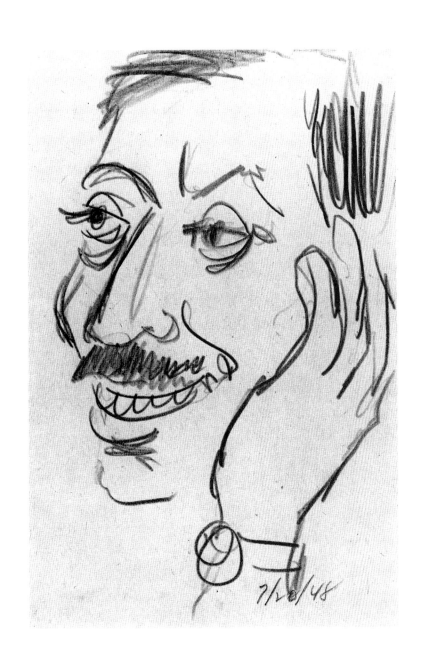

DR. JOSEPH MILGRAM
Pencil on paper, 6 × 4″, July 20, 1948.

Lillian's older brother, whom the artist had known since about 1919,
when they shared Joe's darkroom in the Milgram bathroom.

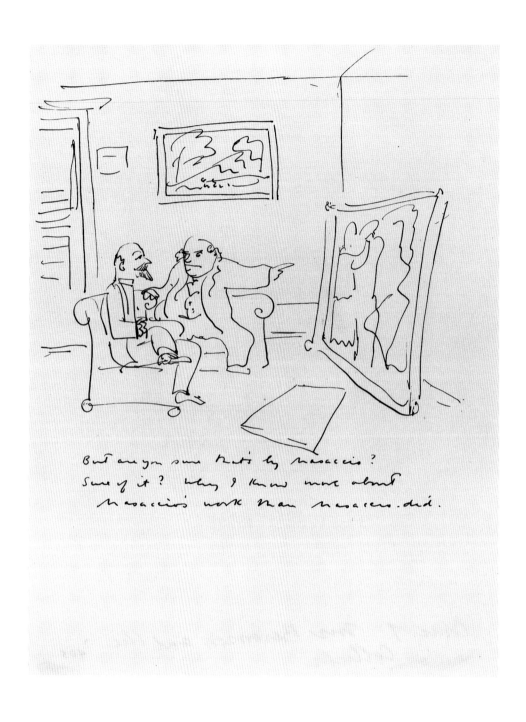

MR. BERENSON AND THE COLLECTOR
Pen and ink on paper, 6¾ × 5⁵⁄₁₆″, 1940s.

"But are you sure that's by Masaccio? Sure of it? Why I know more about Masaccio's work than Masaccio did."

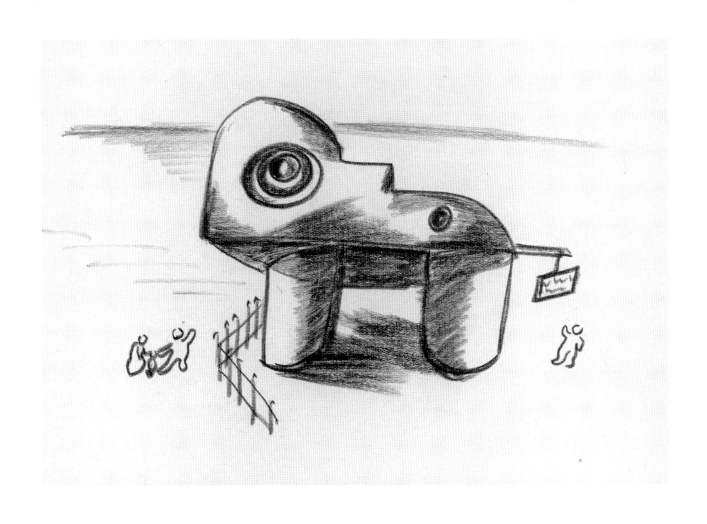

EXPLORERS IN THE DESERT
Conté crayon on paper, image 3½ × 5⅞″, 1940s.

The archaeologist is amazed to find a sign already on the monument.

RAWSONVILLE, KITCHEN
Pen and ink on paper, image 6⅜ × 10″, 1949.

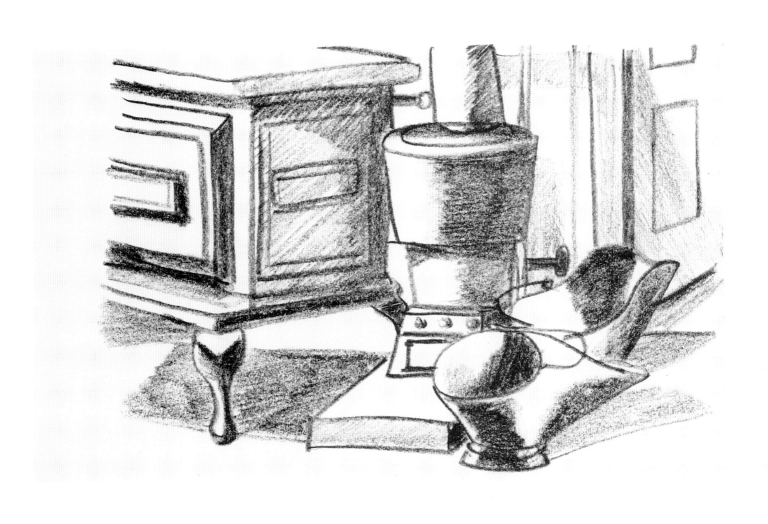

RAWSONVILLE KITCHEN
Conté crayon on paper, 5 × 8⅛″, 1950s.

175

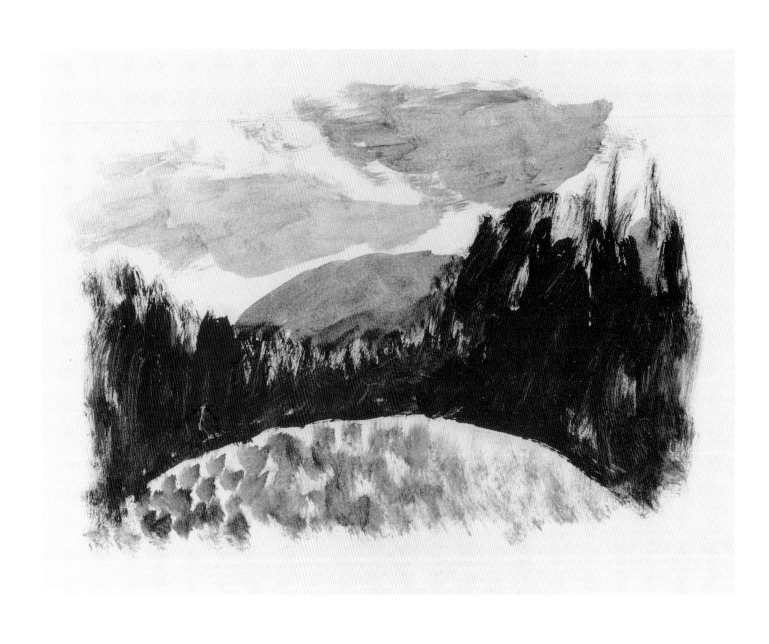

RAWSONVILLE, THE MEADOW AND GLEBE MOUNTAIN
Oil on paper, image 4⅞ × 6¾″, 1949.

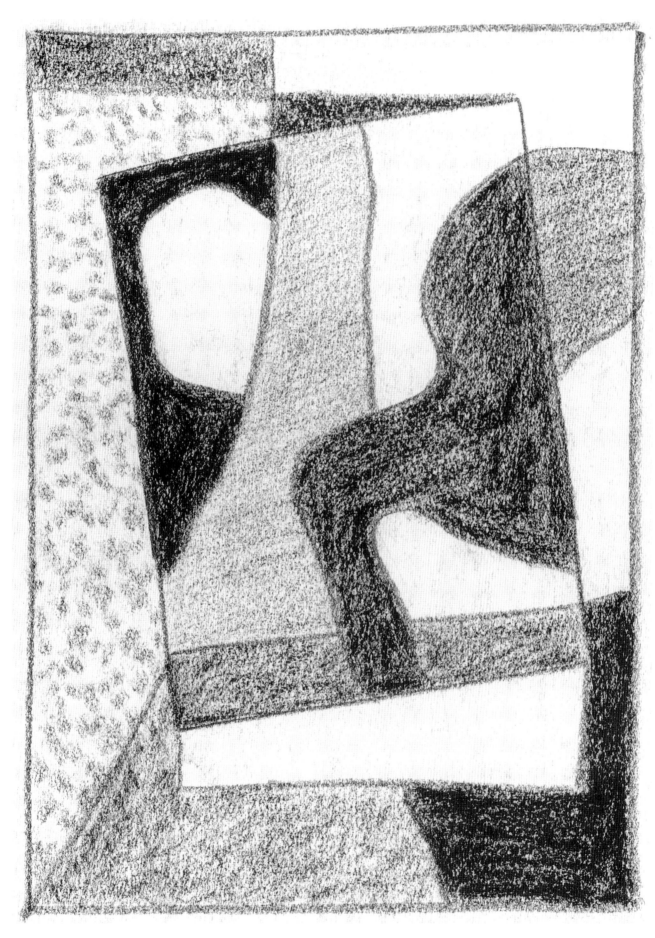

OVERLAPPING PERSPECTIVE
Conté crayon on paper, image 9¼ × 6⅝″, 1949.

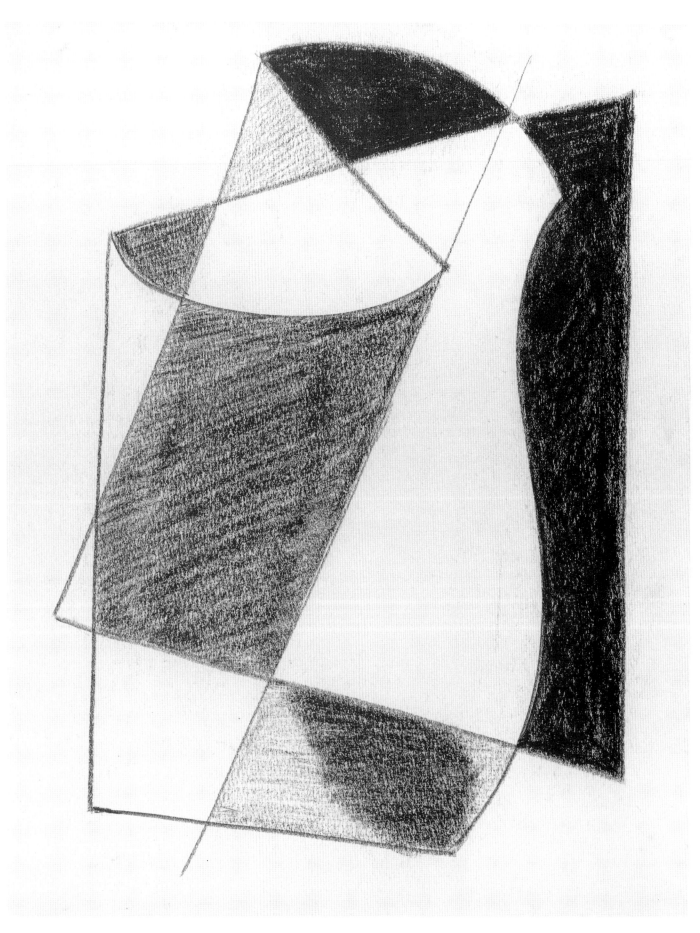

ABSTRACTION #2
Conté crayon on paper, 11½ × 9″, 1949.

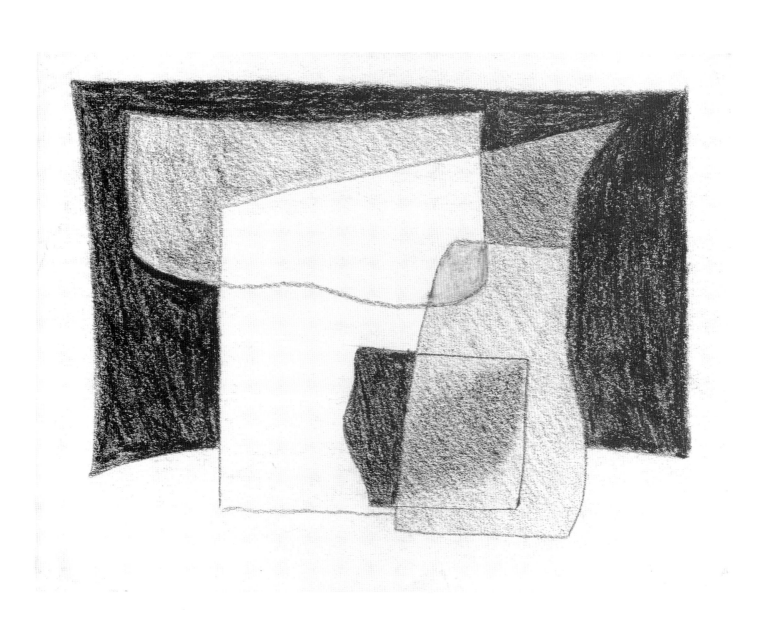

ABSTRACT STILL LIFE
Conté crayon on paper, 9 × 12 ″, 1949.

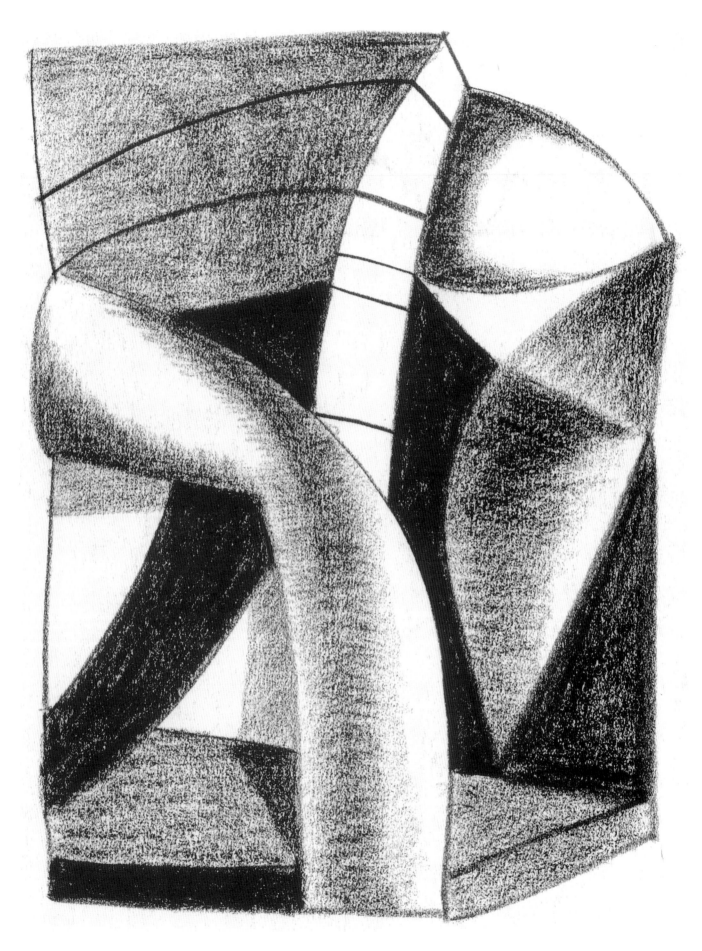

ABSTRACTION
Conté crayon on paper, image 9⅝ × 7⅛″, 1949. Collection of Daniel Esterman.

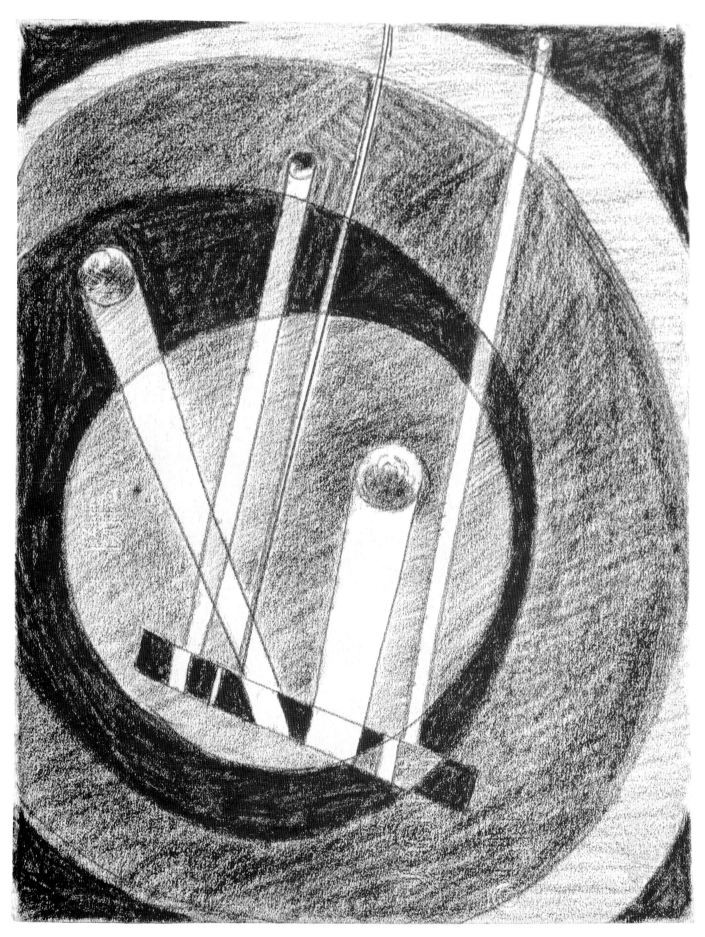

ABSTRACTION, CIRCLES AND TUBES
Conté crayon on paper, 11½ × 9″, 1950s.

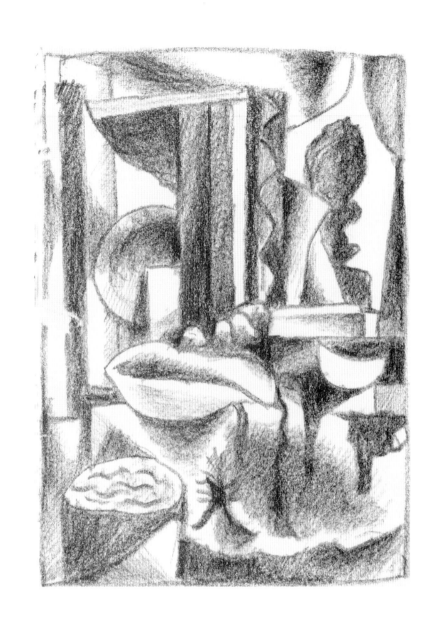

ABSTRACT INTERIOR
Conté crayon on paper, image 5⅝ × 4″, 1950s.

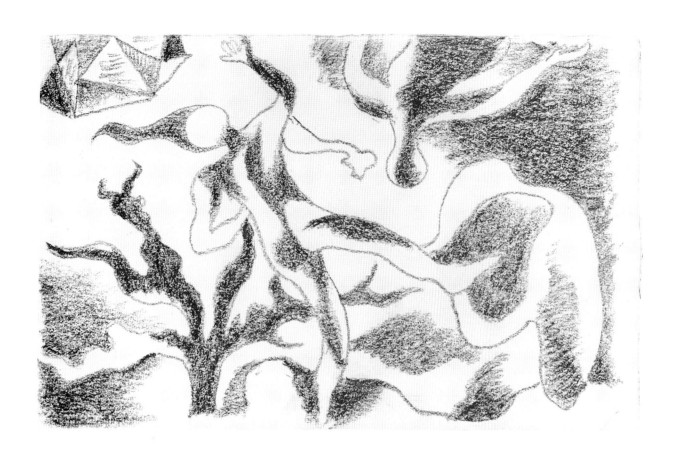

SURREAL FIGURE
Conté crayon on paper, 4⅛ × 6½″, 1940s–1950s.

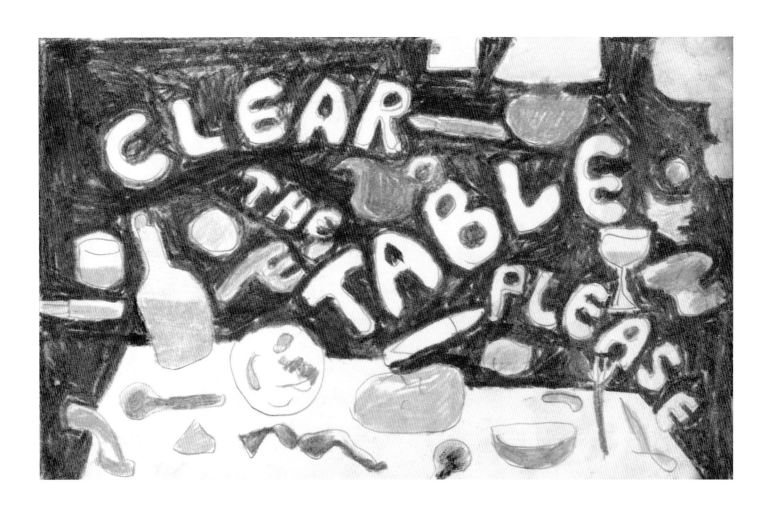

CLEAR THE TABLE PLEASE
Pencil and color marker on paper, 5 × 8″, 1950s.

When guests were dining at Rawsonville this was a reminder to Meyer,
from an overburdened Lillian, that she needed help.

ABSTRACTION, SHAPES ON A TABLE
Oil on paper, image 5 × 7½″, 1940s?

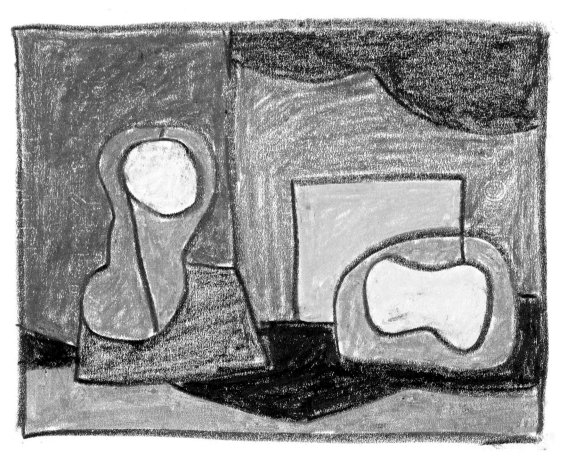

ABSTRACT STILL LIFE #4 AND #5
Oil pastel on paper, images 6½ × 8½″ and 7 × 9″, 1940s or 1950s.

186

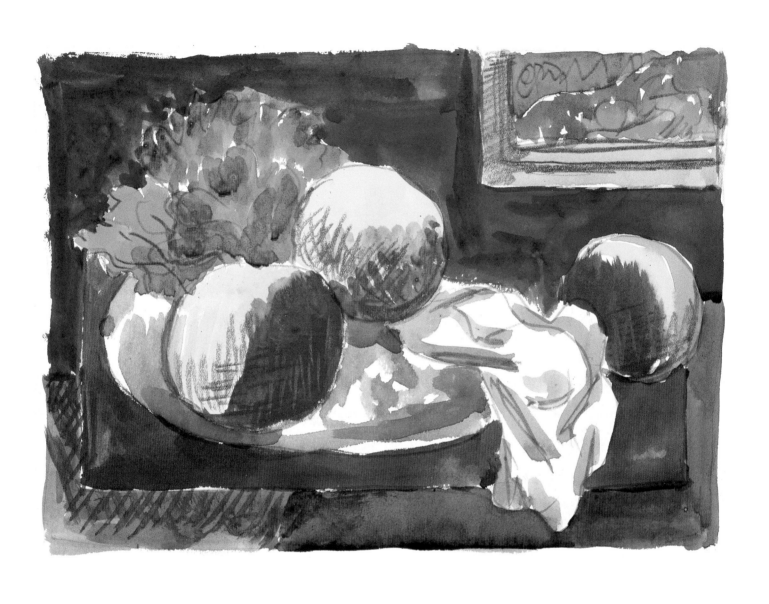

STILL LIFE WITH FRUIT
Watercolor on paper, image 6¼ × 8¾″, 1940s or 1950s

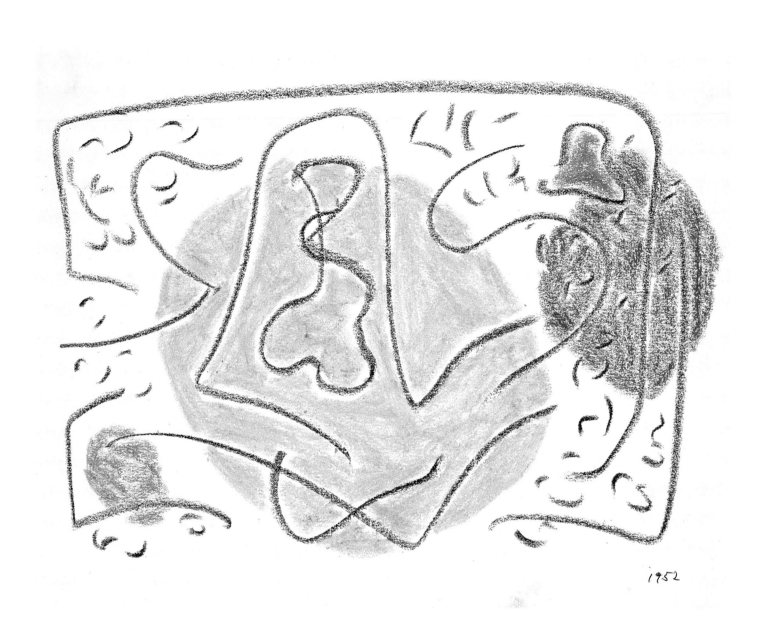

1952

ABSTRACTION, BLACK LINES OVER COLOR OVALS
Oil pastel on paper, 9 × 11½″, 1952.

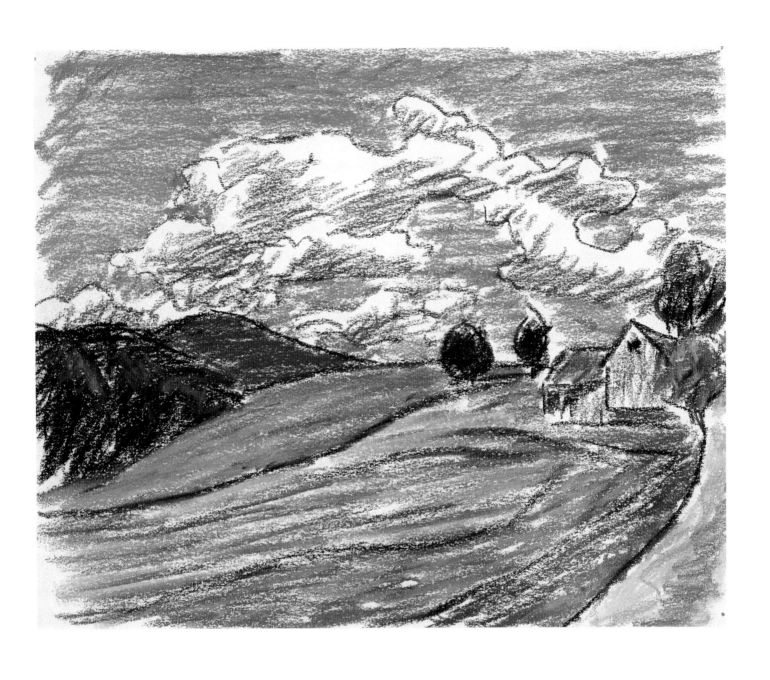

RAWSONVILLE
Oil pastel on paper, image 7¾ × 9½″, early 1950s.

The house from the north.

189

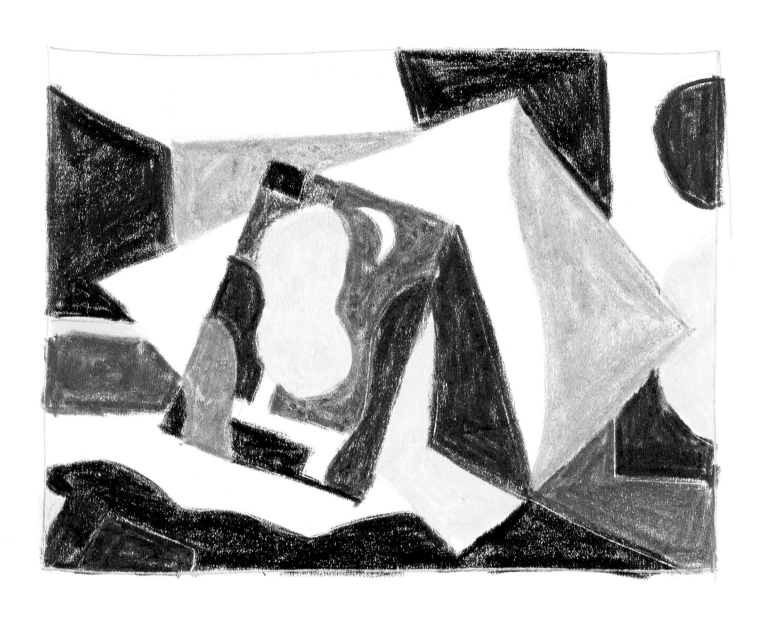

ABSTRACTION
Oil pastel on paper, image 6⅛ × 8⅛″, 1950s.

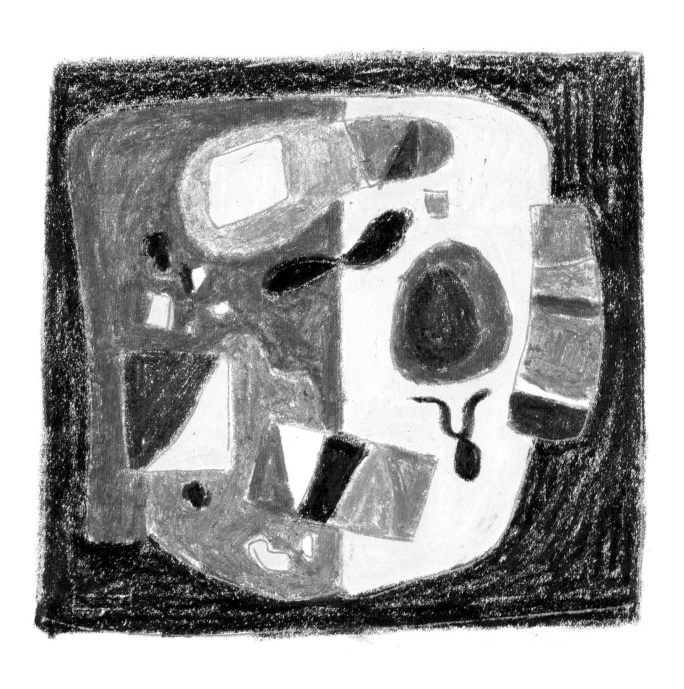

ABSTRACTION
Oil pastel on paper, image 6¼ × 6¾″, 1950s.

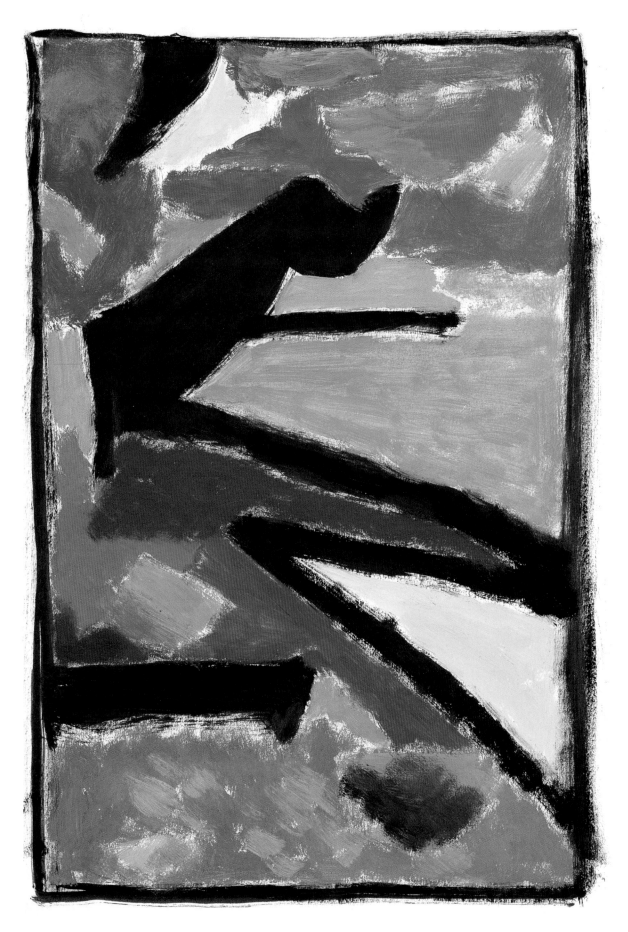

ABSTRACTION #2
Oil on paper, image 12¼ × 8¼″, August 13, 1958.

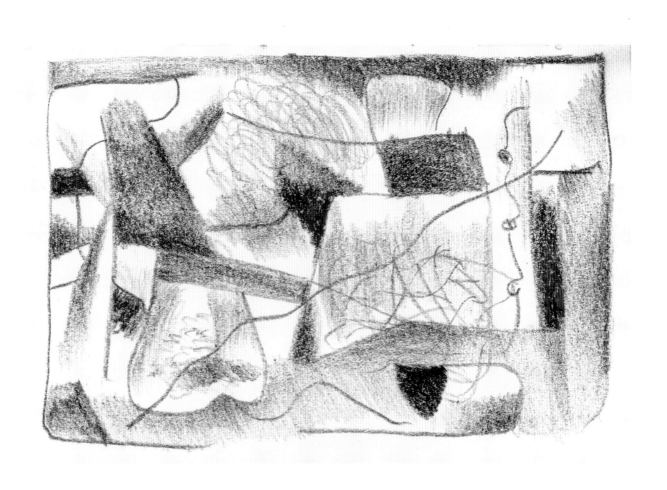

SURREAL LANDSCAPE
Conté crayon on paper, 4⅜ × 6¾″, 1950s.

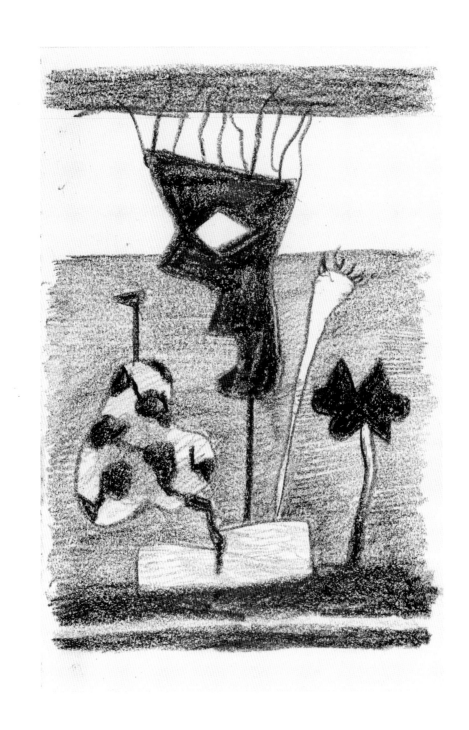

SURREAL PLANTS
Conté crayon on paper, 6¾ × 4⅜″, 1950s.

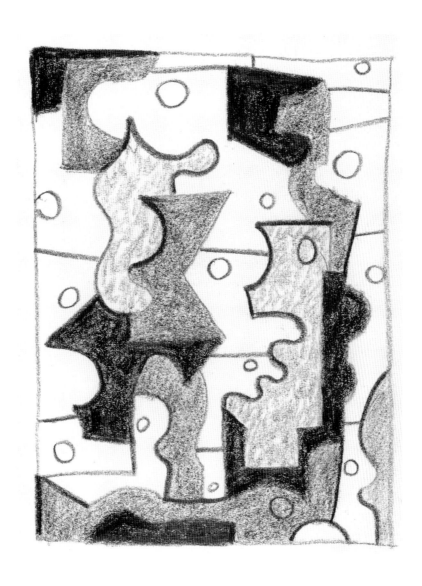

ABSTRACTION
Conté crayon on paper, image 5¼ × 4″, 1950s.

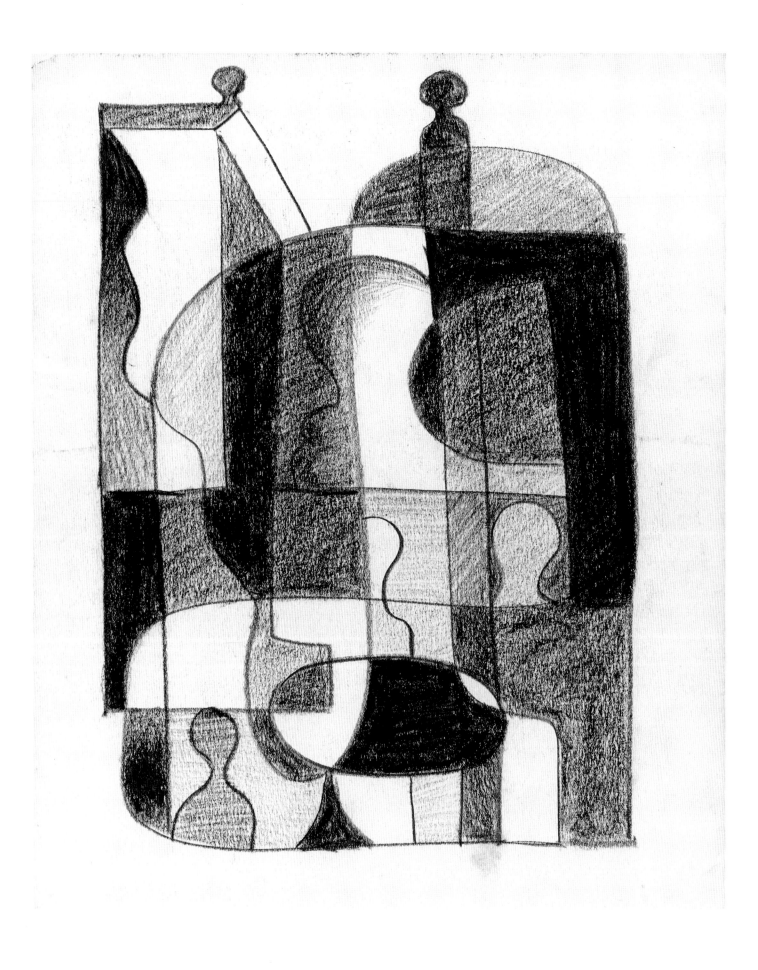

ABSTRACTION
Conté crayon on paper, image 9¹³⁄₁₆ × 7″, 1950s?

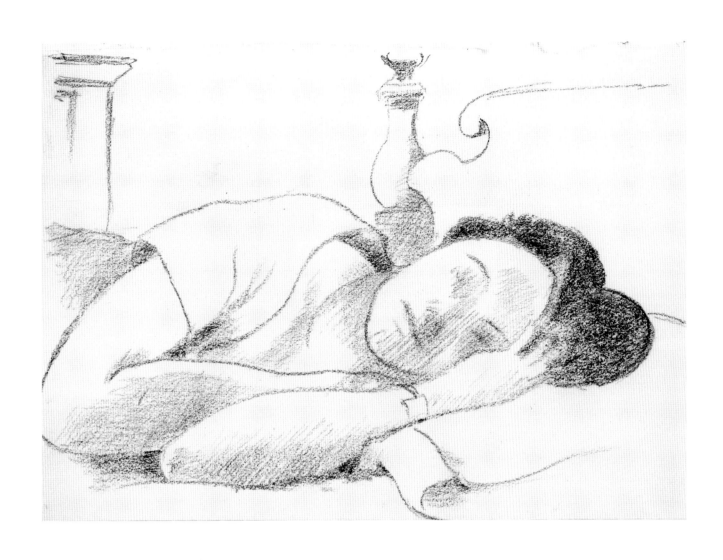

LILLIAN ASLEEP
Conté crayon on paper, 5 × 7″, New York, August 17, 1959

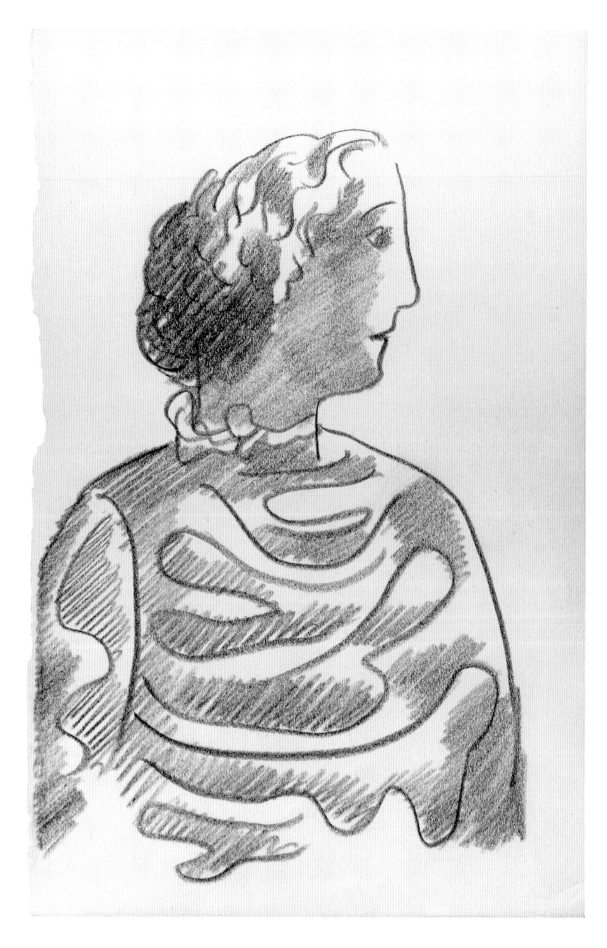

LILLIAN
Conté crayon on paper, 9¼ × 6″, Spring 1952.

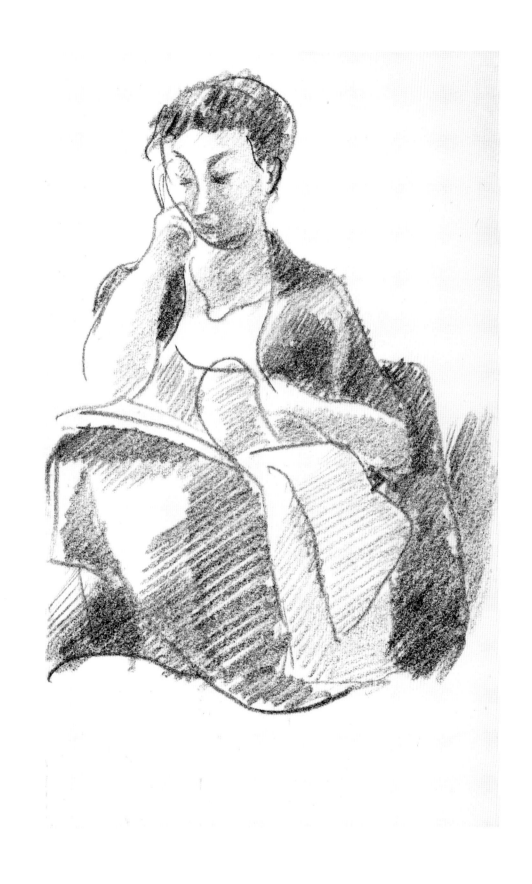

LILLIAN
Conté crayon on paper, 8⅛ × 5″, 1950s.

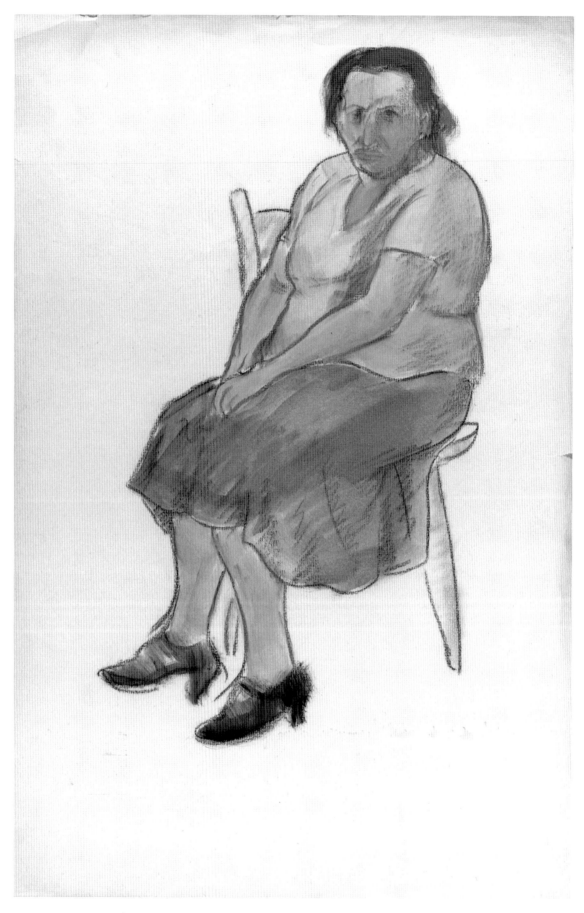

DORA MILGRAM
Conté crayon and oil (color) 19 × 12⅝″, 1940s–1950s

Lillian's mother was a collector of antiques and jewelry, whose taste and judgment the artist much admired.

RAWSONVILLE, HILL HOUSE, CRAB APPLE
Marker on paper, 12¾ × 10⅝″, 1959.

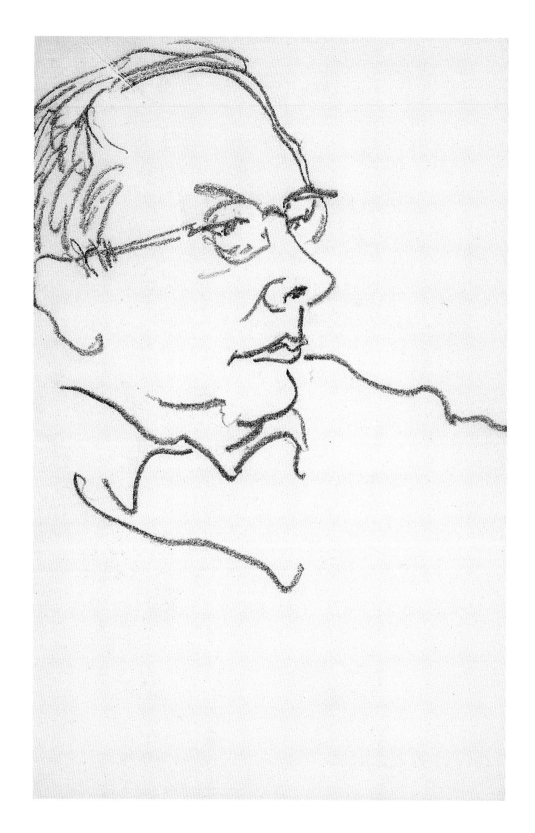

IRVING HOWE
Crayon on paper, 8 × 5¼″, 1960s? Collection of Ilana Howe.

*A friend, writer on literature and politics, who, with the artist and
several others, founded* Dissent *magazine.*

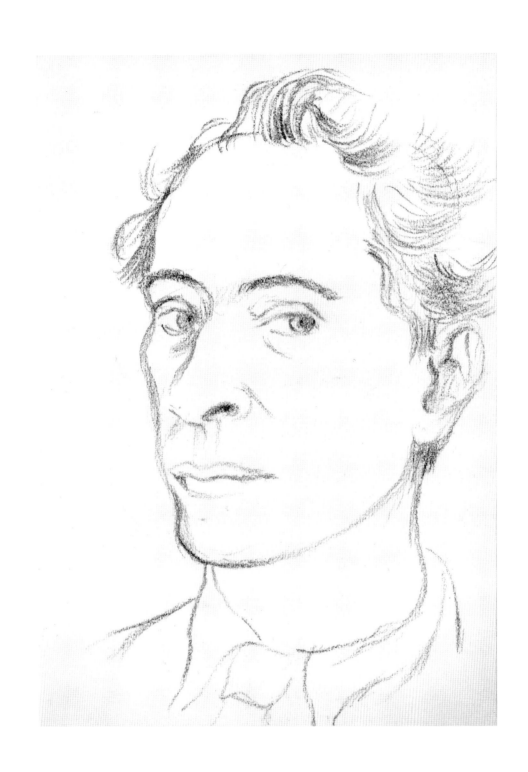

SELF-PORTRAIT
Conté crayon on paper, 7 × 5 ″, October 23, 1960.

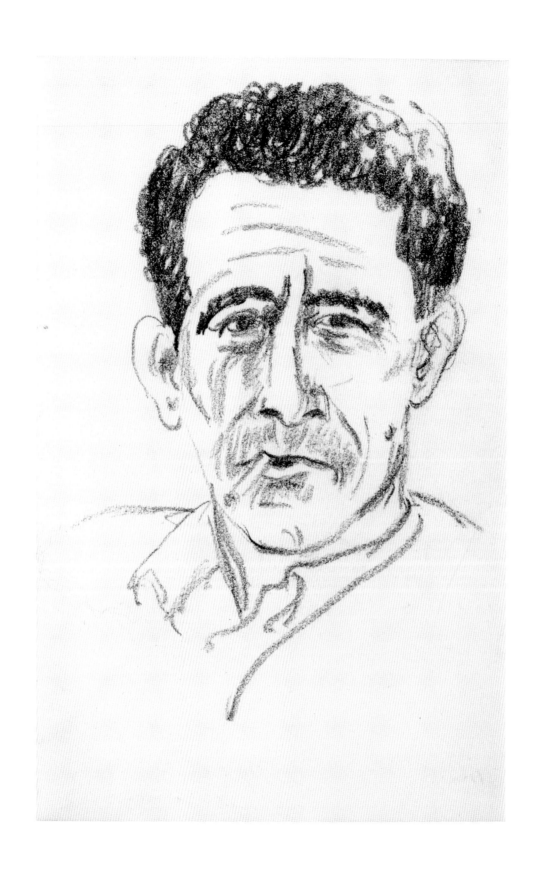

Conté crayon on paper, 8 × 5¼″, Vermont, August 22, 1963.

Playwright.

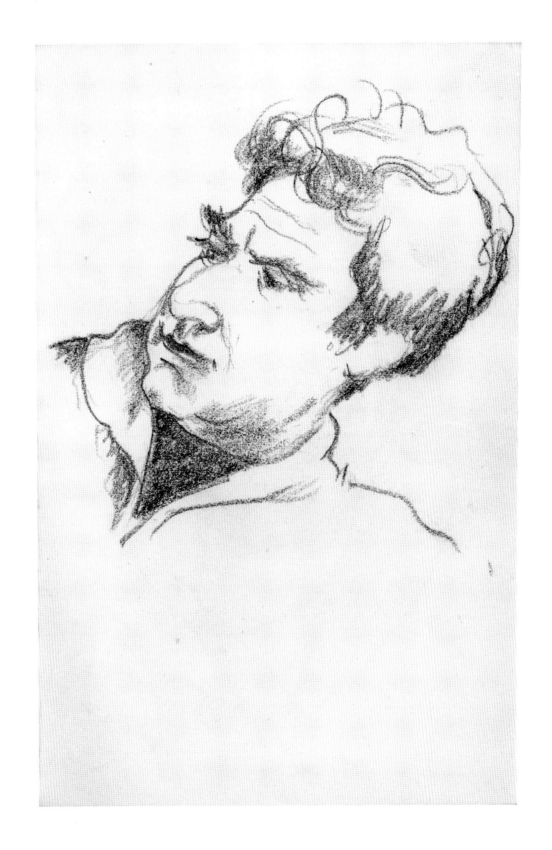

Conté crayon on paper, 8 × 5¼″, Vermont, September 12, 1963.

Artist.

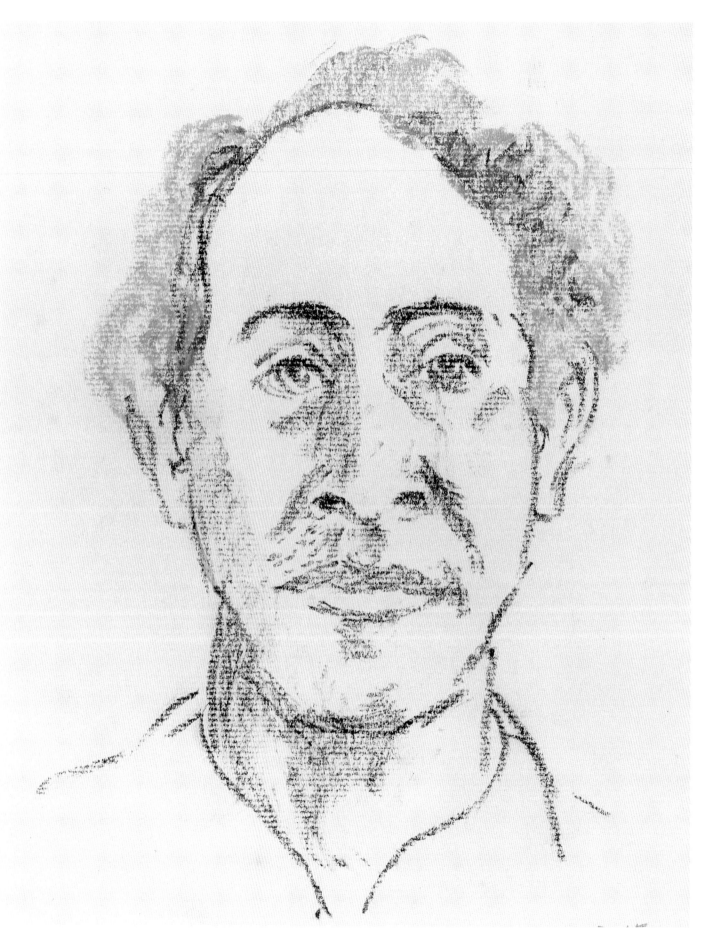

SELF-PORTRAIT
Conté crayon on paper, image 9¼ × 6¼″, August 17, 1965.

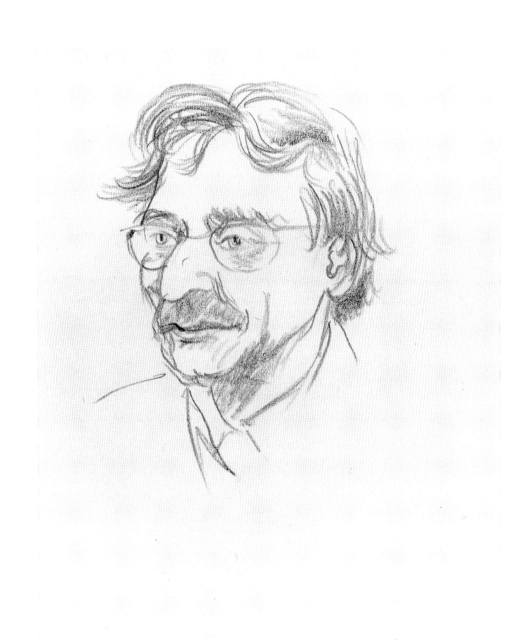

Pencil on paper, image 4¼ × 3⅝″, January 22, 1964.

French philosopher.

HYDE SOLOMON
Oil and charcoal on paper, 20½ × 14¼″, Summer 1958.

This portrait of his friend, the artist, was made while both were at Yaddo, the artists' colony in upstate New York.

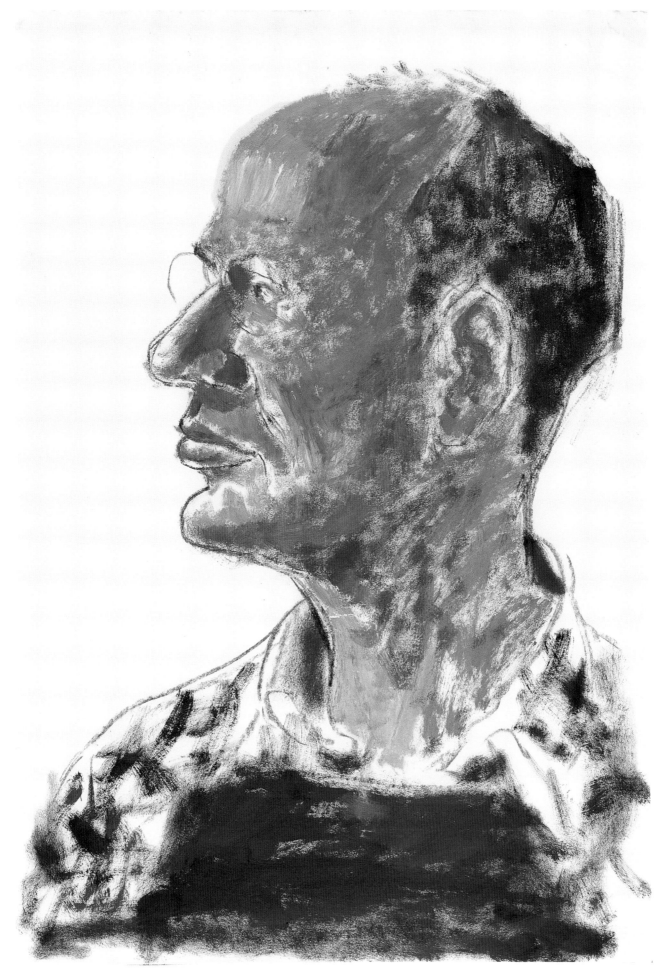

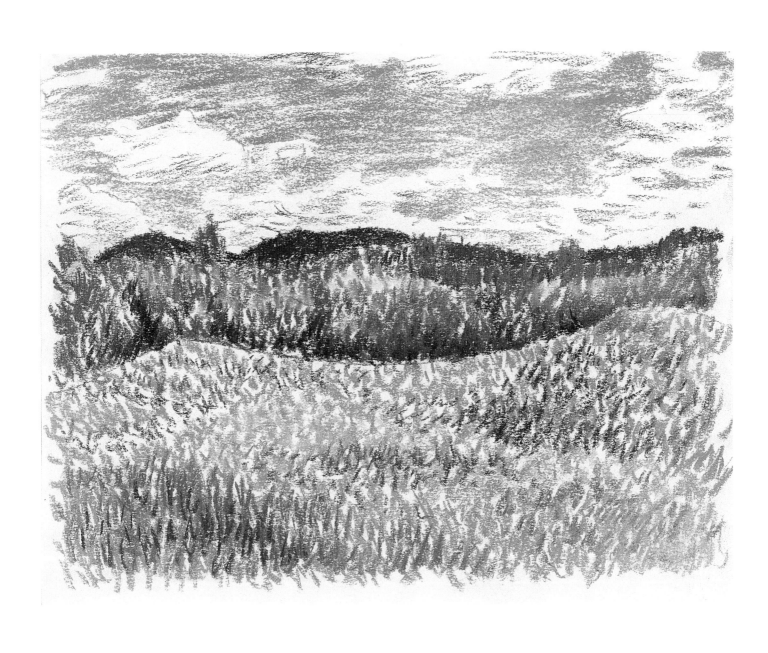

RAWSONVILLE
Oil pastel on paper, image 7¾ × 9⅝″, early 1950s.

The meadow and Glebe Mountain.

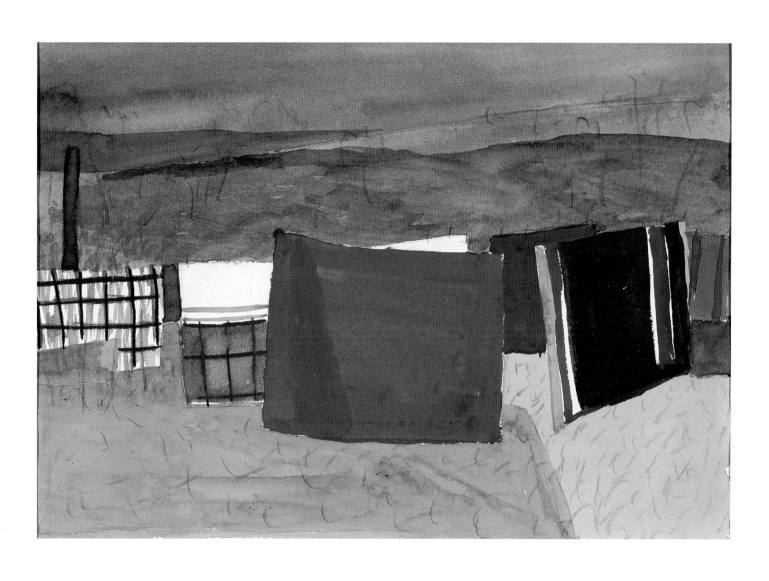

CLOTHESLINE WITH BLANKETS, RAWSONVILLE
Watercolor on paper, image 7⅝ × 11 ″, 1960s.

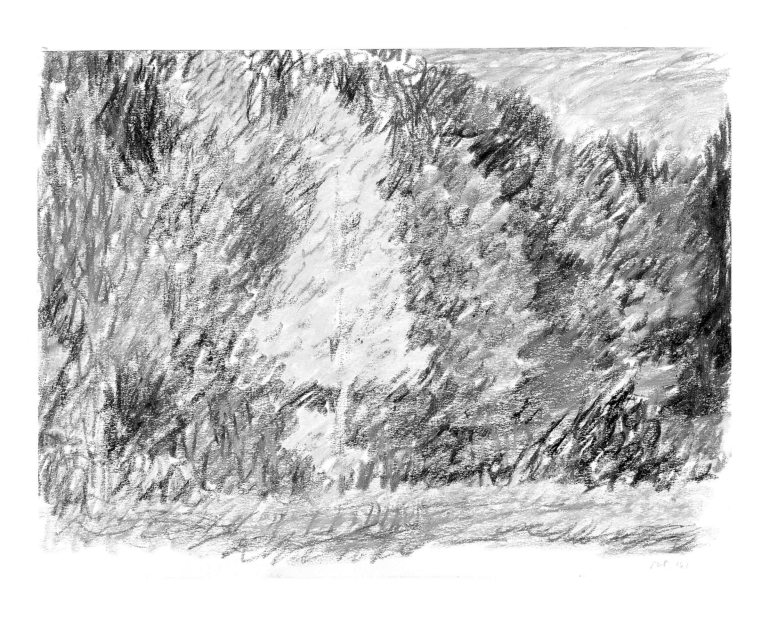

FALL TREES, VERMONT
Crayon on paper, 9⅝ × 12¾″, 1961.

*The Schapiros, not usually in Vermont when the leaves turned color
completely, were there in the late fall of 1961.*

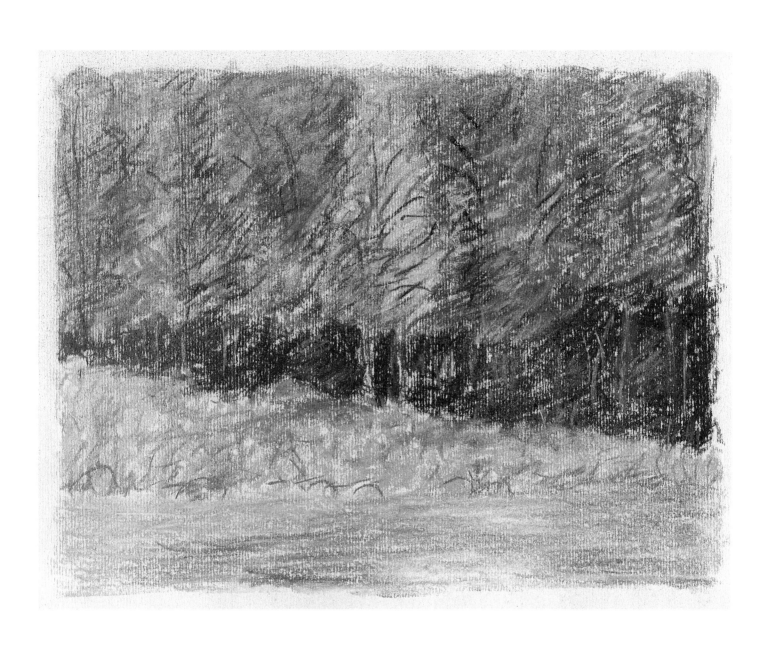

MEADOW, RAWSONVILLE
Oil pastel on paper, image 6¾ × 8¾″, 1960?

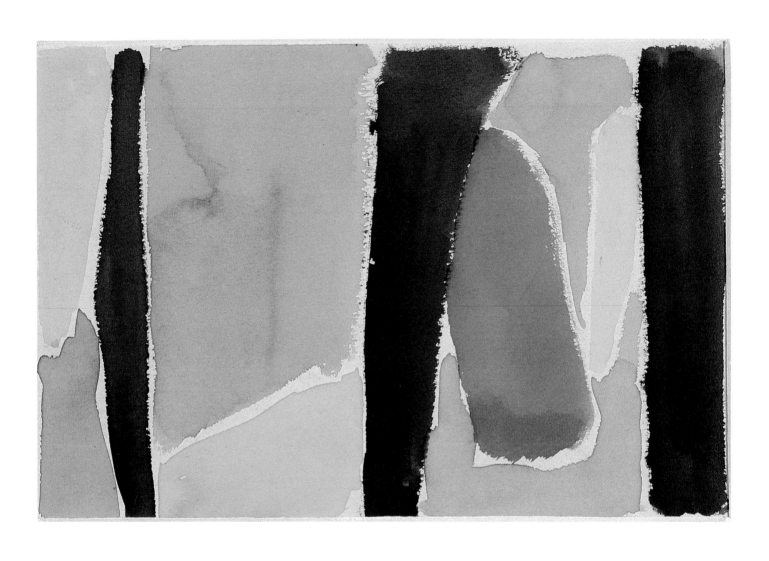

ABSTRACTION WITH BLACK VERTICALS
Watercolor on paper, image 6¾ × 10¼″, July 18, 1961.

214

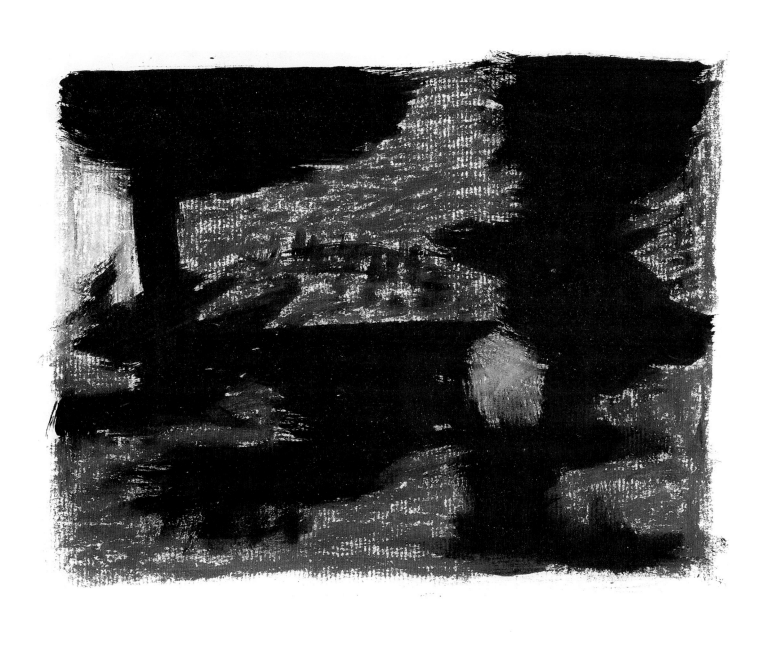

ABSTRACTION
Oil and oil pastel on paper, image 6¼ × 8⅛″, July 25, 1964.

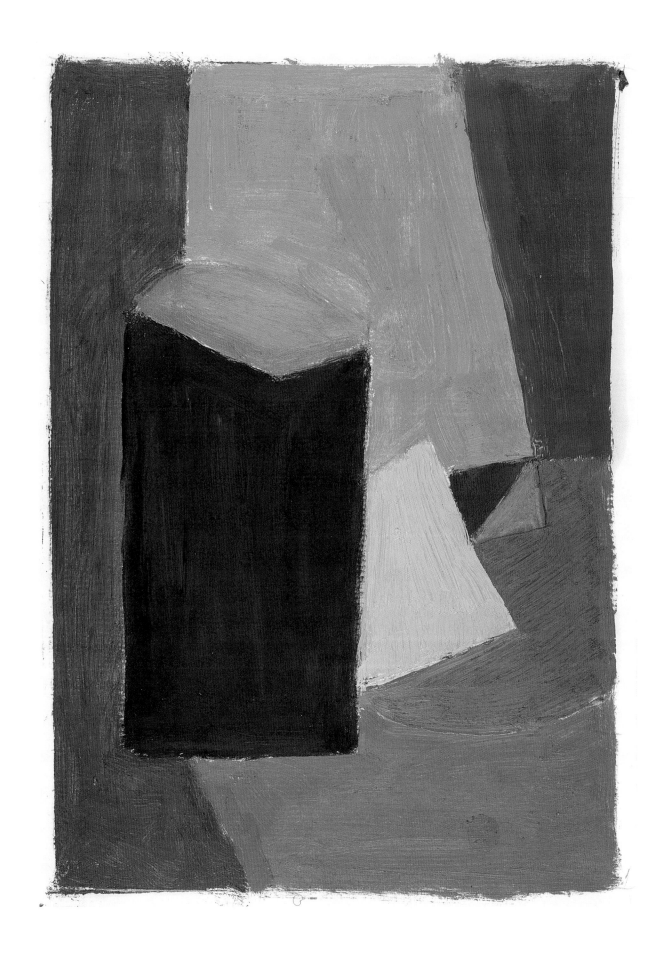

STILL LIFE
Oil on paper, image 8¾ × 6⅛″, July 22, 1965.

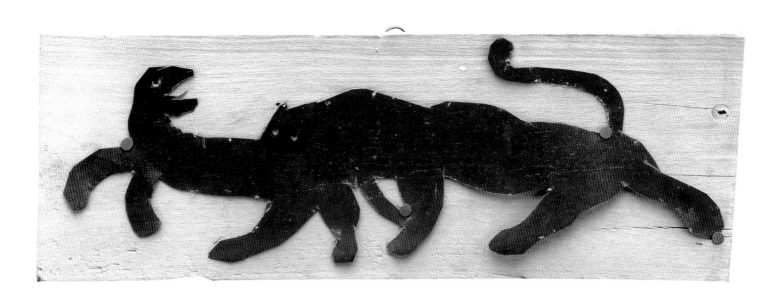

FIGHTING ANIMALS
Stove-pipe tin mounted on board, 4⅛ × 12″, 1961.

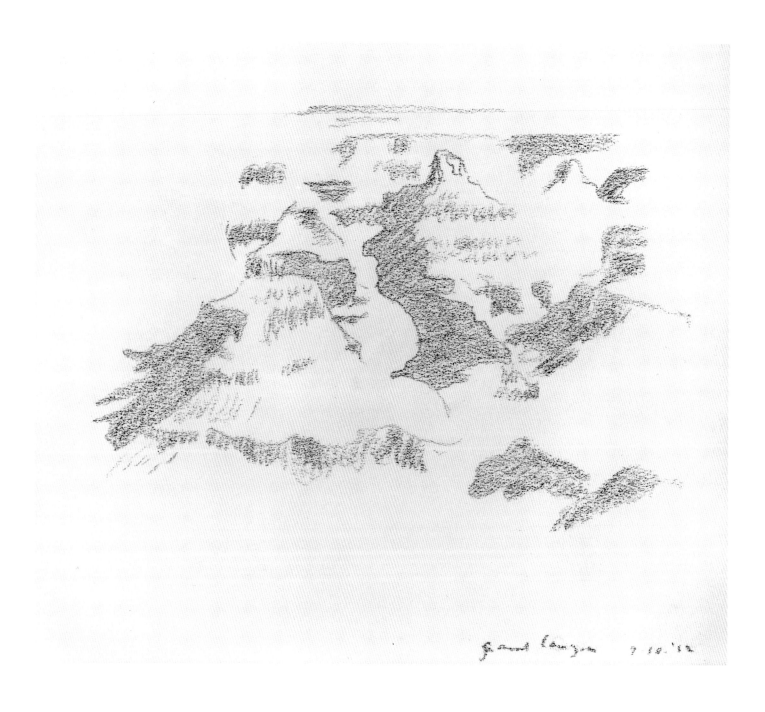

GRAND CANYON
Color crayons on paper, image 5½ × 7¾″, September 10, 1962.

*In 1962–63, the artist was a visiting scholar at Palo Alto. On the way to
and from California the Schapiros did some sightseeing.*

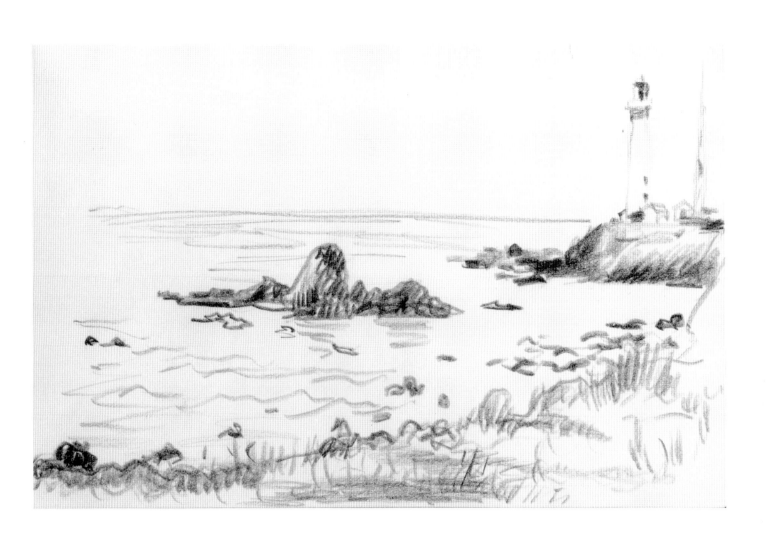

PIGEON POINT LIGHTHOUSE, CALIFORNIA
Conté crayon on paper, 5⅜″ × 8¼″, 1962.

ABSTRACTION
Marker on paper, image 6¾ × 7⅞″, July 5, 1963.

220

ABSTRACT SEASCAPE
Conté crayon on paper, image 7¼ × 10⅛″, 1960.

LANDSCAPE FORMS
Ink and marker on paper, image 6½ × 10⅛″, June 6, 1966.

SURREAL ROCKS
Marker on paper, 4⅜ × 6¾″, 1960s.

CUBIC FORMS
Marker on paper, 8½ × 3¾″, 1960s.

ABSTRACT LANDSCAPE?
Ink on paper, image 7³⁄₁₆ × 6¾″, August 21, 1967.

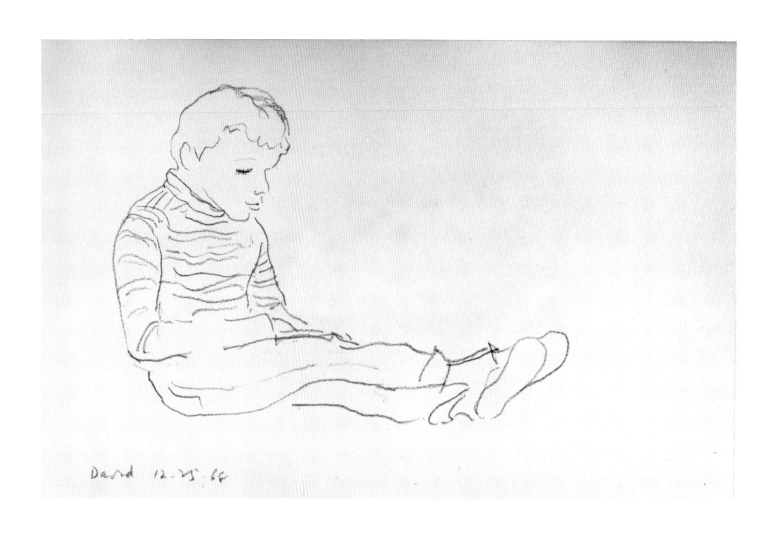

David 12.25.68

DAVID
Pencil on paper, 5 × 8″, December 25, 1968.

The artist's youngest grandson.

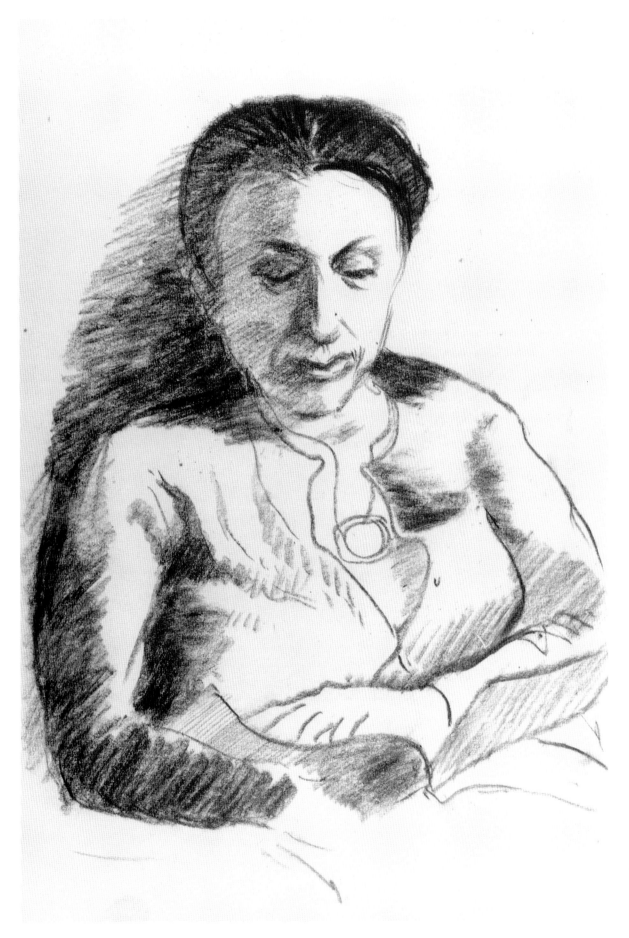

LILLIAN
Conté crayon on paper, 9¾ × 6½″, 1960s?

SELF-PORTRAIT
Pencil on paper, image 9 × 7½″, August 18, 1974.

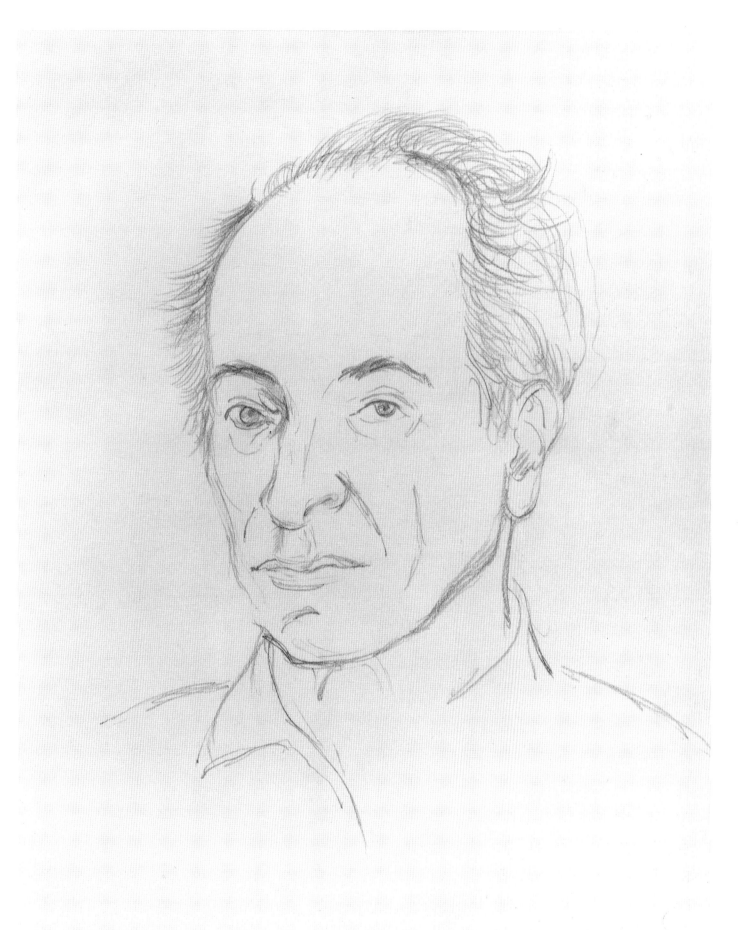

R. 16-74

I.10.69

BLACK SHAPES
Conté crayon on paper, 7⅞ × 4⅞", Florida, January 10, 1969.

ABSTRACTION
Graphite on paper, image 6¾ × 4⅝″, 1970s.

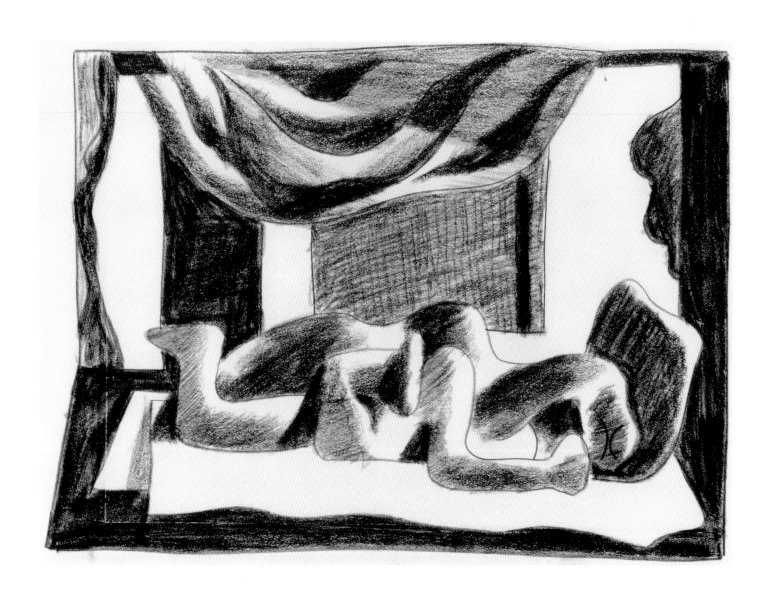

CUBIST NUDE
Conté crayon on paper, 9⅝ × 12¾″, 1970s.

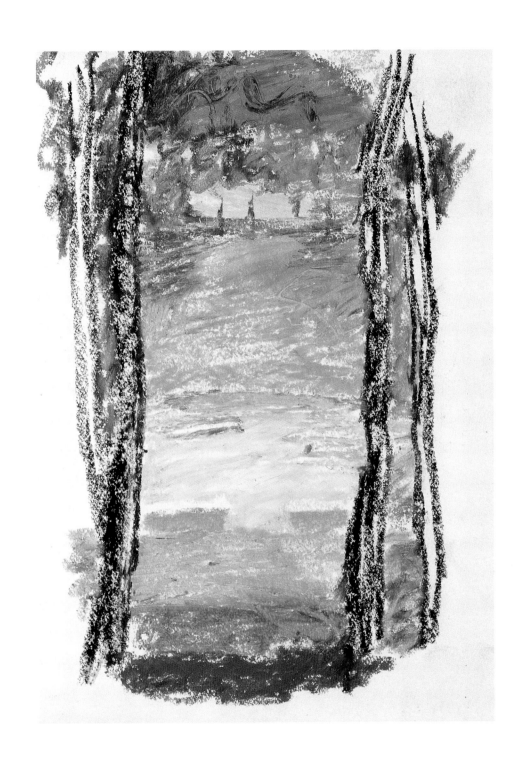

TOWNSEND DAM PARK, VERMONT
Oil pastel on paper 7 × 5″, 1965.

ABSTRACTION

Crayon on paper, image 12¼ × 11 ″, January 14, 1969.

Sunset on the Gulf of Mexico. In 1968 the Schapiros bought a house in Siesta Key,
Sarasota, Florida, where they spent a part of each winter until the early 1990s.

234

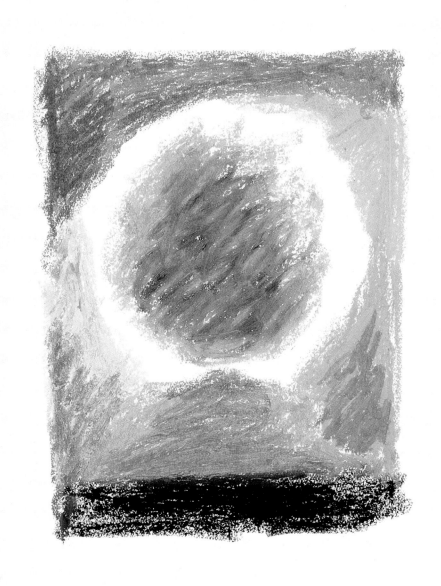

ABSTRACTION
Oil pastel on paper, 7¾ × 5¾″, Florida, late 1960s.

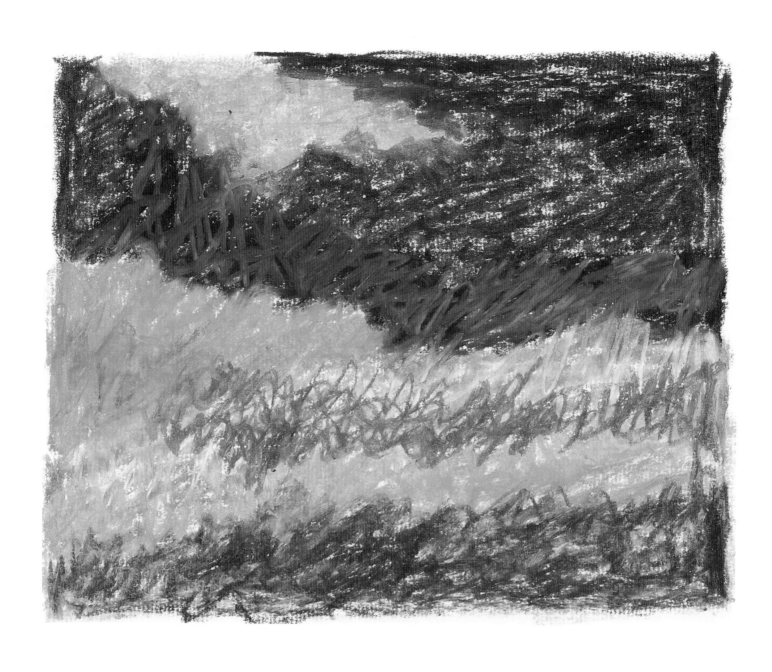

ABSTRACT LANDSCAPE
Oil pastel on paper, image 7¼ × 9⅛″, 1971.

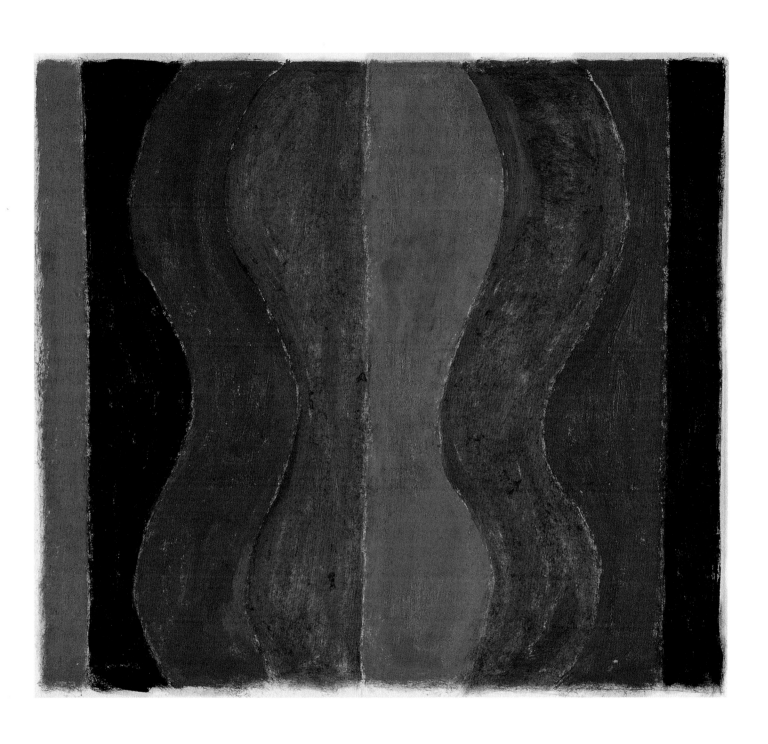

VERTICAL COLOR BANDS
Oil on paper, image 10½ × 12″, August 16, 1971.

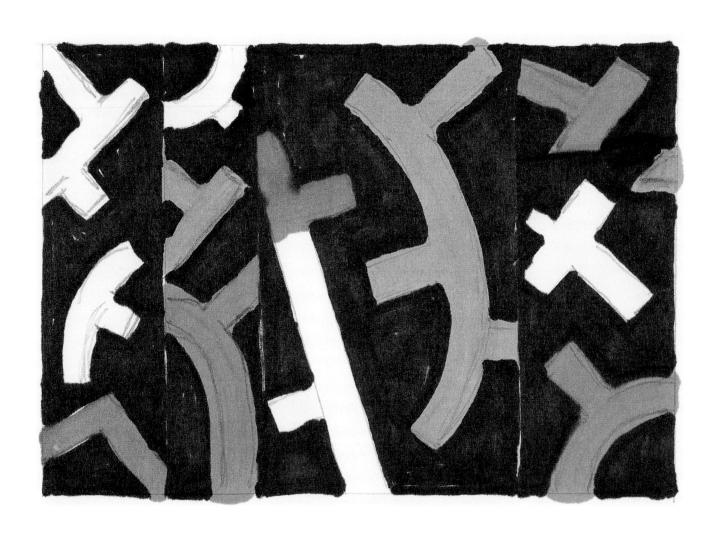

BRANCHED SHAPES ON BLACK SEGMENTED BACKGROUND
Pencil and color marker on paper, image 4¾ × 6⅞″, August 31, 1973.

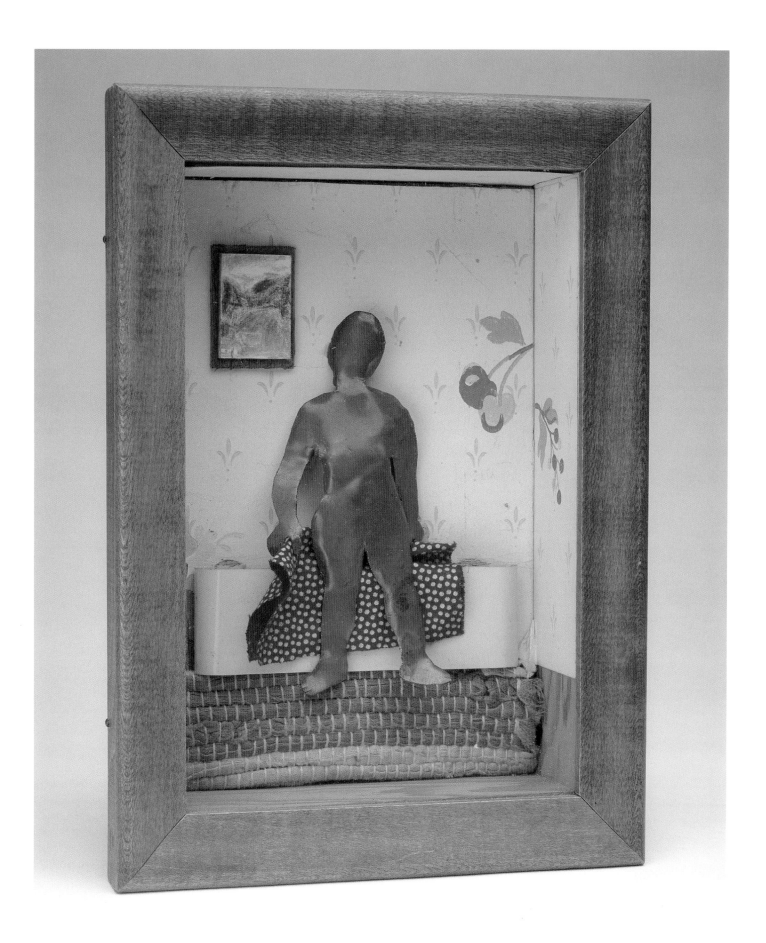

AFTER THE BATH
Wood box and various materials, 8½ × 6 × 2¼″, August 18, 1970. Collection of Daniel Esterman.

Inscribed on the back as a gift to Lillian on her birthday.

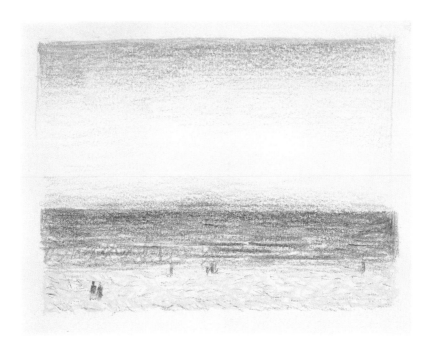

SUNSET, SIESTA KEY, BEACH AT SUNSET
Color pencil on paper, image 2⅞ × 3⅞″, sheet 7¾ × 5″, 1970?

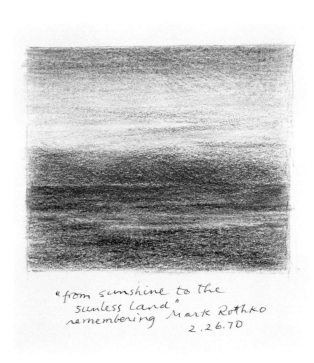

"from sunshine to the
sunless land" Mark Rothko
remembering 2.26.70

SUNSET, SIESTA KEY
Color pencil on paper, image 2⅜ × 2⅞″, sheet 5¼ × 4¼″, February 26, 1970.

Inscribed "from sunshine to the sunless land" *remembering Mark Rothko. The first six words are from Wordsworth,* Extempore Effusion Upon the Death of James Hogg, *and were quoted by Meyer Schapiro more than once in later years.*

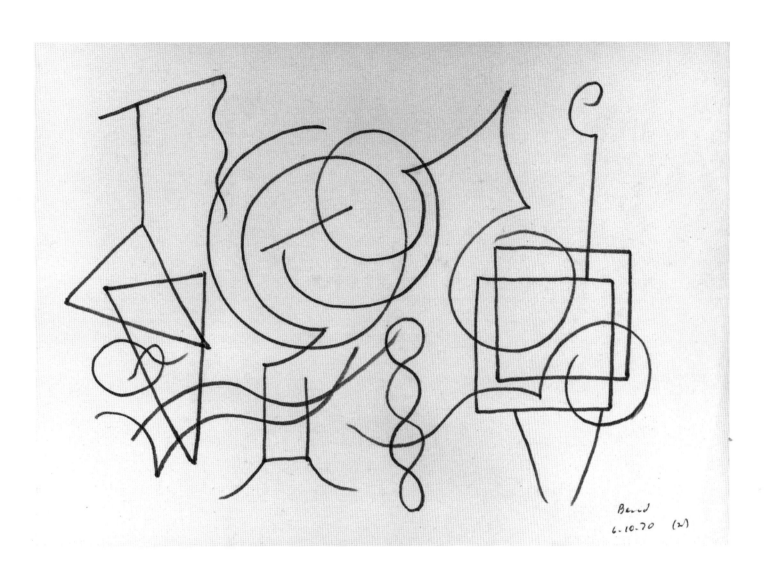

BAND #2
Marker on paper, 8½ × 12″, June 10, 1970.

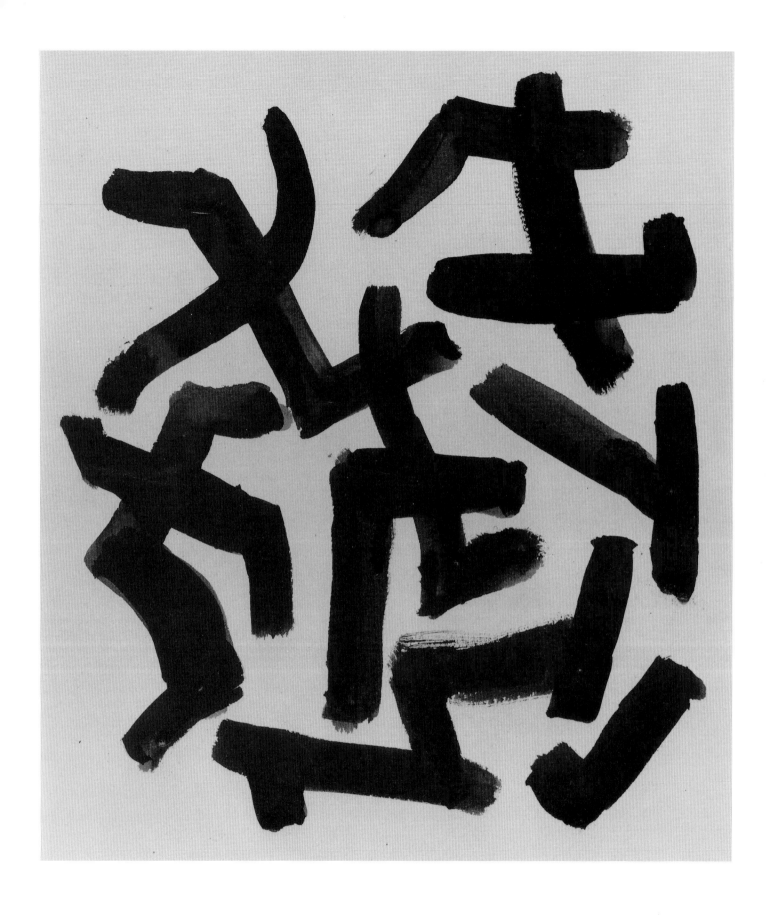

BLACK BARS
Ink on paper, image 8⅜ × 7⅜″, August 13, 1970.

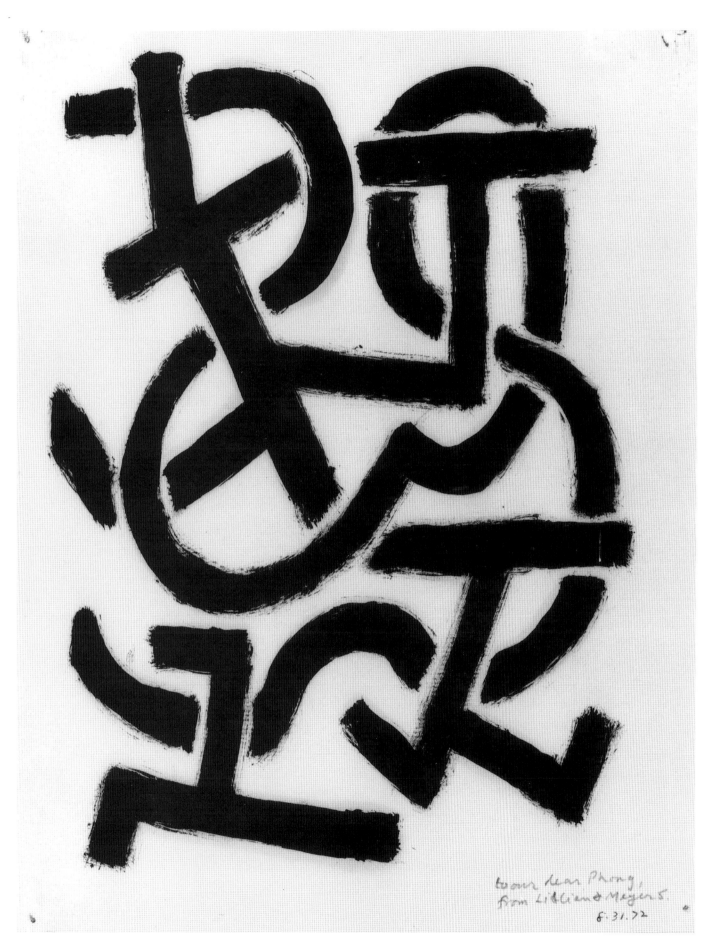

INTERLACE
Oil on paper, 10⅞ × 8½″, inscribed August 31, 1972. Collection of Bui Phang.

243

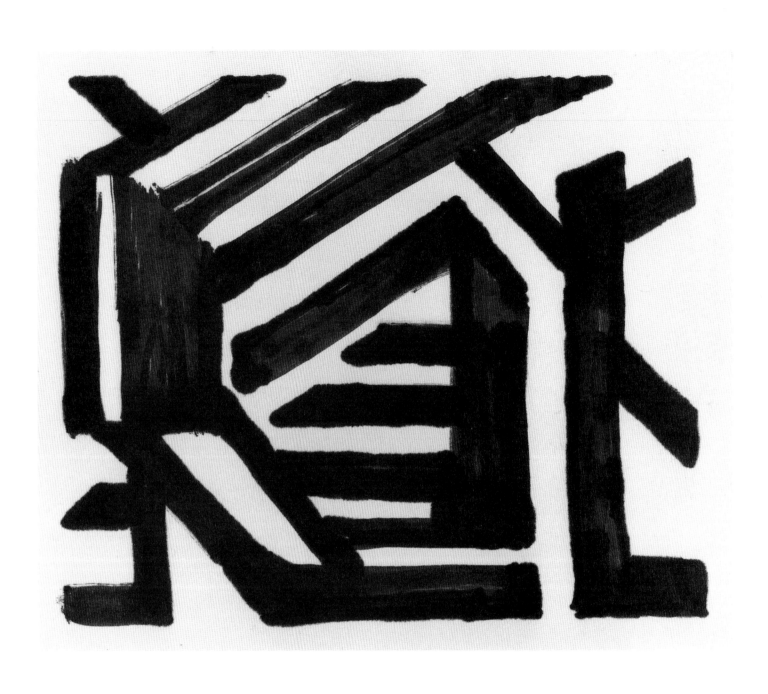

BLACK BARS #1
Marker on paper, image 6⅛ × 7½″, July 8, 1973.

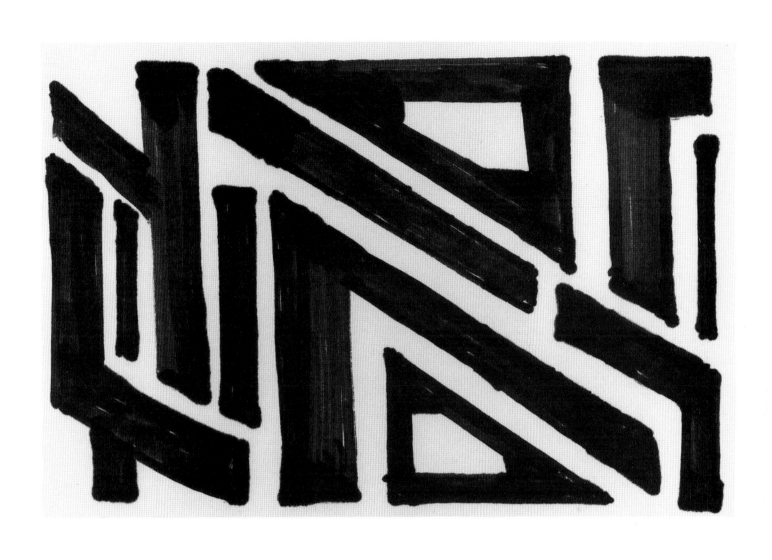

BLACK BARS #2
Marker on paper, image 5¾ × 8¾″, July 8, 1973.

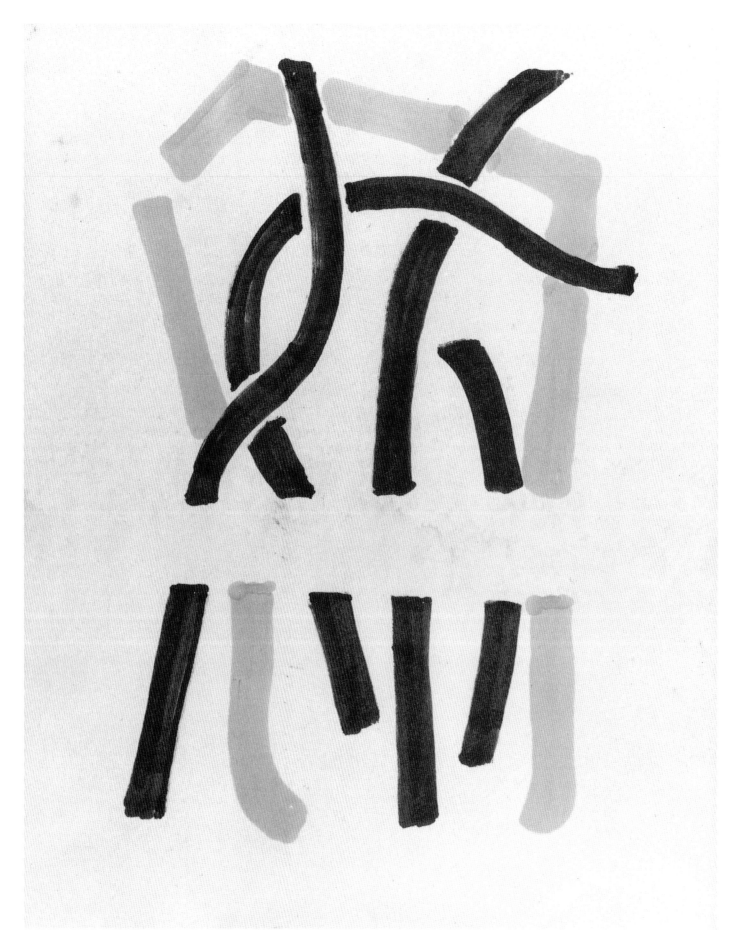

INTERLACED BANDS
Color marker on paper, 12 × 9″, July 8, 1973.

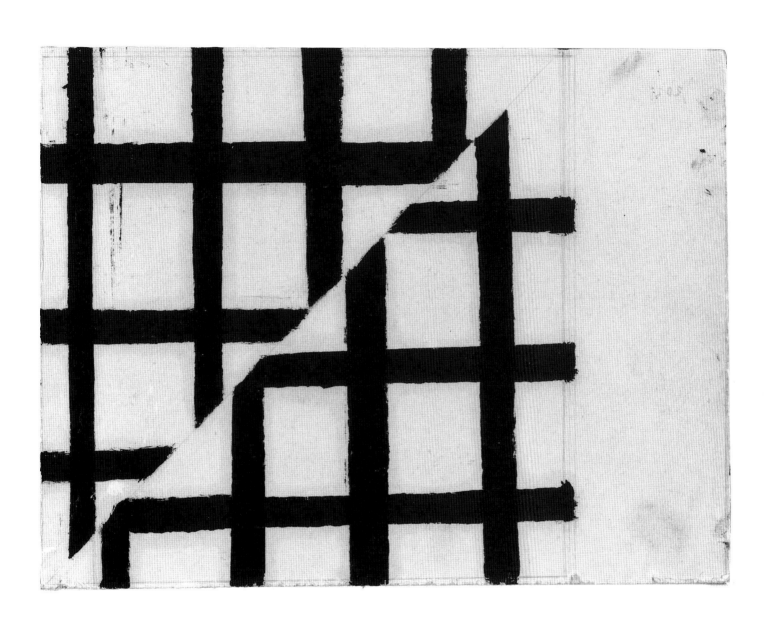

SLIPPED GRID
Oil on plasterboard, 7¾ × 10¼″, July 2, 1975.

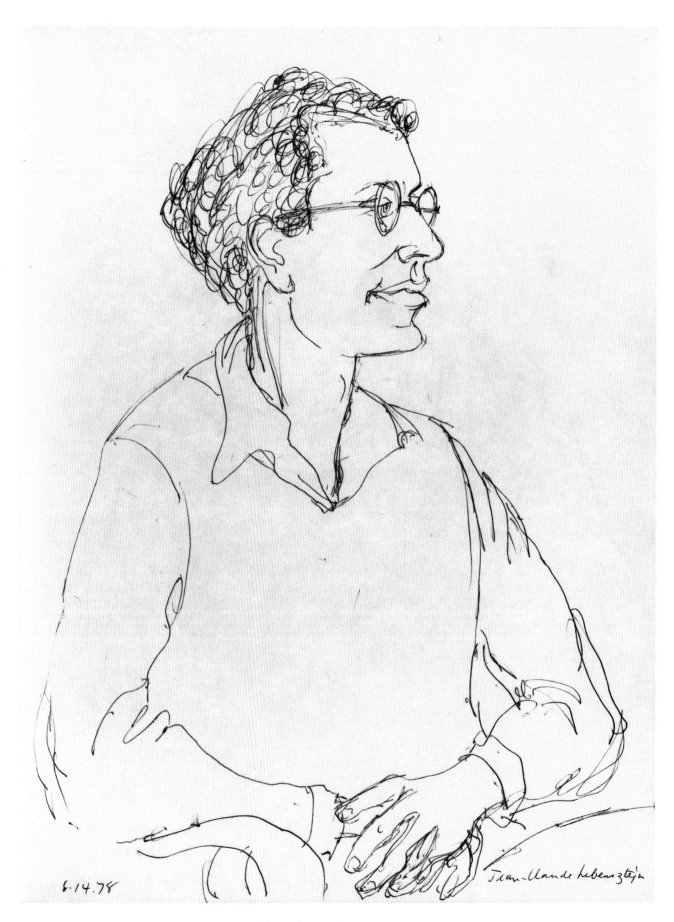

6.14.78

Jean-Claude Lebensztejn

JEAN-CLAUDE LEBENSZTEJN
Ballpoint pen on paper, 12¾ × 10⅝″, August 14, 1978.

Author, art historian, and, according to the artist, the best translator of his works into French.

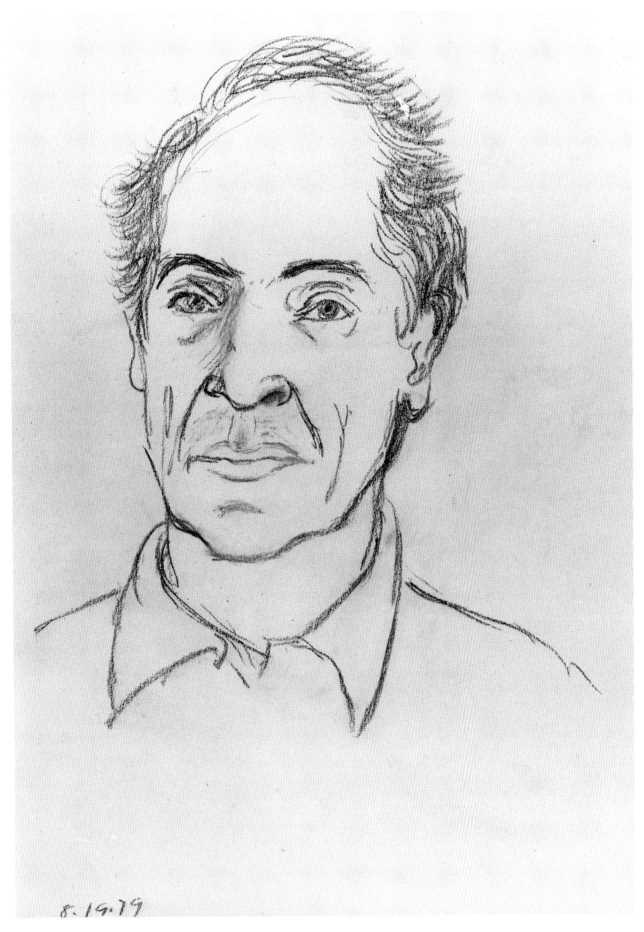

8.19.79

SELF-PORTRAIT
Conté crayon on paper, image 9½ × 7½″, August 19, 1979.

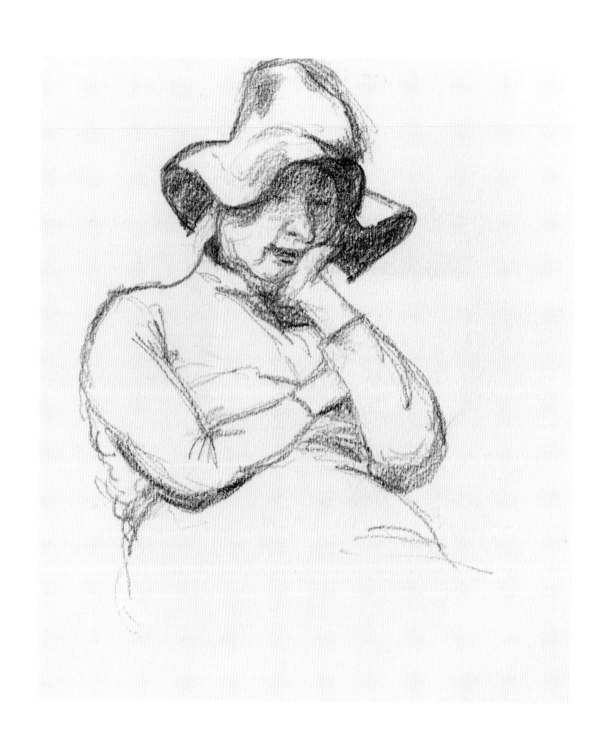

LILLIAN
Pencil on paper, image 4⅝ × 4½″, July 29, 1984.

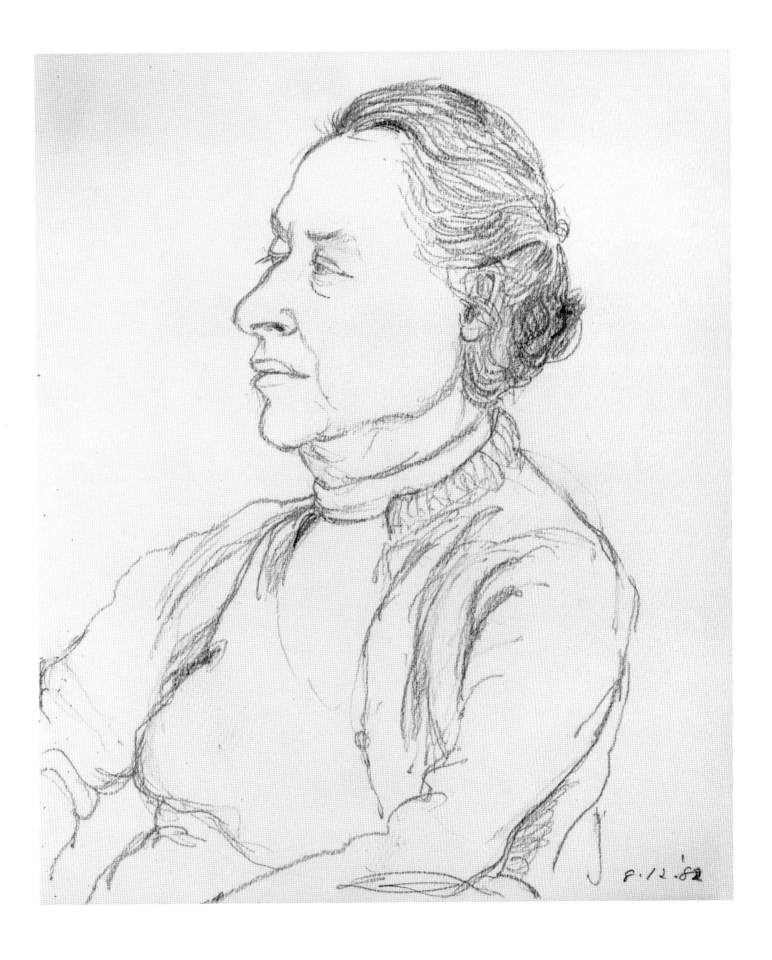

LILLIAN
Pencil on paper, 9½ × 8⅛″, August 12, 1982.

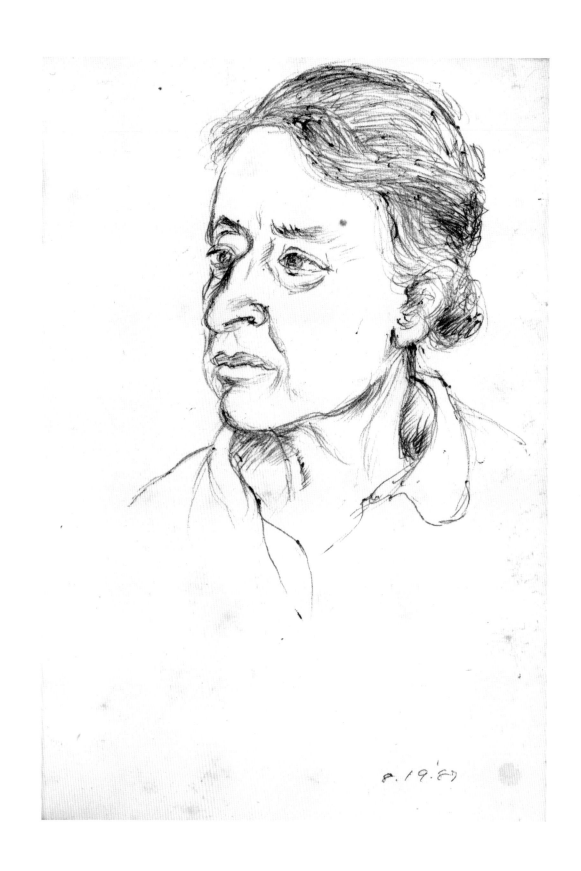

LILLIAN
Ballpoint pen on paper, 7⅞ × 5½″, August 19, 1987.

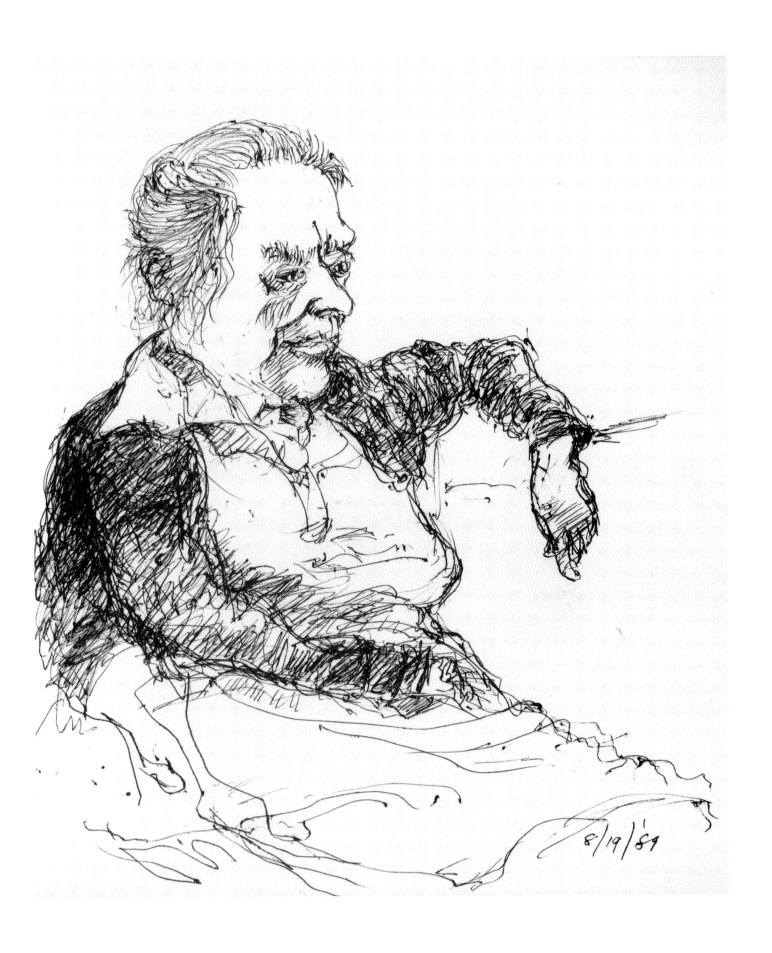

8/19/89

LILLIAN
Ballpoint pen on paper, 9½ × 8⅛″, August 19, 1989.

Index